Apparitions: Photography and Dissemination
Geoffrey Batchen

© Published by NAMU & Power Publications, 2018
© Geoffrey Batchen

ISBN 978-0-909952-80-8 (Power Publications)
ISBN 978-80-7331-495-8 (AMU Press)

Apparitions Photography and Dissemination

Geoffrey Batchen

Contents

05 Prelude

13 Photography and the Photographic Image

30 Photography and Commerce

74 Photography and Reproduction

117 Photography and The Great Exhibition

129 Photography and Empire

138 Photography and Identity

160 Photography and Photomechanical Reproduction

171 Coda

174 Notes

202 Acknowledgements

206 Index

Fig. 2
'Pope Francis and the first "papal selfie"', *Telegraph* website (England), 29 August 2013,
http://telegraph.co.uk/news/worldnews/the-pope/10277934/Pope-Francis-and-the-first-Papal-selfie.html.
Screenshot detail from *Telegraph* website, Courtesy of the *Telegraph*, London.

The Telegraph

HOME » NEWS » WORLD NEWS » THE POPE

Pope Francis and the first 'Papal selfie'

A photo of the Pope posing with young fans at the Vatican has gone viral on social media, with gleeful reports that it was the first ever "Papal selfie".

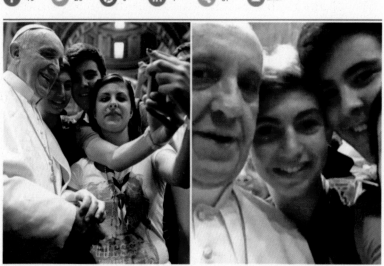

Pope Francis has his picture taken inside St. Peter's Basilica with youths from the Italian Diocese of Piacenza and Bobbio. Photo: AP

Prelude

In August 2013 a PR-conscious pontiff posed for a selfie with some mobile-phone wielding teenagers. The resulting picture—with its telling conjunction of youth and age, contemporaneity and tradition—tells us quite a lot about the current state of photography. Not just about a particular genre of image, which this example confirms as the fashionable pose of the moment, but also about the nature of the photograph itself.

This photograph was of course shot with a camera incorporated into a multimedia communications device. As a consequence, the photograph was primarily taken, not to be printed as a permanent document, but to be exchanged with friends all around the world, mainly by being uploaded onto a social media site to join billions of other, very similar, images. Its maker assumed that the photograph now consists of a stream of electronic signals, representing an entirely ephemeral exclamation of a presence in the present (rather than signifying something in the past 'that has been').[1]

Given the permeability of the private and public realms that social media encourage, this same photograph quickly found its way into the hands of the world's press, circulating in a variety of manifestations for a brief news cycle.[2] But electronic signals and newsprint were only two of this photograph's many possible transmutations (Fig. 2). After all, different kinds of photographs can be produced from the same matrix, and often are. This fluidity of identity is what makes photography such a difficult medium to pin down, both literally and metaphorically. To shift from pixels to newsprint, for instance, this photograph's image had to be transferred from one place to another and transformed from one state of being into another. The image of the papal selfie is common to both screen and newspaper, but retains an existence separate from either. Now it appears in this book, having been reproduced in yet another format. If this example is any guide, then, the ability to separate a photograph from its image—the ability of a photograph to become an apparition of itself—has become the most important aspect of photography, the aspect

that has the greatest value, that gives any particular photograph its capacity to continue to be disseminated in various forms across space and time.

Or has this always been photography's primary mode of being, and historians of this medium have just preferred to ignore it? Driven by a market invested in singular prints and rarity, the history of photography has tended to restrict itself to a discussion of photographs as individual physical objects, as if this—a collective of such objects—is all that the word 'photography' encompasses. But what if we try to imagine another kind of history for photography? What if we try to imagine a history that might be able to speak to, even account for, the medium's present?

At the least, such a history will have to follow a logic quite different from the one that has prevailed until now. For a start, it will have to be a history of photography freed from the tyranny of the photograph. Breaking with the self-imposed ghetto of medium purity, it will have to trace, not just the production of physical photographs, but also their migration as objects and their dissemination as images. No longer confined to precious commodities or specific technologies, this would be a history finally able to consider the full implications of both photography's reproducibility and its capacity for transfiguration. It would become an accounting of dynamic relationships, not only of static things—a tracking of dispersals and transformations rather than a celebration of origins. In short, it would be a history about the relationship of a photograph to its reproductions, wherever and in whatever form these have appeared.

Given the centrality of reproducibility to photography's mode of being in the world, it is surprising that no one has yet written a sustained critical study of the consequences and implications of the reproduction of the photographic image. Perhaps that is because photography's reproducibility generates all sorts of problems for the rigorous photo-historian. Among other effects, it allows photographic images to be widely circulated, but it also gives the same image the capacity to come in many different media, looks, sizes and formats, and have many authors. It also makes it possible for an image to appear in many places at once and to exist simultaneously at many different points of time. A photograph, therefore, almost always comprises a number of different versions of itself. This multiplicity of physical manifestations is matched by a similar proliferation of meanings and effects. Given all this, given

photography's multiple personality disorder, we can no longer be satisfied with determining the possible meaning of a photograph just at the moment of its production. Instead we will have to trace the arc of a photograph's journey through space and time, acknowledging that this journey too is a complex one as images enter new contexts and circumstances.

When Walter Benjamin reflected on these issues in the mid-1930s, he chose to equate the reproductive capacities of photography with the processes of mass production, and thus with the most basic operations of capitalism itself. For Benjamin, these processes are fraught with an inherent contradiction, an alienating inversion of social and commodity relations, such that reproduction is simultaneously capitalism's lifeblood and its poison. Photography, he suggested, contained within it this same contradiction, being equally capable of sustaining capitalism and of destroying it. For him, reproducibility was therefore a politically charged capacity that could be either exploited or suppressed, but should definitely not be ignored.[3]

Yet most commentaries on Benjamin's famous essay are content to do just that, avoiding the essay's larger political concerns by concentrating on what he might have meant by 'aura'—perhaps (with the possible exception of 'punctum') the most misunderstood word in the photographic lexicon.[4] Benjamin described aura as 'a strange tissue of time and space: the unique apparition of a distance, however near it may be'.[5] I take this to be his attempt to account for the hallucinatory effects of commodity fetishism such that unequal relations of power are experienced by individuals in very real, if often invisible, phenomenological and psychological terms. According to Karl Marx, commodity fetishism enables the subjugation of all social conditions and relationships to the needs of capital: 'A definite social relation between men [...] assumes, in their eyes, the fantastic form of a relation between things.'[6] This form is 'fantastic' because the commodity comes to be invested with unearthly powers beyond its capacity to deliver. As Paul Wood explains the process:

> The commodity becomes a power in society. Rather than a use value *for* people it assumes a power *over* people, becoming a kind of god to be worshipped, sought after, and possessed. And in a reverse movement, as the commodity, the thing, becomes personified, so relations between people become objectified and thinglike.[7]

Accordingly, the endless reproduction of an artwork such as the *Mona Lisa* brings this painting close to us, but at the considerable cost of the commodification of our relationship to it. In reproduction form the artwork is near, physically and temporally, but that work's cult value has been exponentially amplified by this same reproduction, and thus we are simultaneously distanced from it. We might flock with enthusiasm to see the original, to see (and photographically copy for ourselves) the source of this torrent of images. However, this copying has transformed the nature of our experience even before we get there. Protected by layers of glass, the original is a mere shadow of what we already know of it from its many reproductions, as if it has been degraded by that very knowledge. Its celebrity status—a consequence of its constant reiteration in reproduced form—denies us access to the painting on its own terms. We see a star, rather than an actor: a masterpiece to be worshipped, rather than a piece of painting to be appraised and understood. Alienated by processes inherent to capitalism, we are prevented from having anything like an authentic relationship to this or any other similarly replicated product of our own culture.

Although not always attuned to the broader politics of this relationship, a number of scholars have written about the role played by photographs in the reproduction of artworks.[8] With this study as a background, Stephen Bann has argued against a 'photographic exceptionalism' that too readily lends itself to a 'tunnel history' in which related media forms or broader contexts are neglected in favour of keeping the photograph in its own little ghetto, detached from everything happening around it. As a counter to this tendency, Bann has situated the professional practice of photography in the nineteenth century within an expanding visual economy that included a range of different kinds of printmaking, measuring, among other things, the competition between photographs and engravings as a means of reproducing paintings. Bann has even asserted that 'on the epistemological level, photographs appeared to present no distinctive and unprecedented vision of the external world'.[9] He therefore concludes that, 'in order to *write* the history of photography, one must *not write* the history of photography'.[10] What one should write instead, he implies, is a history of reproductive media in general, and then locate photography within it.

It is true that future histories of photography will have to embed their accounts in a wider media history and indeed in a larger history of industrial and consumer capitalism. Nevertheless, an argument can still be made for the specificity both of photography's history and

of its particular attributes as a medium of representation. Despite many overlaps with other media and a common social, cultural and economic context, photography does in fact have some distinctive elements. Analog photographs are printed from a matrix, like engravings, but they can be printed at a variety of sizes and sometimes in different media (as either a salt print or an albumen print, for example). Photographs, as Roland Barthes and many others have discussed, have a peculiar relationship with their referents, and thus to referencing in general, due to the indexical means of their generation. This peculiarity matters, psychologically as well as pictorially.[11] Photography eventually became a popular domestic craft, rather than just a professional practice, and this too has distinguished its history from that of most other media forms. All these things are important in understanding both photography's role in the development of modernity and our relationship to photographic images. All these things, and more, would need to be recognised in any media history that included photography.[12]

In any case, my interest here differs a little from that of both Bann and Benjamin. Rather than examine photography's ability to reproduce other images (etchings or paintings, for instance), I want to consider the consequences of its capacity to reproduce itself. The question to be addressed is: what is this 'itself'? What is being copied when a photograph is reproduced? After all, a photograph corresponds to, but does not look like, the negative from which it has been printed. Every photograph is therefore already a copy for which there is no original. As Benjamin put it: 'From a photographic negative [...] one can make any number of prints; to ask for the "authentic" print makes no sense.'[13] That this sort of replication is also a form of displacement, even of dislocation, is made overt when a photograph's image is reproduced in another medium—as a wood engraving, for example.

How does one describe the photographic image that is transferred from one substrate to another during this process? This image seems to be a kind of ghost, a momentarily dematerialised entity derived from a photograph that it resembles but is different from in substance (for such an image is photographic, but not a photograph). This photographic image is simultaneously attached to and detached from an origin point that becomes increasingly difficult to grasp (that is, indeed, often erased in the process of its reproduction). Itself a spectre, a wood-engraved image derived from a daguerreotype, for example, conjures the photograph that was destroyed to make it, a photograph that now can only be imagined. But that wood engraving, by marking an absent presence, in turn torments a history of photography all

too anxious to ignore the complexities of reproducibility. Although rarely discussed at any length in those histories, this strange procedure of erasure and replication, along with the economy of reciprocal haunting just described, is central to photography's way of being, and to its modernity as a means of representation.

This book is about the early history of this procedure. It is about what happens when a photograph is made to 'give up the ghost' in this way and become just one among a multitude of replicas. But a full account of the consequences of photography's reproducibility would take many volumes. To give it limits, and allow for some historical depth, my study will therefore focus on the establishment of commercial photography in England between 1839 and about 1851, and especially on the business practices of the first two studios to open in London. This will necessitate some discussion of the development of these businesses and of their production of daguerreotype portraits for a variety of clients, along with the reception accorded such photographs. Strangely, given its centrality to photography's history, this is a story that has not previously been told in much detail. However, my aim is also to complicate the usual privileging of photographs in the writing about photography's early history. To that end, I will reveal the extent to which these two studios were also involved in selling daguerreotypes to the popular press so that they could be reproduced in other media, and even in offering prints after photographs to their own clients. I will show, in other words, that the dissemination of photographic images was a central feature of their business practices.

Despite this relatively narrow focus on England in the 1840s and 1850s, it will soon become clear that this study is both global in scope and relevant to the present. Necessarily grounded in a larger political argument about the consequences of reproduction, any accounting of photography's dissemination is, after all, also an examination of the operations of industrialisation, capitalism and colonialism. It therefore cannot help but traverse an unusually fraught and contested territory. Concentrating on the reproduction of photographic images in the popular press, my commentary will be studying an entity not easily defined, ephemeral even when first produced, and of no great monetary value in the marketplace today. Doubly displaced from its point of origin (which it nevertheless plagues as a ubiquitous presence), crossing borders without restraint, rejected or ignored as second-rate by our culture's authority figures (including by most photo-historians), this virtual entity, the itinerant phantom that is the photographic image, is, it seems, an unwanted outcast.

The complexity of the identity of this outcast is signalled in the very word 'dissemination', a word that, by being in contradiction with itself, enacts its own alterity; as Jacques Derrida said, 'it marks an irreducible and *generative* multiplicity'.[14] But even the *Oxford English Dictionary* concedes that dissemination means both 'the action of scattering or spreading abroad seed' and 'the fact or condition of being thus diffused', thereby declaring this word to be simultaneously a verb and a noun, a mark and the act of marking. The complications of such a simultaneity—rendering inoperable, for example, any simple opposition of original and copy, material and immaterial, photograph and image—should be kept in mind as one pursues the kind of history I am advocating here.

Fig. 3

Pictures formed by the action of light in Mechanic and Chemist: A Magazine of the Arts and Sciences, 13 April 1839, front cover. Ink-on-paper print from wood engravings after photogenic drawings, 22.0 × 13.0 cm (sheet). Courtesy of Alexander Turnbull Library, Wellington.

THE

MECHANIC AND CHEMIST.

A MAGAZINE OF THE ARTS AND SCIENCES.

Nos. XVI. & XVII. NEW SERIES.	SATURDAY, APRIL 13, 1839. (PRICE TWO PENCE.)	Nos. CXXXVII & CXXXVIII. OLD SERIES.

PICTURES FORMED BY THE ACTION OF LIGHT.

Fig. 1.

Fig. 2.

City Press, 1, Long Lane, Aldersgate Street: D. A. Doudney.

Photography and
the Photographic Image

Where, then, should one begin a history of photography's dissemination? Traditionally one might have started any history of photography with one of the first photographs to be made by Louis Jacques Mandé Daguerre, a French painter and designer who seems to have begun his photographic experiments in 1824, or by William Henry Fox Talbot, the independently wealthy English polymath who was experimenting with a photographic process as early as 1833. The announcements of their discoveries in Paris and London, respectively, in January of 1839 make this month a crucial date for most historians.[15] Depending on one's inclinations, this version of photography's story therefore comes to be founded on one or more of a series of specific origin points: a particular individual, a particular moment, and a particular object, an early daguerreotype or photogenic drawing.[16]

A history of the dissemination of the photographic image, on the other hand, might well set out from the first reproductions to be made after photographs, and therefore with the first exposure of photography to a truly public audience. Wood-engraved 'fac-similes' of photogenic drawings made using Talbot's process were, for example, published in English journals as early as April 1839.[17] On 13 April of that month, *Mechanic and Chemist: A Magazine of the Arts and Sciences* featured on its cover two anonymously produced wood-engraved versions of camera-made photogenic drawings, one a negative and one its positive imprint (Fig. 3). Looking like silhouettes, these images in fact appeared in the same month in which Talbot himself made his first positive prints from a photogenic drawing negative, so presumably the journal's editor was very well informed about the latest photographic innovations.[18]

A week later, on 20 April, the cover of the *Mirror of Literature, Amusement, and Instruction* bore an engraved version of a photogenic drawing contact print of three sprigs of ferns. It was printed twice: once in black, and once in a rust colour to imitate the look of the original photograph (Fig. 4). According to the following week's issue of the magazine:

Fig. 4
Fac-simile of a photogenic drawing in *Mirror of Literature, Amusement, and Instruction*, 20 April 1839, front cover. Ink-on-paper print from wood engraving after a photogenic drawing, contact photograph by Golding Bird, 21.5 × 13.5 cm (sheet). Courtesy of Alexander Turnbull Library, Wellington.

The Mirror
OF
LITERATURE, AMUSEMENT, AND INSTRUCTION.

No. 945.] SATURDAY, APRIL 20, 1839. [PRICE 2*d*.

FAC-SIMILE OF A PHOTOGENIC DRAWING.

VOL. XXXIII. R

[...] the engraving gave a most accurate idea of the photogenic picture, which represents the fern with such extreme fidelity that not only its veins, but the imperfections, and accidental folding of the leaves of the specimen are copied,—*the greater opacity of the folded parts being represented by the large white patches on our fac-simile* [emphasis in original].[19]

These cover images were intended to illustrate an article inside the journal by Dr Golding Bird titled 'A Treatise on Photogenic Drawing'. Bird, the inventor of the stethoscope, published at least two other such essays during 1839, one a letter titled 'Observations on the Application of Heliographic or Photogenic Drawing to Botanical Purposes; With an Account of an Economic Mode of Preparing the Paper' and sent to the *Magazine of Natural History* on 25 March (this being the text reprinted in the *Mirror*) and another titled 'Flora: On Taking Impressions of Flowers, etc, by the Photogenic Process', published in the *Floricultural Cabinet and Florist's Magazine* in December.

Bird's essays were soon circulated around the British Empire. Some time before August 1840, for example, Conrad Martens, an English-born painter who had emigrated to Sydney, Australia, carefully wrote out a recipe for photogenic drawings in his notebooks, the source being a reprinted essay by Bird that Martens had read in his copy of the *Visitor, or Monthly Instructor* of 1839. This was a magazine published in London by the Religious Tract Society but which was obviously also available to homesick readers in Australia. Based on his reading, and perhaps on his own experiments, Martens recommended using 'glazed writing paper of the thinnest kind' and the 'stopping solution recommended by Mr Bird' in order to obtain 'the dark colour produced by the action of the sun'. He also suggested applying the 'Photogenic fluid using a brush' and doing so by candlelight.[20] Although we have no other evidence that Martens made any photogenic drawings himself, we can reasonably say that, thanks to these publications, he had photographed in his imagination well before any photographic camera arrived on Australian shores. Martens' experience of photography—more rhetorical than actual—was fairly typical during these first few years of the medium's circulation.

On 27 April 1839 the *Magazine of Science, and School of Arts*, a relatively new London publication, devoted one of its covers to wood-engraved *Fac-similes of photogenic drawings*: two of botanical specimens and one of a contact print of a piece of lace.[21] The image

Fig. 5
Fac-similes of photogenic drawings in *Magazine of Science, and School of Arts*, vol. 1, no. 4, 27 April 1839, front cover. Ink-on-paper print from wood engravings after photogenic drawings, contact photographs by George William Francis, 22.0 × 13.0 cm (sheet).

THE

MAGAZINE OF SCIENCE,

And School of Arts.

No. IV.]　　　　　SATURDAY, APRIL 27, 1839.　　　　　[Price 1½d.

FAC-SIMILES OF PHOTOGENIC DRAWINGS.

of lace, in its machine-made repetitions of geometric patterns, was the very embodiment of mass-production techniques, and thus of industrial capitalism.[22] The plant specimens conjured nature, photography's generative force, but also the science of botany and its particular pictorial demands (Fig. 5). The photographs were the work of botanist George William Francis (who, as it happened, subsequently emigrated to Australia). Francis explained that he had photographically sensitised boxwood blocks and made the photographic impressions directly on them. These image-impregnated blocks were then sent to an engraver, who carved directly into the wood around them. The editor felt that the lace was accurately represented, but 'in the flowers he has failed to express the delicacy and beauty of the drawings'.[23]

The 4 May issue of the magazine featured two more wood engravings after camera-made photogenic drawings by Francis, one captioned 'Edith Church, Kent', and the other 'Fac-simile of Photogenic Drawing', again showing the same scene in negative and positive versions. Not to be outdone, the Mechanic and Chemist reproduced a 'Specimen of Mr Ackermann's Photogenic Drawing' on its cover of 18 May, displaying some admirably transparent photographic images of insect wings. The issue of 25 May carried what it called a 'Photogenic Printing' on its cover, the first wood-engraved reproduction after a cliché verre photograph, again made by inventor, bookseller and publisher Rudolph Ackermann.[24]

A daguerreotype image was similarly translated into a reproducible media form in France, after which it too was distributed all over the Western world. Although the invention of Daguerre's process was announced at the Académie des sciences in Paris on 7 January 1839, the details of the process were not made public until 19 August of that year. English newspapers published accounts of these details just four days later. A booklet outlining the techniques required to make daguerreotypes, titled Historique et description des procédés du daguerréotype et du diorama, was published in Paris on 7 September (although it was first advertised two days before), the same day that Daguerre began giving public demonstrations of these procedures.[25] The first edition of this booklet became available in an English translation as early as 13 September, but this was just one of many such translations.[26] Indeed, being issued in thirty-two editions and eight languages during the next twelve months, this book had become a global publication well before most people had ever seen a daguerreotype in the flesh. And among its six illustrations was an engraved view of a picturesque landscape representing the

Fig. 6

L.L. Boscawen Ibbetson (England), *Fossils, engraved on a daguerreotype plate*, 1840,
in *Westminster Review*, vol. 34, no. 2, September 1840, following page 460.
Ink-on-paper lithograph by A. Friedel. Courtesy of Senate House Library, University of London/
Smithsonian Graphic Arts Collection, National Museum of American History, Washington, DC.

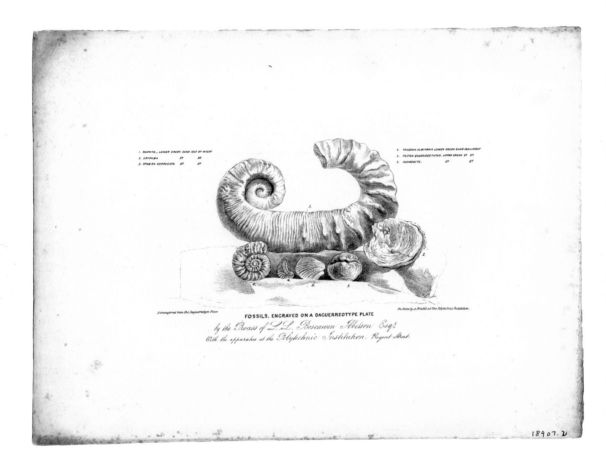

Fig. 7
L.L. Boscawen Ibbetson (England), *A silicified pentaconaster, engraved on a daguerreotype plate*, 1840,
in *Westminster Review*, vol. 34, no. 2, September 1840, preceding page 461.
Ink-on-paper lithograph by A. Friedel. Courtesy of Senate House Library, University of London/
Smithsonian Graphic Arts Collection, National Museum of American History, Washington, DC.

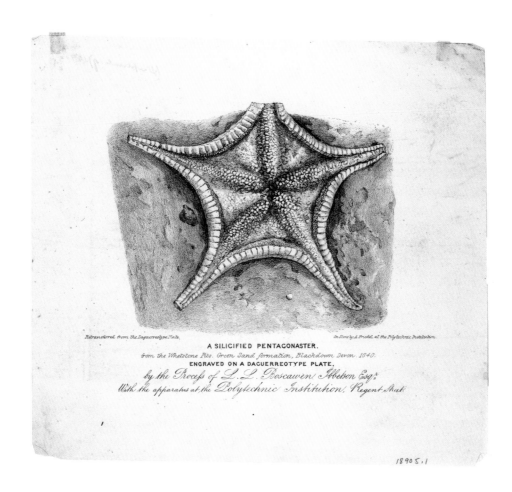

image found on a finished daguerreotype plate (strangely, a kind of picture never produced by Daguerre himself). This was the first daguerreotype image to appear in print.

Other printed facsimiles soon followed. The earliest reproduction after an Italian daguerreotype, a lithograph, appeared in Rome in *Poliorama pittoresco* on 21 December 1839. It shows a still life consisting of statuettes and fabric, along with a gas-light fitting, and was copied from a daguerreotype by Gaetano Fazzini, an Italian scientist and architect who claimed to have learned the process from Daguerre himself.[27] It was followed by the Italian edition of Daguerre's *Historique et description* (*Descrizione pratica del nuovo istromento chiamato il daguerrotipo*), which was published by Alessandro Monaldi in Rome in 1840. In a manifestation of national pride, this publication replaced Daguerre's generic French landscape with an engraving of a view of the Capitoline Hill from the Forum, showing the piazza and facade of St Peter's.[28]

In September 1840, the English journal *Westminster Review* also published two lithographic copies of photographs. One depicted a group of fossils and the other some coral, with both originally 'engraved on a daguerreotype plate' (one of them by limelight, a combustible compound of oxy-hydrogen and calcium) at the Polytechnic Institution in London by L. L. Boscawen Ibbetson (Fig. 6). The fossils were photographed in profile, having been formally arranged for the camera as a still life, with the draped shelf on which they sit still visible in the lithograph. The sample of coral, *A silicified pentaconaster,* has been photographed in close-up and from above, providing a detailed but slightly cropped view of the specimen as seen from an unexpected angle (Fig. 7). According to the journal:

> when the impression was fixed upon the plate an outline of the image was traced upon it by an engraver in the dotting style; a print was then taken from the plate and transferred to stone, when the shading required was filled in by a lithographic artist.[29]

These images were quickly circulated among interested persons. For example, James David Forbes, a Scottish physicist and glaciologist, reported receiving one in August 1840; Lady Pauline Trevelyan was shown some at a meeting of the British Association for the Advancement of Science in Glasgow between 17 and 24 September 1840. As she recorded in her diary, she 'received from Mr Ibbetson some of his plates of fossils engraved by Daguerotype [*sic*] very nice things. Look rather like careful lithographs'.[30] As the *Athenaeum* commented in August 1840:

[...] thus works which, however desirable, no publisher could undertake with any chance of remuneration, from the elaborate detail of the drawings, and the consequent expense of the engravings, may be brought within the means of persons of very limited income.[31]

It also allowed photographic images, in this case images twice removed from the original daguerreotypes, to be sent to the other side of the world. For example, in September 1840, the same month in which they were published, Sir John Franklin, governor of Tasmania between 1836 and 1843, received copies of these *Westminster Review* lithographs in Hobart in Australia. As Franklin's benefactor William Buckland wrote in his accompanying letter, 'there is no calculating the importance of this invention for multiplying figures in Natural History'.[32] In saying as much he was repeating the sentiments expressed in the *Review* itself: 'As this is the first drawing of its kind that has yet been attempted, it must be regarded as but faintly indicating the perfection that may be attained, by similar means, in microscopic drawings, after further experiments.'[33] By this time Sir John would have read about the invention of the daguerreotype—'one has heard of writing by steam; but drawing by sunshine (or moonshine) is a novelty for which the world is indebted to Mr Daguerre of Paris'—in his copy of the *Colonist*, published in Sydney on 1 June 1839. The article asked its readers to

> figure to yourself [...] a mirror which, after having received your image, gives you back your portrait, indelible as a picture, and a much more exact resemblance [... although capturing] only outline, the lights and shades of the model [...] they are drawings [...] pushed to a degree of perfection that art never can reach.[34]

The description is entirely imaginary, as no daguerreotype portrait had yet been made. But it did point to the commercial future of the medium.

Shortly thereafter, on 19 September, Franklin would also have read a reprinted American essay in the *Launceston Advertiser* telling of Talbot's competing invention of photogenic drawing ('the phantasmagoria of inventions passes rapidly before us [... resulting in] a revolution in art'), and shortly after that, on 18 January 1840, would have learned from the *Colonist* that a daguerreotype had been taken in London by a visiting Frenchman.[35] By March of 1840 Australian newspapers provide evidence that the language of photography had become part of the vernacular, with the *Hobart Town Courier* using the word 'daguerreotype' to indicate the

'extraordinary resemblance' between Hobart and Cape Town.[36] All this, once again, before any photograph had been made on Australian soil!

This, then, is how many people first encountered photographic images: as newspaper reports, technical descriptions, or projected fantasies, or in the form of engravings or lithographs based on photographs that were published in popular or specialist magazines. For these people, their first photograph was an imaginary image or a second-order reproduction, with the copy coming before any original had been seen. As far as this public was concerned, the copy *was* the original, with photography presented as a process *about* the generation of such reproductions, before it was anything else.

If we were to continue this line of inquiry we might find ourselves noting that the mercantile identity of a photograph was in fact adopted from a conceptual framework of values already established by the print trade well before photography was invented. In January 1839, for example, when photography was announced, there were already seventy-two printsellers working in London, serving a growing middle-class market anxious to buy engraved reproductions of contemporary paintings. So lucrative was this market that the copyright for a painting was sometimes worth twice the cost of the painting itself. In June 1846, for example, the *Art-Union* reported that 'for the four pictures painted by Mr Edwin Landseer this year, he received nearly seven thousand pounds—ie. £2400 for the paintings and £4450 for the "Copyrights"'.[37] Print publishers were known to commission paintings so that engravings could then be made after them; in effect, the desire for a copy came before the original, thereby confusing that very distinction.

A similar economy existed in France. In 1841 the Romantic painter Horace Vernet published a pamphlet in which he pointed out that, 'the painter has two means of drawing pecuniary gain from his picture, namely: the sale of the picture itself, and the assignment of engraving rights'.[38] As if to prove his point, in the following year he received 2000 francs from Jean-Pierre-Marie Jazet for the right to engrave his *Napoleon reviewing the guard in the Place du Carrousel*, painted in 1838. Importantly, Vernet's text argues that a painter produces both a 'material object' and an 'intellectual object'—that is, both a painting and an image—and that these are separate commodities that can, if necessary, be sold to different parties.

As discussed earlier, Stephen Bann has looked at the situation in France during the nineteenth century, and concluded that the aims

and aspirations of early photographers were generated from within the conceptual limits of contemporary art practice, especially as these were demonstrated in the very competitive business of making reproductive engravings and lithographs.[39] The history of the pioneering photographic experiments of the French brothers Claude Niépce and Nicéphore Niépce bear out this proposition. These experiments, beginning with paper soaked with chloride of silver and moving on to glass and metal plates coated with a solution of bitumen of Judea (a naturally occurring light-sensitive asphalt), were initiated in 1816 by a grant offered by the French government to improve the reproductive capacities of lithography. In keeping with this inducement, the earliest extant photographs made by the Niépce brothers are light-generated copies of ink-on-paper engravings. In 1822, for example, Nicéphore reported being able to make an inverted copy of an oiled engraving of Pope Pius VII placed directly on a glass plate coated in bitumen and exposed to sunlight.[40] Similarly prepared and exposed pewter plates were subsequently etched with acid to increase the depth of the impression, allowing ink-on-paper positive prints to be pulled from this photographically inscribed metal matrix. One print that has survived, *Cheval avec son conducteur* [Horse led by his handler], dating from about July 1825, features a copy of a seventeenth-century Dutch engraving by Dirk Stoop.

Although Nicéphore Niépce also made experiments with images formed in a camera, the copying of existing pictures remained central to his work. In September 1827, for example, Nicéphore went to London to visit his sick brother, Claude, taking with him several examples of his heliography (as he called it). According to Robert Hunt, writing in 1844, Nicéphore ended up leaving behind at least seven photo-engraved metal plates, made using three different processes, as well as two paper impressions printed in 1826 from yet another plate (a heliographic copy of a seventeenth-century engraving, *Cardinal d'Amboise*) (Fig. 8).[41]

Six of Niépce's plates were engraved with copies of existing prints. This did not at first seem like a possibility for daguerreotype photographs. Made on silvered sheets of copper exposed to fumigated iodine and mercury, daguerreotypes resulted in images so delicate that, according to one experienced pioneer, they could be damaged by 'the rubbing of a fly's wing'.[42] As already mentioned, Daguerre had worked on the complicated process's realisation since 1824, joining in a partnership with Niépce in 1829 before officially announcing his invention ten years later. As Niépce reported, '[Daguerre's] process

Fig. 8
Joseph Nicéphore Niépce (France), *Cardinal d'Ambroise*, 1827. Copy of a seventeenth-century engraving by Isaac Briot of Cardinal d'Amboise, French cardinal and member of state. Ink-on-paper print from heliogravure, 17.2 × 13.2 cm (image). Courtesy of Musée Nicéphore Niépce, Chalon-sur-Saône.

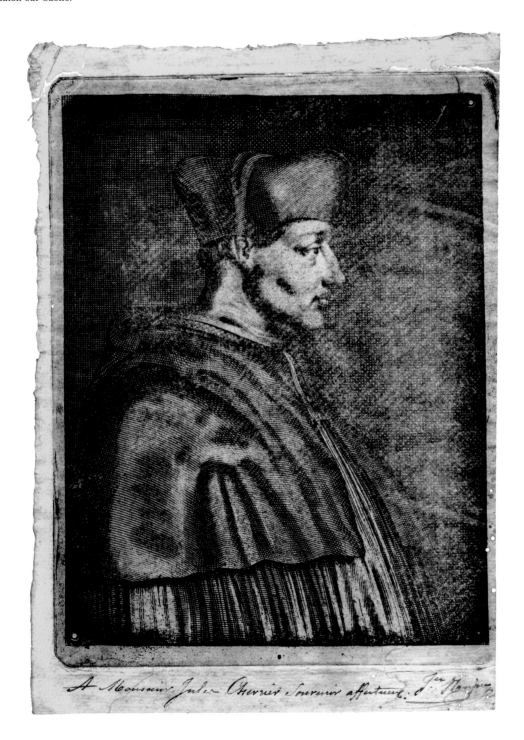

Fig. 9
François Lemaître (France, engraver), after Louis Jacques Mandé Daguerre (France), *Chapelle des Feuillants*, 1827, in Augustin Liébert, *Galerie du Luxembourg, des musées, palais et châteaux royaux de France*, Paul Renouard, Paris, 1828, plate 8.
Ink-on-paper print from etching and engraving after Daguerre's painting *Chapelle des Feuillants*, 1814, 50.0 × 33.0 cm (sheet). Collection of the author, Wellington.

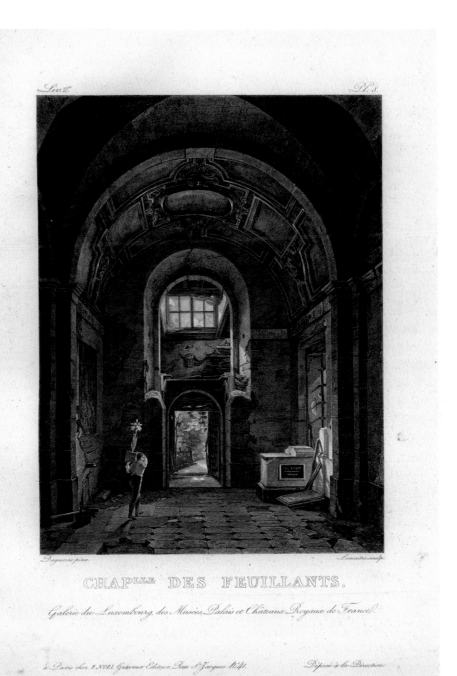

and mine are completely different', Daguerre's being 'connected more with perfection than with multiplying prints'.[43] Stephen Pinson has even associated Daguerre with 'a suspicion of the multiple', the artist apparently being nervous about unauthorised copies of his own paintings in the context of continuing debates about copyright legislation in France.[44]

Nevertheless, Daguerre was an artist very familiar with reproductive engraving, having had one of his own paintings distributed in engraved form in 1827 (Fig. 9), and supplying drawings and painted sketches for the production of at least thirteen other facsimiles in various media.[45] In addition, his diorama paintings had been reproduced in London as rudimentary wood engravings on the cover of the *Mirror of Literature, Amusements, and Instruction* in 1826, 1827 and 1828.[46] Having one's images copied in another medium was not just a normal aspect of artistic practice; it was a commercial necessity and one in which Daguerre actively participated.

The daguerreotype process provided only a unique photograph that combined both negative and positive in a single object. Daguerreotypes were therefore not capable of reproducing their own image numerous times, unlike Talbot's paper photographs. And indeed, in a story headed 'The Daguerrotype [*sic*], or Solar Engraving', a journalist writing for Boston's *Christian Register* in July 1839 quoted London's *Athenaeum* as saying that it is 'all but impossible that impressions from them [daguerreotypes] could be multiplied after the manner of an engraving'. Interestingly, although we are told that Daguerre himself reiterated this impossibility, the story goes on to remind its readers that 'M. Niepce [*sic*] not only declared that it was possible, but produced specimens of such multiplied copies'—the seven or more specimens left behind in London in 1827.[47]

In fact, within a year of this report, several enterprising photographers were attempting to turn the otherwise unique daguerreotype plate into an engraved matrix capable of generating multiple ink-on-paper prints. In Vienna, for example, Joseph von Berres reproduced five illustrations from etched daguerreotype plates in his August 1840 book *Phototyp nach der Erfindung des Professor Berres*.[48] An earlier article about his technique was translated and published in England, France, Germany, Italy and the United States, and also attracted attention in the Netherlands. In October 1839, the *Times* reported on some similar efforts by Frenchman Alfred Donné that allowed as many as forty impressions to be made from a single etched plate.[49]

French scientist Armand Hippolyte Louis Fizeau was perhaps the most successful of these early experimenters, soon devising a method for etching directly into the copper daguerreotype plate and then electroplating the surface, first with gold and then with copper, creating an aquatint matrix but transforming the pristine surface of the daguerreotype in the process. The plate, after details were clarified with an engraving tool, could then be used to make multiple prints on paper in permanent ink. The process was not perfect, however, and the resulting prints often looked imprecise compared to the refined surface and tonal depth of the original daguerreotype. Nevertheless, relatively persuasive images could be reproduced—if not yet mass-produced.[50] Fizeau took out a patent on his process in 1841 and outlined the details at a meeting of the Académie des sciences on 13 February 1843, distributing photogravure prints of the Church of Saint-Sulpice taken from the window of his nearby apartment at rue du Cherche-Midi (Fig. 10).

In addition to these individual efforts, there was considerable public discussion in France about the possibility of copying the images found on daguerreotype plates by means of engraving or lithography, and thereby giving them multiple manifestations. When French minister Charles-Marie Duchâtel presented a bill to the Chamber of Deputies on 5 June 1839, proposing the purchase of the patent for Daguerre's invention, he suggested that, 'being called upon to multiply these images modelled upon nature herself, by reproducing them, the art of the engraver will take on a new level of importance and interest'.[51] This challenge was soon taken up. As Daguerre observed in September of the same year: 'Scarcely a month has passed since my process was made known and already, on all sides, people claim to have extended its boundaries by finding the means of multiplying its results by engraving and other means not yet determined.'[52] At this stage, tracing directly over the daguerreotype image seemed the only way to make its transference to a steel plate possible, thus allowing an engraving to be made. With this in mind, an early edition of Daguerre's instruction booklet, published by Alphonse Giroux in 1839, announced that it was possible to purchase, in Giroux's shop, 'a varnish prepared to safeguard the images and facilitate their tracing'.[53]

The editors of *Le Lithographie*, perhaps fearing competition with their craft, pointed out the unique daguerreotype's obvious limitation and its equally obvious solution: 'In the end, the marvellous way to complete this process would be the ability to engrave,

Fig. 10
Armand-Hippolyte-Louis Fizeau (France), *View of Saint-Sulpice*, **Paris, c. 1843.**
Ink-on-paper print from engraved and etched daguerreotype. Collection of Metropolitan Museum of Art, New York.

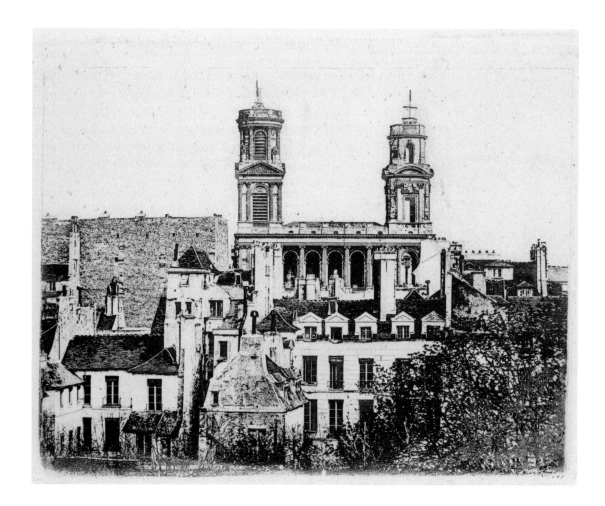

or better yet to lithograph, with the aid of the Daguerréotype.'[54] Achieving this transfer between media forms was, however, easier said than done, as the journal explained:

> Put directly on the glass that covers the daguerreotype proof, the most transparent piece of paper becomes absolutely opaque [...] applied directly to the metal plate, it is almost impossible to not destroy the photographic drawing, which the slightest friction makes disappear.[55]

Nevertheless, this same 1839 issue included one lithograph made after a daguerreotype: a view of a cathedral.

Photography and Commerce

All the efforts and related commentaries discussed so far were bound to attract the interest of experienced businessmen like Richard Beard (Fig. 74) and Antoine Claudet (Fig. 75), the men who opened Britain's first two commercial photography studios in March and June of 1841. The remainder of this book gives attention to their careers in particular, if only to offer a detailed examination of the phenomenon I am seeking to describe, rather than just further generalisations. Although not accorded the same status as Daguerre or Talbot in most histories, Beard and Claudet are certainly worthy of the attention they are given in this one. They were, after all, the figures responsible for founding the business of photography in Britain and its empire, and with it many elements of the ubiquitous photographic culture that we take for granted today. Their first task was to take a mode of representation not yet able to produce even satisfactory portraits and develop it into a viable commodity form, all amidst a severe economic recession.[56] As competing business owners operating in a difficult financial climate, Beard and Claudet had to sell photographs, but they also had to sell photography, as an idea and as an enterprise with social and monetary value.

The profitability of those businesses came to depend on each studio's ability to produce daguerreotype portraits quickly and efficiently, reproducing what soon became a standard repertoire of poses and settings in example after example, day in and day out. Customers, interested in declaring their class affiliations and social aspirations along with acquiring a good likeness, wanted to look like themselves while also looking as much as possible like everyone else. In other words, the commercial photography business came to depend on the methodical maintenance of a visual economy of repetition and difference: on the generation, that is, of unique reproductions.

But it also depended on the capacity of the daguerreotype process to make good likenesses, and at first this seemed an unlikely proposition. Daguerre had certainly hoped to employ his process to take

portraits—in October 1835, for example, he wrote to his collaborator Isidore Niépce (son of Nicéphore Niépce) to say that if photographic portraits could be made using their process, then 'it would sell itself for us'.[57] However, no portraits were among the examples of his work circulated in 1839, and the camera he authorised came without a tripod and with a back that allowed only a horizontal position for its daguerreotype plate.[58] Daguerre obviously intended the instrument to be placed on a portable table, with still life or landscape, rather than portraits, as its principal subject matter. As Sir John Robison, secretary to the Royal Society of Edinburgh, reported after visiting Daguerre's studio in May 1839:

> The subjects of most of the numerous specimens which I saw, were views of streets, boulevards, and buildings, with a considerable number of what may be termed interiors with still life; among the latter were various groups made up of plaster-casts and other works of art.[59]

Indeed, during the announcement of the details of the daguerreotype process in Paris on 19 August 1839, the scientist and politician François Arago admitted that, due to the long exposure times required, 'there is little ground for believing that the same instrument will ever serve for portraiture'.[60] Nevertheless, the second edition of Daguerre's *Historique et description*, published in Paris in November 1839, came with four pages of notes jointly authored by French optician Noël-Marie Paymal Lerebours and the daguerreotype camera manufacturing firm Susse Frerès on their early trials of the daguerreotype technique, including practical advice for those attempting to make portraits. The additional notes in this edition gave the wannabe photographer some serious advice, seemingly based on real experience:

> To make a portrait, you must have access to bright light, and this is even more important with subjects whose complexion is vivid, for red is, so to speak, the equivalent of black. Success will only come in exposing the sitter to the sun, in the open air, with reflectors of white cloth. You can, as Arago has shown, put in front of the sitter a large pane of blue glass; this will eliminate the fatigue which causes the inevitable closing of the eyes.[61]

According to French newspapers from the time, the first photographic portrait in France was attempted by Dr Alfred Donné in Paris on 14 October 1839. Although the daguerreotype itself has not survived,

we know that the portrait subject did—but only just. Apparently, the end result showed a corpse-like portrait of a lady with her face powdered white and her eyes tightly closed.[62] However, on 30 August the satirical Parisian magazine *Charivari* had already published a warning to the would-be portrait photographer, suggesting that some photographers had quickly begun experimenting with the genre:

> You want to make a portrait of your wife. You fit her head in a fixed iron collar to give the required immobility, thus holding the world still for the time being. You point the camera lens at her face; but, alas, you make a mistake of a fraction of an inch [in focusing], and, when you take out the portrait it doesn't represent your wife—it's her parrot, her watering pot—or worse.[63]

A lithograph drawn by Jules Platier and issued in 1839 showed an unfortunate male subject uncomfortably secured by what the cartoonist called 'Le Daguerréotrappe'. A similar contraption featured in Théodore Maurisset's famous caricature *La Daguerréotypomanie*, issued as a coloured lithograph on 8 December 1839.[64] In another example, a lithograph published by Aubert & Co. in Paris in 1839 depicts Daguerre proudly presenting to a shocked husband an entirely fanciful—indeed, then technically impossible—daguerreotype picture of the man's wife having her hand kissed by a lover. This was a popular theme in early caricatures of photography.[65]

Obviously, the possibility of portraiture was being widely imagined and debated at this time, mostly derisively. Despite these dire tales of trial and error, by May of 1840 Lerebours and his partner Buron had introduced a camera fitted with single or double achromatic plano-convex lenses of very short focus, capable, they claimed, of taking quarter-plate daguerreotype portraits in about two minutes.[66] But no professional studios devoted to that enterprise had yet been established in Paris.[67]

In fact, the first commercial photography studio was inaugurated, not in Europe, but in the United States. A detailed account of Daguerre's process had arrived there on board the *British Queen* on 20 September 1839, allowing a number of Americans to begin experimenting.[68] These included Alexander S. Wolcott, a New York–based instrument maker and manufacturer of dental supplies.[69] Less than a month later, on 6 October, Wolcott made the first recorded daguerreotype portrait. As Wolcott's subject, his business partner John Johnson, later recalled:

I sat for five minutes, and the result was a profile miniature (a miniature in reality) on a plate not quite three-eighths of an inch square. Thus, with much deliberation and study, passed the *first* day in Daguerreotype—little dreaming or knowing into what a labyrinth such a beginning was hastening us.[70]

After further refinements, the techniques established by Wolcott and Johnson included the use of a special camera, its interior painted black and fitted with a seven-inch concave mirror rather than a lens, a screen of blue glass suspended from the ceiling (to protect the sitter's eyes from glare), a large mirror mounted on top of the camera (to reflect light in a horizontal direction onto the sitter's face), and a background of light-coloured fabric behind the sitter. By the first week of February 1840, the two partners had opened a portrait studio in New York, with telescope manufacturer Henry Fitz Jr as the camera operator.[71] Using silver-plated sheets of copper imported from England, they were able to achieve exposure times of between three and five minutes while making small profile portraits (Fig. 11).

Early in this same month, even before the studio had attracted a paying customer, John Johnson's father, William, sailed over to England with some samples of the Wolcott/Johnson daguerreotype portraits and the specifications for their camera. Johnson Sr got in touch with a London patent agent, William Carpmael, who introduced Johnson to Beard.

Richard Beard was born in Devon, the son of a grocer. In 1832 he had established a business dealing in coal in London, and in 1839 filed the first of what would be three patents for the colour-printing of fabric. Convinced that there was money to be made from this new American image-making invention, Beard bought one-half of the English rights to the Wolcott/Johnson camera, and then some time later acquired these rights in their entirety, taking out a patent on the camera and related innovations on 13 June 1840.[72]

The patent document, 'Improvements in Apparatus for taking and obtaining likenesses and Representations of Nature and of Drawings, and Other Objects', was submitted on 9 December. It described the Wolcott mirror camera, the use of reflectors (which consisted of 'small squares of looking-glass of five or six inches square', covered in varnished tissue-paper to disperse the reflected light), the heating and polishing of the plates using two rollers, acids, and powdered chalk

Fig. 11
Henry Fitz Jr (New York), *Self-portrait*, November 1839.
Ninth-plate daguerreotype, 12.0 × 15.0 cm (frame). Collection of Division of Photographic History,
National Museum of American History, Smithsonian Institution, Washington, DC.

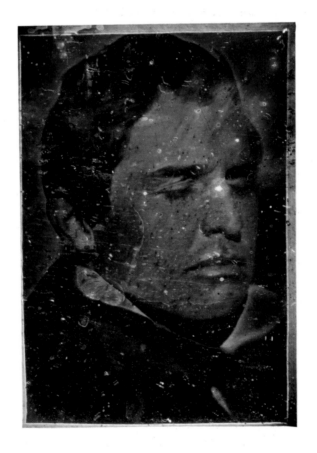

and charcoal, the lining of the iodine box with a square glass vessel, and the use of a mixture of iodine and bromine to sensitise the plate about to be exposed. In conjunction with all these props, the Wolcott camera was said to reduce exposure times (under the often-overcast English weather conditions) from twenty minutes to five. Beard rented the Medical Hall of Furnival's Inn, Holborn, in order to test the apparatus and conduct further experiments.[73] As he was to do throughout his photographic career, he ensured that a steady stream of promotional stories appeared in the press, with the first being published in the *Times* on 25 August 1840. It faithfully reported, 'there is little doubt that when in perfect order the novelty will become generally attractive'.[74]

With this encouragement, John Johnson joined his father in October 1840 to work with Beard, followed by Wolcott in July 1841. Johnson and Wolcott continued to conduct research aimed at improving the daguerreotype process, with Johnson experimenting with chloride of iodine as an accelerating agent and developing a better way to polish the silvered plates (by mechanically buffing them with a velvet cloth). These plates were produced in a factory in Birmingham, while Wolcott supervised the manufacture of mirror cameras in another factory in London.[75] By the end of 1841, Wolcott had also introduced a chemical formula designed to accelerate exposure times. Involving bromine, nitric acid, muriatic acid and water, this concoction came to be known as Wolcott's Mixture.[76] On 18 March 1843, the year before Wolcott returned home to the United States (where he was to die suddenly), Wolcott and Johnson patented an apparatus to make daguerreotype enlargements from smaller pictures, the first such instrument to be introduced.[77]

Beard also hired the services of John Frederick Goddard, until then a lecturer in optics and natural philosophy, to improve the chemistry of the daguerreotype. By September 1840 Goddard claimed to be able to reduce exposure times to between one and four minutes, by using bromide of iodine in his formula.[78] According to the *Morning Chronicle* of 12 September, in Goddard's first portraits:

> The eyes appear beautifully marked and expressive and the iris is delineated with a peculiar sharpness as well as the white dot of light on it, and this is done with such strength and clearness as to give the portrait a really astonishing appearance of life and reality.[79]

Claiming his rights to the discovery as Goddard's employer, Beard included the breakthrough in his patent document of 9 December 1840.[80] On 28 January 1841, Goddard noted that he had

successfully taken a portrait of Beard, 'the picture strong but very blue' (meaning, perhaps, that it had been accidentally solarised).[81] On 12 February, Goddard made what he called 'by far the most beautiful & perfect' portrait he had thus far achieved, of William Johnson, and afterwards even took a daguerreotype of himself.[82] These and other specimens were exhibited at a meeting of the Royal Society on 18 February.

Perhaps as a consequence of this exhibition, on 24 February 1841 Henry Talbot received a letter from his scientific colleague Charles Wheatstone, telling him that Wheatstone had 'recently seen some miniature portraits taken by the American process which are absolutely perfect; I could not have thought the expression of the features could be so excellently preserved'.[83] It seems likely that Talbot visited the Beard studio shortly thereafter, before it had officially opened to the public, and had his portrait taken. If these photographs were indeed exposed during the first week of March, it would make them the earliest extant daguerreotypes produced by this studio—and thus the earliest extant commercial photographic portraits made in Great Britain.

Two of these portraits have survived, being small ninth-plates. But neither could be described as 'absolutely perfect'. In one of them Talbot stares grimly at the camera, his eyes cast in shadow and his hair dishevelled. In the other, he stares off to his right, hair now inelegantly combed across his bald forehead. Both portraits are dark and softly focused. Talbot's features are captured with chemical certitude, but any hint of personality has been subsumed by the long exposure time and strain of posing. He looks, in other words, like someone still learning how to look like himself in a photograph. These portraits have been mounted in black wooden hanging frames, one surrounded by an elaborate dolphin-and-pheasant mount, the other by a chased-metal rectangle. On the back of each is affixed a green label bearing the words 'Wolcott's Reflecting Aparatus' [sic]; one of them has the trademark term 'Beard Patentee' inscribed in relief on the front (Fig. 12).[84] Beard's name therefore appears under this picture like a signature. This is the signature of a business owner and patent holder, not of an artist/author. As a consequence, Talbot's stolid countenance finds itself disconcertingly sandwiched between two 'legal' declarations of Beard's proprietorial rights to photography.

On 10 March, John Johnson sent one of the metal mirrors used in the camera (he called it a 'metallic speculum') to Talbot's London address, along with extensive written instructions on how it should

Fig. 12
John Johnson et al. (Richard Beard studio, London), *William Henry Fox Talbot*, March 1841.
Ninth-plate daguerreotype in frame, 14.5 × 14.5 cm. Collection of British Library, London.

be situated and manipulated inside the apparatus.[85] Johnson speaks of the 'prepared material' that Talbot would use in the camera to make a photograph, presumably a reference to Talbot's newly announced calotype paper.[86] It seems likely, then, that Johnson was among those on the team who took Talbot's portrait, and that they discussed at length the making of portrait photographs, including even paper photographs.

Nevertheless, it was Goddard who soon became the public face of the Beard enterprise. He offered a well-attended lecture at the Royal Institution on the evening of 26 March 1841, on 'the application of Daguerreotype to obtain likenesses of living men', during which he photographed a plaster bust illuminated by artificial light in less than three minutes.[87] In the published version of the lecture, which appeared in at least two journals that year, Goddard described the specific advantages of daguerreotype portraits over other kinds of representation:

> The metallic hue of the portrait is not becoming; nor is it possible for the truth-telling operating influences to flatter: but the face is there, wearing the very expression of the moment. This effect is the stamp of excellence to all who desire to perpetuate the looks of fond beings in the several stages of existence, or to catch and hold fast the features of those so dear, ere they flee away for ever.[88]

In a story published on 24 March, the *Times* described such portraits in similar terms, as 'admirable, and closely true to nature, beauties and deformities being alike exhibited'.[89] Nevertheless, experiments of various kinds continued. On 13 August 1841, for example, an engraver from the firm of McQueen's put two of Goddard's daguerreotype portraits (made just the day before) through a printing press, leaving a faint impression on pieces of paper, presumably from the chemical residue on the plates.[90] This might be counted as yet another early effort to turn the daguerreotype process into a vehicle for multiple reproductions.

We shall return to this effort in a moment. But first, it is important to establish the context in which the effort occurred and, in particular, to trace the transformation of photography from an experimental science into a thriving commercial enterprise.

Beard had officially opened his studio (on 23 March 1841) on the mistaken presumption that his patent rights over the Wolcott camera

and Goddard's technical refinements of the daguerreotype process placed him outside the jurisdiction of Daguerre's own patent. This Daguerre had been granted on 14 August 1839, to cover the use of his invention within 'England, Wales and the Town of Berwick-on-Tweed, and in all Her Majesty's Colonies and Plantations abroad', meaning that anyone in these designated areas (which encompassed the British Empire in its entirety) wishing to practise the daguerreotype was legally obliged to pay Daguerre or his agent a licence fee.[91] Threatened with the closure of his studio, on 23 June 1841 Beard hurriedly concluded his negotiations with Miles Berry, Daguerre's patent agent in England, and purchased the English patent rights to the daguerreotype process. On 16 July 1841 Beard also signed a licence agreement with Daguerre and Isidore Niépce.[92]

Right from the beginning, then, the taking of photographic portraits was a multi-national affair, requiring a collaboration of French, English and American contributors, and dependent on a steady series of technical innovations and legal negotiations, involving numerous hands and a range of skills. Indeed, this story reveals that Beard himself played a quite particular role in this new business, having little to do with either research or actual photographing. He was, before all else, the proprietor.[93] One is also reminded of the nature of his investment. A photography studio in 1841 was in effect a new-technology start-up company, one that incorporated mechanical and chemical inventions and some specific divisions of labour, along with targeted marketing stratagems, into a traditional hand-craft small-business model. There was no guarantee of financial success. Beard and his team therefore had to invent, not just a workable photographic apparatus, but also a sustainable financial plan.

An important step in this plan was the choosing of a prime location for the studio itself. Beard opened his in the attic of the Royal Polytechnic Institution at 309 Regent Street, London.[94] He thus immediately placed photography in a context of applied science, manufacturing and pedagogical entertainments. Other attractions, for example, included a diving bell capable of immersing in a tank of water with four or five persons inside, a 'Colossal Electrical Machine', steam engines, models of mining, glass spun by steam, lightning conductors, 'Mr. Green's Balloon' and 'Two Metallic Reflectors by which a Whisper may be Heard and Meat Cooked at 100 Feet distance', along with various 'Magnetical & Electrical Experiments'.[95]

Beard's competitor Claudet located his studio in a very similar, if competing, institution: the Royal Gallery of Practical Science, or

Adelaide Gallery, as it was known. Antoine François Jean Claudet was born in France in 1797 and moved to London in 1827 to establish a retail outlet for imported French glass sheets and glassware. He soon became co-proprietor of 'Claudet and Houghton', a shop at 89 High Holborn. Having maintained close connections with his native country, Claudet, on the advice of his compatriot Lerebours, travelled to Paris in late 1839 to learn the daguerreotype process. He later claimed to have taken instruction from Daguerre himself.[96] He also remembered buying all the existing specimens he could procure—'made by his [Daguerre's] pupils'.[97] Following his return to London, and an unsuccessful attempt to have the daguerreotype process made freely available in England, Claudet purchased a licence for £200 from Miles Berry on 25 March 1840, to 'use a limited portion of the apparatus', and on that basis imported French daguerreotypes and cameras made in Paris by Giroux & Cie.[98]

No doubt anticipating this purchase, on 3 March 1840 an advertisement in the *Times* pronounced that, 'having obtained a license from the patentee', Claudet and Houghton

> have on hand a collection of splendid specimens of this wonderful discovery, representing the most interesting monuments, ancient and modern, of Paris, Rome, and other cities, also panoramic views of these towns, landscapes, portraits taken from nature, &c.[99]

Potential buyers were advised that these pictures were 'like the reflection of an image seen in a mirror, and there retained by some magic power'. The advertisement stressed an attribute of the daguerreotype image that was often discussed in early accounts: the fact that the closer you looked, the more you saw. 'Details, imperceptible to the eye, can be discovered on these plates with a magnifying glass as we see distant objects by the help of a telescope.' These daguerreotypes varied in price from one to four guineas ('according to their perfection and the expense attending their production'). Finally, anxious to assert their own legal right to the daguerreotype process, Claudet and Houghton warned that 'injunctions will be taken against any person possessing apparatuses, making use of them, or selling proofs without license or the authority of the patentee'.[100]

A fascinating conjunction of the efforts of Beard and Claudet is manifested in (literally *inside*) a ninth-plate daguerreotype now in the National Gallery of Australia in Canberra. Produced with a Wolcott Reflecting Apparatus, this daguerreotype was made by

Fig. 13
Richard Beard studio (London), *Portrait of a man*, c. 1841.
Ninth-plate daguerreotype made with a Wolcott Reflecting Apparatus, in flip-top leather case with
newspaper clipping insert, 15.2 × 6.1 cm (open). Collection of National Gallery of Australia, Canberra.

the Richard Beard studio, not long after that studio was established. It features a portrait of an older man, staring off to one side. Underneath this portrait, inscribed into the brass mat, are the words 'Beard Patentee'. Like all daguerreotypes, this is an object as much as an image. Its perception combines touch and sight, with the case having to be opened before the photograph inside can be seen. But when it is opened we find that this photograph is joined by a small newspaper clipping, attached to the velvet pad opposite the daguerreotype (Fig. 13).

Ironically, this newspaper clipping points to the traffic in engravings after daguerreotypes that was already underway at Claudet and Houghton's glass shop, just up the street. Someone who was a customer of the Beard studio chose to save an advertisement placed by this glass shop to announce that both daguerreotypes and copies of the first six fascicles of a publication titled *Excursions daguerriennes* were available for sale at that shop. The daguerreotypes being sold included 'Views of London, Paris, Rome, Naples, Venice, Florence and Moscow', thus demonstrating the degree to which photography, from its very beginnings, engineered an unprecedented collapse of time and space, bringing indexical traces of the outside world even to the humble denizens of glass shops in London. But, according to the newspaper clipping, the daguerreotypes on sale also included 'Figures from the Living Model, Portraits from Nature, and Microscopic Objects'. Copies of the publication and 'Small Daguerréotype Specimens' could both be bought for 10s 6d a piece.

So where did these daguerreotypes come from? Soon after the announcement of the details of the daguerreotype process in August 1839, Claudet's friend Lerebours had decided to publish a set of engravings after daguerreotype views, to be titled *Excursions daguerriennes, vues et monuments les plus remarquables du globe*.[101] Encouraged by François Arago, who in January had first announced Daguerre's invention to the Académie des sciences, Lerebours, the principal optician attached to the Paris Observatory, had immediately begun making cameras, and training men in his workshop in how to use them to make daguerreotypes. After the official release of the technical details of the process, Lerebours quickly set about commissioning numerous landscape and architectural daguerreotype studies from throughout Europe and elsewhere around the globe. By 15 December, he was able to display numerous such daguerreotypes in his shop on the Pont Neuf. This suited Arago's political purposes, proving that ordinary workers could make images as well as any

'savant'. A report in *Le National* (edited by Arago's brother) in January 1840 attempted to describe some of these photographs, resorting to using the word 'prints', as if fully cognisant of what these daguerreotypes were to become (Fig. 14):

> M. Arago placed in front of the academy several daguerreotype prints, which M. Lerebours has just received from Rome. These fine prints, representing the principal Roman monuments and some scenes of the Italian countryside, are remarkable for the vigor of their tints, even though they were taken in winter. The correspondent of M. Lerebours is a simple worker out of the optician's workshop, which can reassure those who claim that M. Daguerre's procedure can only succeed between the hands of a savant.[102]

These 'simple workers', however, were not the only people photographing on behalf of Lerebours. Among the first to be sent abroad was painter Frédéric Goupil-Fesquet, who travelled through the Middle East in the company of his uncle, the painter Horace Vernet—the same Vernet who later ruminated on the value of reproductions. As Vernet reported on 6 November 1839: 'We keep daguerreotyping away like lions.'[103] The following day they photographed the exterior of Pasha Mehemet Ali's harem building in Alexandria in Egypt, using a two-minute exposure; the engraved version became Plate 6 in Lerebours' publication (Fig. 15).[104]

On a boat going up the Nile, the two artists met a French-born Canadian wine merchant, Pierre-Gustave Joly de Lotbinière, also travelling on assignment from Lerebours. By 22 November the group was photographing the Pyramid of Cheops at Gizeh, this time with an exposure of fifteen minutes.[105] Five of these Egyptian plates, the first photographic images to be made in Africa, were included in *Excursions daguerriennes*, along with scenes photographed in Spain, France (Fig. 16), Greece, Italy, Palestine, Russia, Sweden, Switzerland and Syria. Also included was one view of London, taken by an unknown photographer from an elevated position looking across the Thames towards Saint Paul's Cathedral and, in its printed incarnation, replete with swirling clouds and a boat being rowed in the foreground (Fig. 17).

Needing only about 112 images for his publication, Lerebours soon owned many more daguerreotype views than he could use himself. Claudet's shop offered some of these excess daguerreotypes for sale, along with fascicles containing Lerebours' engravings, which were

Fig. 14

Noël-Marie Paymal Lerebours (France), *Italie: L'Arc de Titus à Rome*, c. 1841, in Noël-Marie Paymal Lerebours, *Excursions daguerriennes, vues et monuments les plus remarquables du globe*, vol. 1, Rittner & Goupil, Paris, 1840–42, plate 33. Ink-on-paper print from steel engraving by J. Callow after daguerreotype, 26.0 × 38.0 cm (sheet). Collection of the author, Wellington.

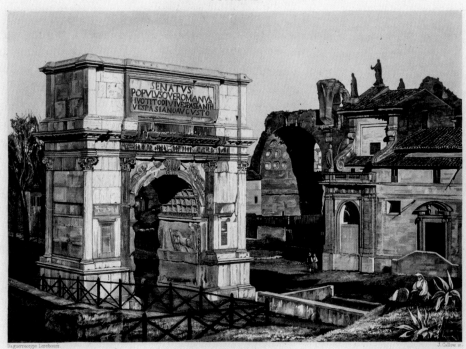

made by twenty-seven engravers and accompanied by texts written by twenty-six different authors. Lerebours issued four aquatint engravings in each fascicle, beginning in June 1840, and published a bound edition of sixty prints in 1842 (with a second edition, to comprise another fifty-two prints, including some lithographs, announced in June 1843).[106] Only rarely are the names of the photographers acknowledged, with Lerebours usually claiming that status for himself: the inscription of 'Daguerreotype Lerebours' under a print is a reference to the photograph's owner, rather than to its author.[107]

How were these prints made? According to curator Russell Lord:

> The prints were produced using a meticulous tracing process that destroyed the daguerreotype image in the process. A sheet of tracing paper or *papier glacé* was placed directly on the daguerreotype and then an engraver, stylus in one hand and magnifying glass in the other, scrupulously traced the lines and details of the daguerreotype image. [...] This tracing was then transferred to a steel plate coated with varnish.[108]

Claudet would, of course, have noted that three of the later prints were derived directly from daguerreotypes, without any tracing, using Fizeau's method of engraving. (Claudet subsequently took out an English patent on this process in November 1843 and promoted it throughout Britain.)[109] Two of the Fizeau images were printed directly from etched daguerreotype plates of urban scenes, but one, titled *Maison élevée rue St. Georges par M. Renaud* and added to a few special editions only, was printed from a daguerreotype of a drawing that the architect named in the title had exhibited at the Louvre (Fig. 18).[110]

The exhibition of these French-sourced daguerreotypes at Claudet and Houghton's brought at least one unexpected consequence. A British industrial chemist from Newcastle-upon-Tyne, Hugh Lee Pattinson, dropped by to see them on his way back from the United States and Canada, where he had made a number of daguerreotypes of, among other places, Niagara Falls.[111] Claudet ended up sending one of Pattinson's daguerreotype plates to Lerebours. It was subsequently published in 1841 in engraved form as *Amérique du Nord, Niagara: Chute du Fer a Cheval* [Horse Shoe Falls], along with a text written by Pattinson and 'translated by Antoine Claudet, our countryman, who was the first to introduce Daguerre's discovery in London'.[112] The image includes a man in the foreground looking towards the waterfall, perhaps Pattinson himself acting as our surrogate. There are also two puny boats braving

Fig. 15

Noël-Marie Paymal Lerebours (France), *Egypte: Harem de Méhémet-Ali à Alexandrie*, c. 1840, in Noël-Marie Paymal Lerebours, *Excursions daguerriennes, vues et monuments les plus remarquables du globe*, vol. 1, Rittner & Goupil, Paris, 1840–42, plate 6.

Ink-on-paper print from steel engraving by Weber after daguerreotype by Horace Vernet and Frédéric Goupil-Fesquet taken on 7 November 1839, 26.0 × 38.0 cm (sheet). Collection of the author, Wellington.

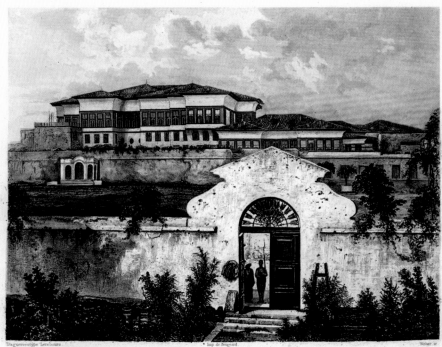

HAREM DE MÉHÉMET-ALI A ALEXANDRIE.

PUBLIÉ PAR

RITTNER & GOUPIL, Boulev.ᵈ Montmartre. 15. N.P. LEREBOURS, Place du Pont-Neuf 15. Hᵉ BOSSANGE, Quai Voltaire. 11.

Fig. 16
Noël-Marie Paymal Lerebours (France), *France: Maison Carrée à Nismes*, 1841, in Noël-Marie Paymal Lerebours (France), *Excursions daguerriennes, vues et les monuments les plus remarquables du globe*, vol. 1, Rittner & Goupil, Paris, 1840–42, plate 15.
Ink-on-paper print from steel engraving after a daguerreotype, 26.0 × 38.0 cm (sheet). Collection of the author, Wellington.

FRANCE

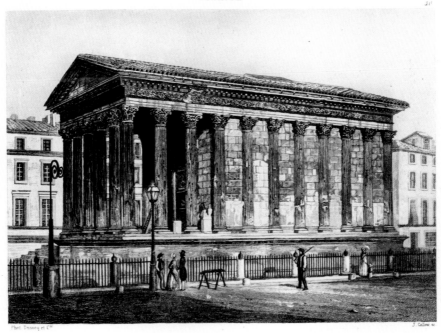

MAISON CARRÉE À NISMES .

Fig. 17

Noël-Marie Paymal Lerebours (France), *Angleterre: Saint Paul a Londres*, c. 1841, in Noël-Marie Paymal Lerebours (France), *Excursions daguerriennes, vues et monuments les plus remarquables du globe*, vol. 1, Rittner & Goupil, Paris, 1840–42, plate 4.
Ink-on-paper print from steel engraving by Frédéric Salathé after daguerreotype, 26.0 × 38.0 cm (sheet). Collection of the author, Wellington.

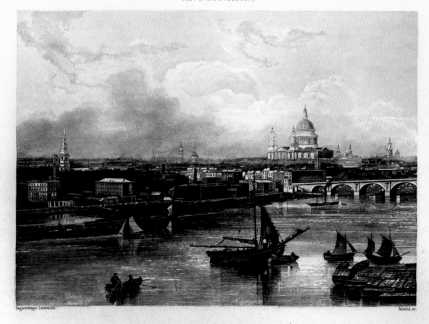

Fig. 18
Armand-Hippolyte-Louis Fizeau (France), *France: Maison élevée rue St. Georges par M. Renaud*, c. 1841,
in Noël-Marie Paymal Lerebours (France), *Excursions daguerriennes, vues et monuments les plus
remarquables du globe*, vol. 2, Rittner & Goupil, Paris, 1843.
Ink-on-paper print from engraved and etched daguerreotype of a drawing, 26.0 × 38.0 cm (sheet).
Collection of Metropolitan Museum of Art, New York.

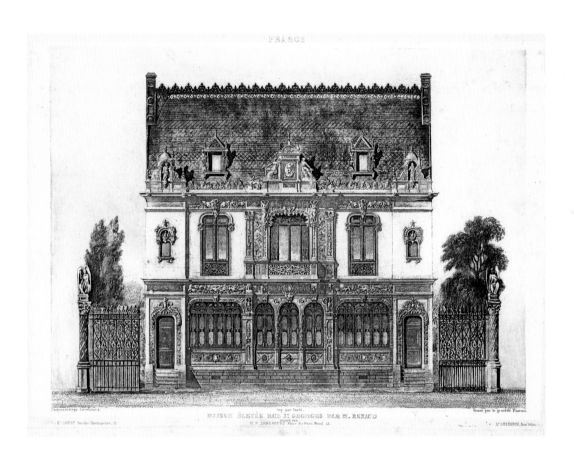

the spray to get a closer look, as if to enhance the 'sublime effect' of the waterfall that is described by Pattinson in his text (Fig. 19).[113] The original daguerreotype has not survived the process of being turned into an engraving, but another plate taken at the same time shows that, despite the demands of a lengthy exposure time, the man *was* present in the photograph; the boats, however, were added by an imaginative engraver.[114]

Given this background, Claudet was very familiar with all aspects of daguerreotypy from an early date. Indeed, in an advertisement placed in the *Times* on 13 April 1841, Claudet and Houghton further announced that they could now supply customers 'wishing to use the invention for amusement or experiment' with a complete daguerreotype apparatus, including prepared plates, thus catering to the surprisingly large number of amateur British daguerreotypists.[115] By June of that year Claudet himself had become a commercial photographer, operating out of the Adelaide Gallery.

The Adelaide Gallery seemed an ideal setting for such an operation. It was initially established 'with a view to the promotion of the arts and manufactures by their connection with science', including exhibits 'combining the astonishing powers of electricity with the wonders of optical illustration'.[116] As with the Royal Polytechnic Institution, patrons paid a shilling to enter. There were promenade concerts and daily scientific lectures, as well as displays of the latest technologies. As an advertisement in the *Times* reported in January 1839:

> SPLENDID EXHIBITION, Adelaide-street, West Strand.— Novelty and amusement blended with instruction are the peculiar features of this Institution. Here only is to be seen Perkins's steam gun, which discharges a stream of bullets at the rate of 1,000 in a minute. The electrical eel in full life and vigour, the only specimen ever brought to England, in addition to a splendid oxy-hydrogen microscope, with working models of steam engines, steam boats, &c.[117]

It is clear that, given the locations of these first two studios, English photography was framed from its outset by a particular class aspiration: the desire of the bourgeoisie to be both entertained and enriched by innovations in science and technology. But this setting also reminds us of the larger context in which photographic portraiture established itself, being just one small contribution to an industrial economy increasingly driven by labour-saving

Fig. 19
Noël-Marie Paymal Lerebours (France), *Amérique du Nord, Niagara: Chute du Fer a Cheval*, 1841, in
Noël-Marie Paymal Lerebours (France), *Excursions daguerriennes, vues et les monuments les plus
remarquables du globe*, vol. 1, Rittner & Goupil, Paris, 1840–42, plate 3.
Ink-on-paper print from steel aquatint engraving by Frédéric Salathé after a daguerreotype
by H.L. Pattinson taken in April 1840, 26.0 × 38.0 cm (sheet). Courtesy of Hans Kraus Jr, New York.

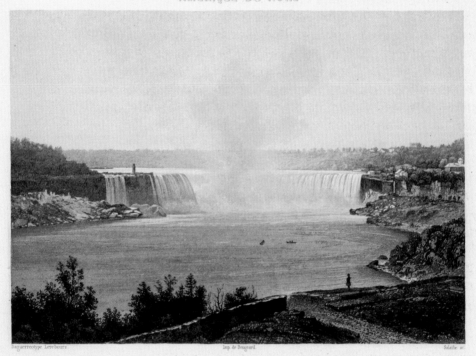

automation that included steam engines, machine guns and electric lights. A Czech commentator writing in 1839 was one of a number who immediately recognised photography as an industrial, rather than a merely scientific or artistic, innovation:

> What the poets have only conjectured in their vision our century is bringing to reality. To the railways, steam engines, steamships, weaving looms, etc, Mr. Daguerre has added his little invention of almost magical painting. [...] The effects of this invention cannot be even surmised.[118]

With this association in mind, both the Polytechnic Institution and the Adelaide Gallery had offered demonstrations of photography as early as October 1839. Adjacent advertisements featured in the press on 9 October to promote the appearance at the Adelaide Gallery of a French daguerreotypist, M. de St. Croix (or Ste Croix), who had first lectured there on 25 September, and of John Thomas Cooper, a chemist, who offered lectures, with the permission of Daguerre's agent, Berry, at the Polytechnic Institution.[119] The *Mirror of Literature* reported on their demonstrations of the new process in an issue dated 19 October 1839, complaining that little was learned about the process itself as a result. The report nevertheless praised the pictures that were seen at the Polytechnic: a view of a church in Langham Place (generated after a half-hour exposure and judged to be 'most beautiful, exhibiting the most perfectly clear and accurate view'), a depiction of a studio containing various busts, and an enlarged picture of a water-scorpion, produced by Cooper using an oxy-hydrogen microscope.[120]

We also have detailed and appreciative descriptions of visits to each institution at about this time by a pair of naval architects from India: Jehangeer Nowrojee and Hirjeebhoy Merwanjee. After speaking of various technical wonders that they witnessed at the Adelaide Gallery, they recorded that 'we also saw the Daguerreotype which is the most extraordinary production of modern times'. They even had its 'five distinct processes' explained to them by 'M. Dele Croix'. They describe the example that they saw this gentleman make as 'peculiar' in appearance, 'somewhat like a moonlight scene', and accurate in its delineation, but, in their view, 'not pleasing'. It apparently required an exposure time of twenty-five minutes.[121] They offer an even more extensive report on the exhibits at the Polytechnic Institution, including 'several drawings taken by the Daguerreotype [...] a view near Windsor, some views taken from the front of the Institution and several views

of places in and near Paris', which they looked at through powerful magnifying glasses.[122] In addition to this exhibition and Cooper's three lectures a week, the Polytechnic also hosted experiments by L. L. Boscawen Ibbetson devoted to speeding up the exposure process, the same Ibbetson who had lithographs made from some of his daguerreotype images.

It was a predictable development, therefore, for both these institutions to house a permanent photographic establishment. Embedded in an industrial economy, the founding of these professional photography studios was a consequence of the inexorable logic of commerce. In pictorial terms, this logic manifested itself in practices of reproduction that sought to replace human skills with mechanical substitutes, resulting in an increase in speed and a reduction in labour costs; a clear—even antagonistic—differentiation between owners, overseers and workers; a multiplication of outputs; and, most importantly, increased profits.[123] In early nineteenth-century Britain, one was as likely to witness the effects of this logic in the starkly functional architecture of cotton-spinning factories as in the various earlier efforts to mechanise the production of portraits, including the introduction of silhouette machines and the physionotrace.[124]

Both Beard and Claudet built studios with glass ceilings in the upper levels of their respective hosts for making daguerreotype portraits. It was then believed that blue light was the best under which to photograph, so this became a standard feature of all daguerreotype studios. Johnson recalled that

> in the early part of 1841 much of my personal time was devoted to the planning and constructing of the operating room and building at the Polytechnic Institution, London, and looking after the blue plate glass for its skylight, in plate-glass works in Lancashire, etc.[125]

This is another reminder that the operation of a studio in London necessitated the establishment of lines of supply and a manufacturing base that could regularly produce all the necessary components: flat copper plates (likely to have been supplied by G.R. and H. Elkington & Co. of Birmingham), chemicals (which Johnson says he obtained from 'Dimond and Co. [per Mr. Turner] of Holborn Bars, London'), glass, frames, cases and so on.[126]

Three days before the Beard studio opened, the *Spectator* magazine told its readers what to expect:

The visitor is introduced into an apartment lighted from
above, and having a flat roof of blue glass, which subdues
the glare of the sun's rays without materially diminishing
their luminous intensity; the livid paleness of complexion
visible in the faces of the persons assembled, and the effect
on the eye from the sudden change in the hue of light, cause
a strange sensation, which after a while is agreeable. [...] The
individual to be limned is seated in a raised chair, the face
towards the sun, the head being steadied by resting against a
forceps-like framework; and opposite, on a level with the eye,
is an open square box containing a reflector which presents
the image of the sitter upside down. [...] the sitter is invited to
'call up a look' of pleasurable animation, which has scarcely
time to relapse into dullness when the operator announces
that the picture is completed.[127]

In 1842 the cartoonist George Cruikshank published a wood engrav-
ing of the Beard studio in operation that confirms these details, and
adds a few more (Fig. 20). Titled *Photographic phenomena, or the
new school of portrait-painting*, and accompanied by a quotation
from Shakespeare and a long poem by editor S.L. Blanchard, the
illustration shows a man seated on a high platform, so that he is
close to the blue glass ceiling and thus to the maximum amount
of light.[128] The platform is mounted on rollers, to allow it—and the
subject seated on it—to be turned towards the sun as needed. One
is left to imagine the strange blue light that bathes the whole scene.
The man grips the side of his chair with one hand and rests the
other on his knee while his head is held steady by metal pincers, a
device adopted from those already used by portrait painters such
as Thomas Lawrence. Opposite the man's head, and at the same
level, is a narrow ledge suspended from the ceiling on runners,
allowing it to be moved around the perimeter of the studio as
needed. Two rectangular boxes sit on this platform, one closed and
the other with its end raised, as if propped on its hinges. A young
man resembling Jabez Hogg, another operator associated with
the Beard studio, stands on a foot-ladder, staring at a watch in his
left hand while holding, in his right, a metal focusing-mirror that
he has just lifted out of the camera and replaced with a sensitised
silvered plate of copper.[129]

We appear to be viewing a portrait-sitting in mid-exposure, with
the Wolcott reflecting apparatus open and the operator counting
down the seconds until it needs to be closed to the light. A concave
mirror sits at the rear of the box, facing forward so that it focuses

Fig. 20
Photographic phenomena, or the new school of portrait-painting, in Laman Blanchard (ed.), *George Cruikshank's Omnibus: Illustrated with One Hundred Engravings on Steel and Wood*, Tilt and Bogue, London, 1842, p. 29 (accompanying a poem of the same title, by Laman Blanchard, pp. 29–32).
Ink-on-paper print from wood engraving by George Cruikshank of the Richard Beard studio (London), 23.0 × 14.0 cm. Collection of the author, Wellington.

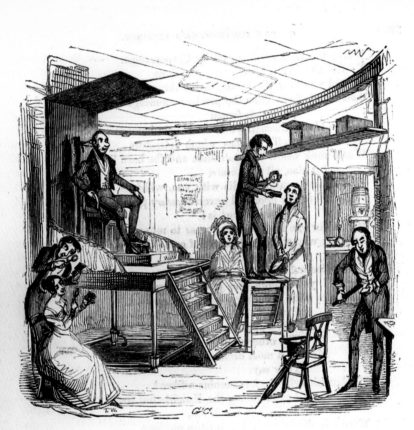

PHOTOGRAPHIC PHENOMENA, OR THE NEW SCHOOL
OF PORTRAIT-PAINTING.

light onto the small rectangle of polished metal placed before it. The daguerreotype plate therefore faces away from the portrait subject at the moment of its exposure.[130] Down on the floor, in the right foreground, we see another man (he resembles Johnson) vigorously polishing one of these plates with a velvet-covered piece of wood in preparation for the next exposure. We are offered a glimpse of another room through an open door, and can see an open flame and a water barrel there; this is where each plate would be prepared before being handed to the operator and put in the camera. Two customers, a man and a seated woman, wait their turn at the back of the studio, avidly watching the camera operator. On the left we are shown two other, apparently satisfied, customers, each eagerly examining their own ninth-plate portrait through magnifying glasses.

This, then, is what clients of the Beard studio would have encountered when they mounted the stairs of the Polytechnic Institution, with Cruikshank having compressed several moments from the multi-step process of being photographed into a single, sharply observed scene. Notice what these clients *don't* get to see at the Richard Beard studio: Beard himself. It seems as if the day-to-day procedures of the studio were handled, not by the proprietor, but by operators like Hogg, Goddard or Cooper, along with their various assistants. Despite being confined to daylight hours, and to just six afternoons a week, by November this team of subsidiary workers was making as many as forty portraits a day.[131] Portraiture, once the preserve of the very wealthy, had been here turned into a regimented production process available to any prosperous member of the general public.

In fact, early customers of the Beard studio tended to be, like Talbot, members of the aristocracy or captains of industry. Photographic portraits, in other words, had a distinct class profile. The studio, for example, could boast of early customers of the social calibre of Charles John Canning (later Earl Canning, but in 1841 under-secretary for foreign affairs) (Fig. 21); George Francis Robert Harris (Third Baron Harris and governor of both Madras and Trinidad); William King (Earl of Lovelace and a fellow of the Royal Society); Sir Robert Joseph Phillimore (a judge); John George Children (another fellow of the Royal Society, and father of early botanical photographer Anna Atkins); and Robert Curzon (Fourteenth Baron Zouche). Each would have paid about a guinea for the privilege—an average week's wages for a working man (or the cost of a ton of coal).

Foreign customers sometimes included wealthier members of the middle class. One of the latter was the American abolitionist Wendell Phillips. He arrived in London in June 1839 with his wife, Ann, to tour Europe and attend the World Anti-Slavery Convention in June and July of 1840. In about mid-April 1841 the couple came back to London from a visit to Naples and sometime between then and July, when they sailed for Boston, Wendell had his daguerreotype portrait made at the Beard studio. Interestingly, another prominent abolitionist, the British activist George Thompson, also had his daguerreotype portrait taken at Beard's studio around this time. The two men were well known to each other and in later life were photographed together. Perhaps they also visited Beard's on the same day in 1841? Both of these daguerreotypes were donated to the Boston Public Library in 1899 by the family of yet another important American anti-slavery activist, William Lloyd Garrison, suggesting that they may have been given to him at some stage (he also was in London in 1840). As a man dedicated to socialist principles, Phillips would no doubt have appreciated that photography depicted him with the equivalent dull dispassion that it accorded aristocratic customers. Although set in a vertical flip-top leather case, his portrait was mounted in the same type of chased-brass mat as one of Talbot's portraits, but this time with a small roundel added to the front, containing the words 'Beard Patentee' (Fig. 22).

It might be said that photography's association with a drive to mechanical automation was made manifest in such portraits. Not only were they produced automatically on a sheet of shiny metal, as if the Industrial Revolution had embodied itself in image form, but the poses and facial expressions of Beard's subjects—stern and fixed, almost always looking slightly beyond the camera as if towards a future of unbounded prosperity—were faithfully repeated in example after example. ·

Despite this repetition of form, the small size, soft focus and limited tonal range give a mysterious air to such portraits, imparting a distant, even melancholic character less evident in later, more accomplished examples. Walter Benjamin evoked this primitive quality rather well in his 1931 essay 'Little History of Photography':

> The first reproduced human beings entered the viewing space of photography with integrity—or rather, without inscription. [...] The human countenance had a silence about it in which the gaze rested. In short, all the potentialities of this art had not yet been established. [...] The procedure

Fig. 21
Richard Beard studio (London), *Charles John Canning*, c. 1841.
Ninth-plate daguerreotype in vertical leather case, 15.2 × 6.1 cm (open). Collection of National Portrait Gallery, London.

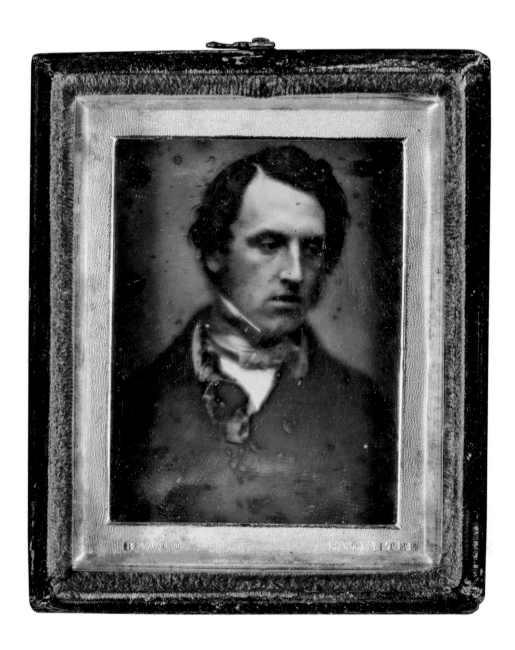

Fig. 22
Richard Beard studio (London), *Wendell Phillips*, c. April–July 1841.
Ninth-plate daguerreotype in vertical leather case, 15.0 × 6.0 cm (open). Collection of Rare Books Department,
Boston Public Library.

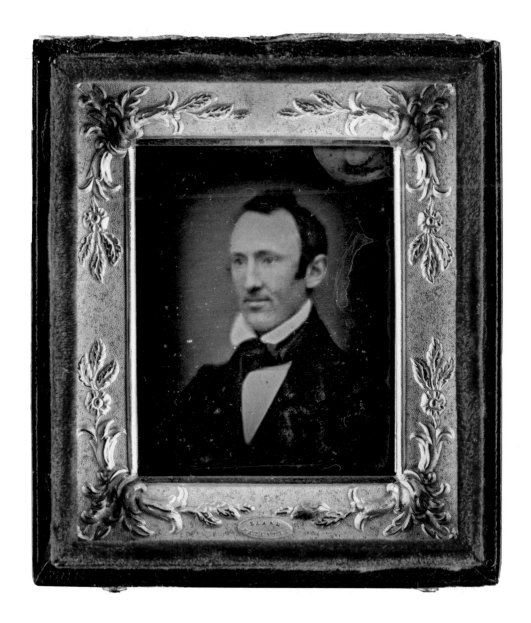

itself caused the subjects to live their way into, rather than out of, the moment; during the long duration of the exposure, they grew into the picture.[132]

One of the earliest clients of the Beard studio was the 73-year-old Anglo-Irish writer and property owner Maria Edgeworth, who had several portraits taken, at a guinea each, during mid-morning on 25 May 1841.[133] Her letter about the experience to her half-sister Fanny Wilson helps to recall the mystery of this hitherto unknown process, a reminder that, for the vast majority of visitors, this was their very first experience of photography:

> Lestock came with me to breakfast here at 8 o'clock and then he took Honora and Captain Beaufort and me to the Polytechnic and we all had our likenesses taken and I will tell you no more lest I should some way or other cause you disappointment. For my own part my object is secure for I have done my dear what you wished. It is a wonderful mysterious operation. You are taken from one room into another up stairs and down and you see various people whispering and hear them in neighboring passages and rooms unseen and the whole apparatus and stool on high platform under a glass dome casting a *snap-dragon blue* light making all look like spectres and the men in black gliding about like &c. I have not time to tell you more of that.[134]

In another letter to Wilson, written on 28 May, Edgeworth explained that the daguerreotypes taken on the 25th had just been delivered 'after breakfast': 'I fear you will not like any of my daguerreotype faces—I am sure I do not—the truer, the worse.'[135] At least two of these 'faces' have survived. In both cases Edgeworth, wearing a lace-edged bonnet over the curls of her dark wig, looks away from the camera and slightly down, allowing a three-quarter view of her face and the upper portion of her body. It's an affectation impudently borrowed from the conventions of aristocratic portraiture. There is nothing behind her to distract us, so that her figure, turned as it is, floats in the picture plane like a monochrome relief sculpture against a silver backdrop. The depth of field is very shallow, making her far shoulder fade out of focus. This gives an illusion of movement and depth to an otherwise static and shallow scene. The cold metal armature that would have restrained that movement remains unseen, but Edgeworth's face bears the stoical expression of someone enduring a long pose. She stares vacantly to one side, pretending to be caught unaware, as if in a moment of reverie. As

a consequence, we can look directly at her, uninhibited by a return of gaze. Equally, by declining to acknowledge our presence, she carefully presents herself as someone worthy of being looked at.

Although, as Edgeworth lamented, the daguerreotype process ensured a 'true' likeness, its ability to convey character was limited by its lack of colour and the static nature of the pose. Nevertheless, like all portraiture, these examples were as much about the inscription of social identity as they were an effort to describe the appearance or personality of the sitter. As John Tagg has suggested, the making of portraits involves 'at once, the production of significations in which contending social classes claim presence in representation, and the production of *things* which may be possessed and for which there is a socially defined demand'.[136] Such a thing is an image, but it 'is also a commodity, a luxury, an adornment, ownership of which itself confers status'.[137] Like other early portraits from the Beard studio, Edgeworth's was indeed a thing, packaged in a distinctive domed red-leather case, a format appropriated from the miniature-painting tradition. This suited any images made with the Wolcott camera, which was capable of generating only small ninth-plate daguerreotypes. Softly focused and poorly lit, these plates were surrounded by a rectangular brass mat, a micro-version of a gold frame, and set in a brass tray.

After 24 August 1841, this tray was supplied by Thomas Wharton & Co. from Birmingham. A fancy logo for this company, complete with an inferred royal patronage, was inscribed on the back of the tray. Printed in raised relief on the front of the brass mat were the words 'Beard Patentee', an effort by the proprietor to insist on what he claimed were his exclusive rights to the process. Some examples are also signed in blue, 'R. Beard' or 'Richard Beard', on a printed label found underneath the daguerreotype. The earliest examples have the daguerreotype set in a deep box and covered in a sheet of roughly cut glass, facing a piece of red velvet in a vertical, flip-top case with a leather hinge and metal hook and eyelet. Able to be held by the viewer, and thus made touchable as well as visible, the subject is nevertheless distanced from us by the thick, reflective glass and murky image.[138] Clients of the Beard studio could also purchase their portraits mounted in black wooden hanging frames, as were Talbot's, or set in a small gilded frame made of wood and ornamented gesso (Fig. 23). This format suggests that some patrons intended to exhibit their portraits on the walls of their homes, allowing for a more constant, if less intimate, relationship between image and viewer.

As it happens, this was an option not yet available at Beard's rival, the studio of Antoine Claudet. All his portrait photographs came in cases. We have an 1867 reminiscence by Thomas Sutton of his visit to Claudet's studio in about 1841:

> In that year I remember having my daguerreotype portrait taken by M. Claudet on the roof of the Adelaide Gallery. I was seated, one sultry summer afternoon, at about three o'clock, in the full blazing sunshine, and after an exposure of about a minute the plate was developed and fixed with hypo. My eyes were made to stare steadily at the light until the tears streamed from them, and the portrait was, of course, a caricature. It has since faded. I paid a guinea for it. M. Claudet himself superintended the pose, and an assistant, a mere youth, prepared and developed the plate.[139]

Sutton goes on to describe the setup of the studio itself, and even claims to recall the details of his conversation with the photographer:

> There was on the roof of the building a studio of blue glass, the use of which had been abandoned because the blue glass was not found to shorten the exposure; so I was posed outside. In some conversation with M. Claudet about the wonderful art which he practiced, he informed me, with the utmost gravity, that to achieve anything like success or eminence in it required the chemical knowledge of a Faraday, the optical knowledge of a Herschel, the artistic talent of a Reynolds or Rembrandt, and the indomitable pluck and energy of a Hannibal; and under these circumstances he strongly dissuaded anyone from taking it up as an amusement. I thought of the assistant who had really executed the practical part of taking my picture. I smiled at the principal's pompous and discouraging observations, and I determined one day to try my own hand at photography.[140]

Remarkable here is the combination of skills and knowledges that Claudet supposedly saw as being necessary to photography: apparently chemistry, optics, art and war all played a role. To this list he might well have added 'the commercial ingenuity of a Wedgwood', for this was perhaps the most important talent of all, if a studio were to survive. From Sutton's description, it seems that Claudet himself 'superintended the pose' while an unnamed assistant, 'a mere youth', prepared and developed the plate. For all the talk of noble predecessors and artistic talent, Claudet's photography studio

Fig. 23
Richard Beard studio (Royal Polytechnic Institution, London), *Portrait of an older man*, c. 1841.
Ninth-plate daguerreotype made with Wolcott Reflecting Apparatus in gilded wooden frame with remnants
of green Richard Beard studio label on verso, 14.2 × 13.0 × 3.2 cm. Collection of the author, Wellington.

was organised like any other modern business, with a recognised hierarchy of skills and a clear separation of procedures and workers, all arranged to ensure an efficient operation and maximum profit.

Quite a few early portraits from the Beard studio have survived, but it is difficult to identify daguerreotypes by Claudet from the 1841 to 1842 period. One portrait by Claudet that appears to be quite early is a sixth-plate portrait of an unnamed bearded man presented in a vertical, red-leather case with a pronounced domed top (Fig. 24). This top is deeply stamped with a logo featuring a crown and the words 'Claudet's Daguerreotype Process', designed to encircle 'Adelaide Gallery Strand'. Photographed from the waist up, the seated man inside this case rests his elbow on a table and looks steadfastly off to the side, as if unaware of the camera's presence. His eyes are slightly obscured by shadow, making his vest and the cuff of his shirt the brightest elements of the picture, even as his face and one hand also remain prominent. The picture is characterised by an overall softness of focus, very unlike later Claudet portraits, and it lacks a background.

Another undoubtedly early example is a portrait of Claudet himself. A sharply focused ninth-plate daguerreotype, it shows the photographer seated in profile, looking up from writing something with a quill pen, the painted backdrop depicting a door and shelves of books (Claudet patented the use of painted backdrops in December 1841). The photograph is packaged in a folding Morocco case, with a gilt stamp saying 'Claudet's Daguerreotype Process, Adelaide Gallery Strand'.[141] The pose allows him to present himself as a man of letters and learning, alert and caught in mid-thought. As Claudet was using a lens-camera imported from France, the image we see is probably reversed, such that the arm that appears to be his right is actually his left.[142] This reversal was one characteristic that distinguished Claudet's work from Beard's. But it was also a characteristic that soon attracted unwelcome criticism in the press.

On 4 September 1841 an unnamed journalist published a story in the *Spectator* directly comparing portraits made in the two studios, in the process also describing the operations of each. We are told, for example, that Claudet took two different views of the face of his subjects at the same time, using two cameras placed side by side, whereas the photographer at Beard's took two views in quick succession with the one camera. Beard's exposure times were reported to be between four and seven seconds on a bright day, whereas Claudet admitted to times of between ten and ninety

Fig. 24
Antoine Claudet studio (London), *Portrait of a man*, c. 1842.
Sixth-plate daguerreotype in vertical leather case, 16.2 × 9.2 cm (open). Collection of the author, Wellington.

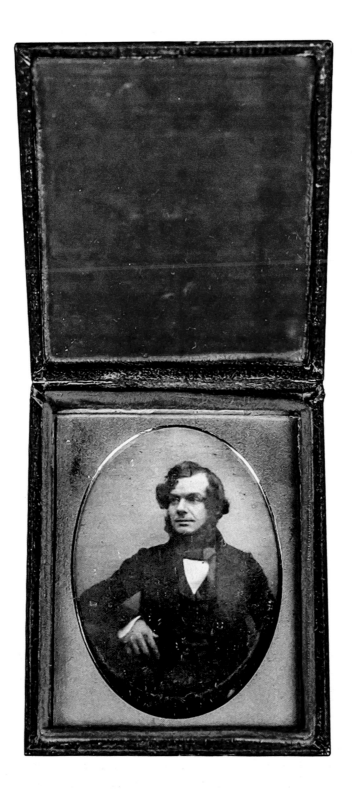

seconds, depending on the month and the weather. The writer
has a lot to say about the relative effects of the two different types
of camera being employed, noting that the reversal of features
engineered by Claudet's achromatic lens-camera adversely affected
the resemblance achieved. He is also critical of the 'sombre effect
of the strong shadows and colourless light of the photograph',
which, he says, 'increased to an unpleasing degree of sternness,
occasionally amounting to a repulsiveness, and sometimes even
falsifying the likeness'. Having looked closely at examples of the
work of both studios, the author concludes:

> On an attentive comparison of the two, we are bound to say
> that the Photographic Miniatures taken at the Polytechnic
> Institution by Mr BEARD's process are superior to those
> taken by M. CLAUDET at the Adelaide Gallery. In fidelity of
> appearance, delicacy of marking, and clearness of effect; in a
> word, they are more pleasing and artistical: the shadows are
> denser and the lineaments less defined in those produced
> by M. CLAUDET; though these objections are less important
> than the reversal of the countenance and figure.[143]

Four days later, the same newspaper published an indignant letter
by Claudet, objecting to this assessment, claiming that he had made
improvements to his process that counteracted the optical distor-
tions noted by the writer, and disputing the critical assessment of
his work. He also mentions that his camera is furnished with a 'par-
allel mirror', used to re-reverse the portrait image (but at the cost of
a longer exposure time) and that he 'can electrotype my portraits so
as to obtain as many fac-similes of each portrait as are required'.[144]

Claudet had, it seems, already adopted the work of English scientist
William Grove and his voltaic process for reproducing daguerreotype
plates. This process produced an accurate but shallow facsimile of
the original daguerreotype image on a copper plate. Ink-on-paper
impressions could be pulled from this plate, thus producing a reversed
(corrected) version of the initial daguerreotype image. Grove claimed
that, on an area of one square millimetre, five lines of a photographed
inscription could be read from his etching of it by the aid of a micro-
scope. However, the paper impressions were not as sharp or detailed
as the original image, and so usually the electrotyped copper plate
was put behind glass and exhibited as a 'beautiful sienna-coloured
drawing of the original design'. As Grove himself put it: 'instead of
a plate being inscribed as "drawn by Landseer, and engraved by
Cousins," it would be "drawn by Light, and engraved by Electricity"'.[145]

Claudet continued to conduct his studio more or less as described by Sutton, occupying three locations in London and employing assistants but remaining the principal operator. As a consequence, the Claudet name was soon associated with the production of daguerreotypes of the highest quality. One early customer was Talbot, who first seems to have visited Claudet's studio in October 1842. The end result of their association was at least three cased portraits. Compared to the small, dour portraits of Talbot produced by the Beard studio in 1841, Claudet was able, less than two years later, to induce a relatively dynamic set of poses from the same man. Wearing a top hat and brandishing an open book in one hand—a suitable attribute for a distinguished man of letters—Talbot looks across to his left, as if struck by a sudden thought, presenting what amounts to a profile view of his head (Fig. 25). Behind him is a painted backdrop featuring a column and a leafy, receding landscape. That this flattering pose is repeated in three daguerreotypes suggests how carefully composed it was, presumably the result of a collaboration between photographer and subject. The main variation between the three images involves the opening of Talbot's jacket in one of them, a self-consciously relaxed gesture that gives more prominence to his hanging magnifying glass, an instrument that, like photography, improved one's ability to see.

Always looking to innovate, on 18 December 1841 Claudet had taken out a patent on certain further improvements he claimed to have made to the daguerreotype process, including the addition behind the sitter of 'painted scenery representing landscapes, interiors of apartments, and other representations adapted to the taste and habits of the sitter or to his profession'. These painted backgrounds, able to be slid back and forth on grooves, '[gave] to the portrait an effect quite pictorial' and allowed Claudet to isolate the sitter's figure against light or dark areas, and to combine several backgrounds 'shifting one upon the other like theatrical decorations'. Included in the patent document was the suggestion that a red light be used in the darkroom to prevent fogging of the light-sensitive plate.[146] He also proposed illuminating his studio by artificial means, including by burning coal in oxygen, in conjunction with a concave mirror to direct the light.[147] By 10 March 1842 Beard had taken out his own patent on 'Colouring Daguerreotype Pictures', consisting of, among other techniques, depositing various coloured powders on the surface of the plate using 'a pattern or screen resembling a stencil'.[148] Promoted in advertisements by Beard and Claudet (which were often printed side by side), but not defended in the courts, the use of a red safe light, the addition of painted backdrops, and the hand-colouring of daguerreotype portraits soon became standard features of all British commercial photography.

Fig. 25
Antoine Claudet studio (London), *William Henry Fox Talbot*, c. 1843.
Daguerreotype in leather case, 6.5 × 5.3 cm (image). Collection of British Library, London.

It should be noted that Beard, in contrast to Claudet, played almost no role as a photographer. He instead occupied his time as an entrepreneur intent on establishing a franchise. By the end of 1841, apart from his own studio at the Polytechnic Institution, Beard had licensed twelve other studios in provincial towns and larger cities: Plymouth (31 July), Bristol (10 August), Cheltenham (13 September), Liverpool (20 September), Nottingham (2 October), Liverpool (a second studio, at 34 Church Street, opened in October), Southampton (October), Brighton (8 November), Bath (11 November), Manchester (8 November), Norwich (18 November) and Portland Terrace, Guilford (late November). By 1842 he had opened two other studios under his own name in London, on 29 March at 34 Parliament Street, Westminster, and on 25 April at 85 King William Street. These additional London addresses were then stamped into his leather cases, so that each purchase of a daguerreotype advertised all the other Beard studios.

Over the next two years, Beard licensed further studios in Birmingham (1843), Bradford (1843), Hull (1843), Leamington Spa (1843), Leicester (1844), Newcastle-upon-Tyne (1845), Sheffield (1843) and York (1844), among other places.[149] As well as offering provincial photographers a licence to practise the daguerreotype, Beard also sold them the necessary training, copper plates, chemicals, mats and cases, all stamped with the words 'Beard Patentee'.[150] In other words, a portrait that came stamped with Beard's name was almost certainly never made or even seen by him, and could have been produced at any one of numerous locations throughout Britain.

An Irish engraver turned photographer named Francis Beatty sent some recollections of his early career to the *Photographic News* in August 1879, and these included an account of his meetings with Beard in 1841. Having made daguerreotype views of Belfast as early as September 1839, Beatty went on to make his own version of the Wolcott camera and by 1841 was able to capture portraits:

> Having communicated my success to Mr. Beard, he invited me over to London, and in the October of that year found me in the Polytechnic Institution, when I was introduced to Messrs. Cooper and Goddard'.[151]

Beard was in Southampton, trying to establish a studio there, and invited Beatty to work as an 'operator' in his London studio until his return. According to Beatty's recollection, recorded almost forty years later, the average amount of money taken in during his time at the Beard studio was (he was told) £150 per day.

> In the waiting rooms of this establishment you would see waiting their turn to enter the blue glass-roofed operating rooms, the noble dames and daughters of England's aristocracy, accommodating each other as well as their limited space would allow, awaiting for hours together before their desires were accomplished.[152]

When Beard returned he invited Beatty to help him establish a studio in Dublin, under his direction: 'If I would accept of the operative management he would pay me a per centage of the work done.'[153] Beatty declined the offer, and went on to open his own portrait studio in Belfast in 1842.

Beard's eagerness to find new licence holders led him to open up the photography business to persons usually excluded from such a pursuit. In the *Times* of 19 April 1842, he advertised 'Licences for working the invention in provincial towns and the British colonies granted by Mr. Richard Beard, patentee'.[154] In that same year Beard appears to have sold a licence to an ambitious would-be-photographer, George Barron Goodman [also known as Gershon Ben Avrahim], who was preparing to emigrate to the British colony of Australia. Goodman duly arrived in Sydney on 5 November 1842 with a 'reflecting apparatus' daguerreotype camera and twenty-seven boxes of blue glass to use in his photography studio, which opened at 72 George Street on 12 December. Goodman announced that he would be operating 'By Her Majesty's Royal Letters Patent'.[155] Goodman's advertising copy included a full column of British press reviews lauding Beard's studio at the Royal Polytechnic Institution, a practice very much in the Beard style. Goodman, like Beard, charged one guinea for a portrait—about a week's wages—plus the cost of a frame, and advertised exposure times of about ten seconds. He went on to make daguerreotypes in Hobart, Bathurst, Melbourne, Adelaide, Maitland, Newcastle and Goulburn.[156] None of Goodman's earliest daguerreotypes seems to have survived. And perhaps that's just as well, as the *Sydney Morning Herald* unkindly described them as having a 'cadaverous, unearthly appearance'.[157]

By 1843 Goodman was using a new lens-based camera, the same year in which such an apparatus was adopted by the Beard studios in London, and he continued to advertise that he was receiving from 'the patentee in England every recent improvement of the art of the Daguerreotype'.[158] As was the case for Beard's other licensees, Goodman's tasks included explaining to potential customers exactly *what* he was selling. His advertisement in

the *Sydney Morning Herald* of 28 November 1844 is a particularly striking example of this effort:

> It may be as well for general information to observe, that these Portraits are taken almost instantaneously, and produce as faithful a representation of the face and figure as is presented by standing opposite a mirror, being in fact the reflection itself fixed permanently in the glass or polished surface, thus producing in effect a '*Second Self*'.[159]

The level of Beard's ambition, aimed at building an empire of subsidiary studios throughout Britain and beyond, is further underlined by the details in a letter sent to associates in New York by Alexander Wolcott from London on 15 November 1841:

> Things are jogging along so so—November has been a fine month thus far, a large portion of the days having sunshine, some days as many as forty portraits being taken. The Polytechnic folks have differed a little with Mr. B. respecting the readmission of sitters whose likenesses were not good at the first visit. Mr. B. is looking out for another place at the West end. There is talk of doing the lacquered and gilt work at the factory. [...] They have opened at Manchester—Bath is about commencing—Brighton is doing well.—Leeds will soon go into operation.[160]

'Mr. B' was a very busy man. Between mid-June and the end of December 1841 he wrote no fewer than thirty-nine letters to just one of his licensees.[161] No wonder he had no time to take photographs!

Stories such as these tell us that Beard's principal business was the selling of licences to practise photography, rather than the taking of photographs, and it was this activity that took up the bulk of his own work time. In other words, the inscription 'Beard Patentee' on a photograph represented a displacement of individual authorship in favour of a brand identity invested in the name of an otherwise absent franchise holder. As a consequence, hundreds of 'Beard' daguerreotypes were made during this period by photographers other than Beard.

To maintain the profitability of his franchise system, Beard defended his patent rights aggressively in court, initiating at least six legal actions in the Court of Chancery against other photographers who, he argued, were infringing on his rights as the British patent holder (that is, who were practising daguerreotypy without having

paid him a licence fee) or who had not fulfilled their obligations after receiving a licence from him to practise. These included actions against Claudet (1841–43), Edward Josephs (1842), Alfred Barber (1842–43), Edward Holland of Yorkshire (1843), Robert Blake and William Chapple of Cornwall (1843), and John and Jeremiah Egerton (1845–49).[162]

Barber and Holland had defaulted on their payments and were forced to cease operations. Beard similarly obtained an injunction against Josephs, 'otherwise called Edward Joseph Edwards', who had set up an unlicensed portrait studio in a garden in Finsbury, London. It seems as if there was an intriguing back-story to this action, as an Edwards had previously worked for Beard at the Polytechnic. As Wolcott reported in his letter of 15 November 1841: 'Edwards has gone into the employ of Claudet, and will of course, expose *all* he knows, that is to say *but little*.'[163] Having first been poached by a rival, it seems that Edwards had subsequently decided to go into business on his own. No wonder Beard was keen to pursue him in the courts. The lengthiest suit brought by Beard was against John and Jeremiah Egerton, who he alleged were illegally taking portraits and selling apparatuses at prices that undercut those charged by Beard licensees. This case was never fully resolved, petering out as Beard himself was forced into bankruptcy in 1849.

Much has been made of the antagonistic legal actions between Beard and Claudet, and these did indeed result in soured relations between the two men. (In a letter to Talbot dated 18 January 1843, Claudet referred to Beard as his 'competitor and fierce enemy'.)[164] Having acquired the patent from Berry, Beard argued that he should by law be able to buy back the licence that had been issued to Claudet and thus prevent him from operating a rival studio. Claudet refused to sell. Beard took out an injunction against him, and the initial hearing took place at the Vice-Chancellor's Court on 15 July 1841, with the decision being made in Beard's favour. A week later, on 22 July, Claudet successfully appealed against the first decision before the Court of Chancery. On two subsequent occasions, Beard tried and failed to have the Lord Chancellor's decision rescinded. These various legal successes and failures were quickly promoted in advertisements issued by each studio, which suggests that both men saw the court of public opinion as vital to continued financial success.

The press itself was also used for this purpose. For example, following their contentious legal battle, an interesting paragraph

appeared in the *Literary Gazette*, *and Journal of Belles Lettres, Arts, Sciences* of July 1841:

> Injunction, and Injunction Overruled—A contrast: Two photographic groups, by M. Claudet, exhibited, with many others, at the Adelaide Gallery. The former, the moment of the receipt of the 'Interlocutory degree [*sic*] out of the Chancery,' prohibiting the practice of the art by M. Claudet, and producing in him and in his friend gravity and gloom; the latter, the moment after the removal of the prohibition, when freedom from restraint and sparkling champagne were calling forth expressions of congratulations and joy; very spirited, and were it not for the hue, lifelike. The figures in the latter are numerous; one standing in the very act of pouring out the exhilarating modern nectar.[165]

Sadly, neither of these extraordinary daguerreotypes has survived. Nevertheless, their creation, and the back-story that has just been recounted, reminds us that the practice of photography in those early years was a tough, competitive business. A studio survived only if it operated according to the logic of mass production, turning out relatively formulaic portraits in a repetitive and cost-effective manner, while regularly promoting their quality and social standing in the organs of the press. Studio proprietors like Beard and Claudet were always looking for new opportunities to ensure photography's profitability, even as they continued to offer innovations in their existing operations. These innovations, however, were driven by the needs of commerce rather than of art. It was in this context that they soon recognised the possibility of separating the photograph from its image, and of making money from both. The remainder of this account will examine the ramifications of this separation.

Photography and Reproduction

As a consequence of his experiences as a seller of photographs, Claudet was always attuned to the commercial potential of reproductions based on daguerreotypes. Indeed, by early 1842, a little over six months after opening his own studio, Claudet was being commissioned by the newly established *Illustrated London News* to make a series of daguerreotype views of London, so that a wood-engraved panorama of the city might be derived from them. This panorama, 'a picture bigger than anything previously issued', was promised in the *News*'s inaugural issue of 14 May 1842 as a gift to all who subscribed to the journal for six months (Fig. 26). In this same issue, the journal's editor, Herbert Ingram, promised its readers that, through vivid reporting and an extensive use of wood engravings, 'the public will have henceforth under their glance, and within their grasp, the very form and presence of events as they transpire'.[166] Ingram recognised that engravings based on photographs, 'facsimile engravings' as they came to be called, could only strengthen this rhetorical promise.[167] The choice of wood engraving (rather than the cheaper wood-cut process) as the means of illustration also allied the *News* with middle-class taste and thus with the aesthetic and political interests of its intended market.[168]

To create this panorama, Claudet set up his camera on a small balcony at the top of the Duke of York's Column, erected in 1834 in Waterloo Place above Pall Mall and, at 124 feet high, then the tallest lookout in London. Over a period of several days, he exposed a sequence of consecutive horizontal daguerreotypes of the city using a lens-camera imported from France, providing a 180-degree view of that city, looking north and south. The plates were then copied by Henry Anelay, an artist and illustrator, who sat at the top of the column with Claudet's plates and transcribed them into a drawing (with, as one commentary put it, 'the deficiencies filled in from nature'). This reversed drawing was then transferred by a Mr Sargent onto approximately sixty hard end-grain blocks of boxwood imported from Turkey, each about six inches square. These blocks, joined by bolts to form a continuous surface, were subsequently inscribed over two months by eighteen journeymen engravers working

in a kind of assembly-line system under the direction of master engraver Ebenezer Landells. Among other tasks, Landells would have worked over the joins between the blocks to ensure a smooth transition. The final matrix was then cast in metal to enable it to be run through presses, an electrotyping system of this kind having recently been invented.[169]

Very much a product of collective, if subdivided, labour, the finished panorama was titled *London in 1842* and given away to subscribers as a two-sided ink-on-paper print, along with a key identifying London's principal sights. Others could buy it separately for a guinea (or a hand-coloured version, wound onto a wooden roller, for two guineas). At 36 × 50 inches each, the prints were both a costly publicity stunt and a huge success. The first issue of the *News* sold 26,000 copies, but by the end of 1842 its circulation had reached 60,000 copies.[170] In response to demand from new subscribers, the 30 July 1842 issue offered another imprint of the panorama, along with a selection of the extensive comments on it that had already appeared in other newspapers. A number of these comments mention Claudet's involvement, with many marvelling at the accuracy of the panorama's perspective and its extraordinary delineation of detail:

> Whoever be the artist, he has given an accurate representation of London as it is at the present moment, and all the steeples, including the scaffolding round the Nelson monument, are handed down to posterity with wonderful precision.[171]

This 'photographic' precision, made manifest in the print's indiscriminate display of visual information, was underlined by the addition of contingent details that could not possibly have been captured by Claudet's primitive apparatus, including strolling pedestrians, horse-drawn carriages and, most apparent in the south view, smoke billowing from factory chimneys. The panorama's subtitle, *The picture of the metropolis of the British Empire*, exemplified both its publisher's imperial worldview (subscribers received, along with the panorama, the music and lyrics to a song titled 'London the City of the World') and the scope of the publication's reporting.[172]

The photographic image was by this means presented as a kind of abstraction, allowing an impossibly extended vision (a vision acquired as if in motion, through the continual turning of one's head) beyond the normal optical capacity of either a human viewer or any single camera. By means of this abstraction, and by using the latest industrial technology and modes of production married to manual

Fig. 26

Ebenezer Landells et al. (engraver, England), *London in 1842, taken from the summit of the Duke of York's Column (north view)*, 1842, in *Illustrated London News*, 30 July 1842.

Ink-on-paper print from wood engraving after daguerreotypes by Antoine Claudet taken in 1842, 29.5 × 117.0 cm.

Courtesy of Getty Research Institute, Los Angeles.

craftsmanship of the first order, the *Illustrated London News* managed to turn London into a spectacle. And because this spectacle was coded as a photographic one, it could be at once plausible and impossible. But it also signalled a new place for photography, as but one component of a continuous multimedia flow of topical news and images. In this transference from unique daguerreotype to a multitude of ink replicas, we surely see photography hovering between an artisanal past and its imminent future as a virtual image form.

Moreover, the introduction of engravings after daguerreotypes, as disseminated in the illustrated press, meant that photographic images were themselves now itinerant entities, being potentially distributed all over the world and capable of being experienced simultaneously in, say, Sydney, Hong Kong, Calcutta, New York and London.[173] A daguerreotype of a comfortably plump Englishman, shown seated while casually holding a copy of the *Illustrated London News* in one hand (Fig. 1), is, in effect, an occupational portrait of a typical middle-class British citizen of the mid-nineteenth century, with the newspaper signifying both his class and an implied imperial world-view. In this context, the sharing of printed images gathered from all over the world allowed the British Empire to maintain a sense of its own coherence as an apparently benign and yet all-seeing, all-powerful colonial enterprise.

The various Beard and Claudet studios would make frequent contributions to this itinerant flow of mass-media images. A particularly notable commission for the Beard studio involved taking daguerreotype portraits in May 1845 on the deck of HMS *Erebus* of fourteen of the officers about to set out under the command of Sir John Franklin in search of the Northwest Passage. Beard's operators seem to have exposed at least two sixth-plate daguerreotypes of each of these officers, with one set given to Lady Franklin as a memento of the voyage.[174] One of the subjects, Lieutenant James Walter Fairholme, mentioned the experience in a letter to his father, written 'Off Aberdeen, May 29th, 1845':

> I hope Elizabeth got my photograph. Lady Franklin said she thought it made me look too old, but as I had Fitzjames' coat on at the time, to save myself the trouble of getting my own, you will perceive that I am a Commander! and have anchors on the epaulettes so it will do capitally when that really is the case.

Each of the sitters adopts a similar seated pose, having been photographed from the waist up in naval uniform, often clutching an attribute such as a telescope, and looking off to one side, beyond

the camera. Franklin himself, a relatively passive pictorial presence, wears a cocked hat and various medals. By comparison, the portrait of Lieutenant Graham Gore is far more dynamic, signalled by the intensity of his gaze and the way he has crossed his arms tightly across the front of his body. Most of the officers are posed against a backdrop of drapery, as if they have been shot in a studio, rather than on deck and in full sunlight. However, Lieutenant H. T. D. Le Vesconte, wearing what would have been a blue cap with a gold band and holding what appears to be a copy of Captain Frederick Marryat's book *Code of Signals for the Use of Vessels Employed in the Merchant Service*, sits by the ship's wheel in front of the mast.[175] This portrait therefore has a depth and sense of casualness lacking in the others.

These pictures became particularly famous when the entire expedition disappeared, never to be heard from again. (Only much later was it discovered that Franklin had died on 11 June 1847, in the Northwest Territories of Canada, soon to be followed by the remnants of his 128-member crew.) After a public campaign by Lady Franklin in the illustrated press, many other ships were sent during the ensuing years to try and find the expedition. Their crews were also photographed, perhaps fearing a similar fate to whatever had befallen Franklin.

In April 1852, for example, a Beard operator was commissioned to make portraits of members of the Arctic Searching Squadron, under the command of Captain Sir Edward Belcher, as they prepared to depart to look for Franklin and his ships. Wood engravings of some of these portraits were printed as a montage in the 24 April and 1 May issues of the *Illustrated London News*, the portrait of Belcher also featured in the United States in *Frank Leslie's Illustrated Newspaper* on 19 January 1856.[176] In this context, Beard's daguerreotype portraits of Franklin and his officers could be found frequently reproduced in the same medium, their engraved figures vignetted against a stippled background. Fourteen of them appeared, for example, in the *Illustrated London News* of 13 September 1851 and then on the cover of another American journal, *Gleason's Pictorial Drawing-Room Companion*, on 18 October of the same year (Fig. 27). In January 1854 a group of portraits of those searching for the Franklin expedition were even featured in an exhibition in St Andrew's Picture Gallery in Calcutta, along with 'likenesses of Sir John Franklin, Captain FitzJames, and Sir John Barrow'.

But this example merely maintained a traffic in reproductions after photographic portraits that was already well established. The *Illustrated London News* published its first examples of portraits

Fig. 27

Engraver unknown (England?), *English Exploring Expedition to the Arctic Seas: Portraits of Sir John Franklin and Officers of the English Exploring Expedition*, taken in May 1845, in Gleason's *Pictorial Drawing-Room Companion*, vol. 1, no. 25, 18 October 1851, front cover.

Ink-on-paper print from wood engravings after daguerreotypes by Richard Beard studio (London). Courtesy of Ryerson Image Centre, Toronto.

Fig. 28
Engraver unknown (England), *Portrait of Master Thirlwall*, c. 1844, in *Illustrated London News*, 13 January 1844, p. 29. Ink-on-paper print from wood engraving after a daguerreotype by Richard Beard studio (London). Courtesy of Alexander Turnbull Library, Wellington.

PORTRAIT OF MASTER THIRLWALL.

Fig. 29

Engraver unknown (England), *His Imperial Highness the Grand Duke Constantine of Russia, Admiral Lutke [sic], M. Haurowitch, and Baron Friedericks. From a Daguerreotype, by Mr. Beard*, c. 1847, in *Illustrated London News*, 12 June 1847, p. 372.

Ink-on-paper print from wood engraving after a daguerreotype by Richard Beard studio (London). Courtesy of Ryerson Image Centre, Toronto.

HIS IMPERIAL HIGHNESS THE GRAND DUKE CONSTANTINE OF RUSSIA, ADMIRAL LUTKE, M. HAUROWITCH. AND BARON FRIEDERICKS.
FROM A DAGUERREOTYPE, BY MR. BEARD.

Fig. 30
Engraver unknown (England), *The Right Hon. Lord Brougham. — From a photograph by Claudet*, c. 1858, in *Illustrated London News*, 30 October 1858, p. 407.
Ink-on-paper print from wood engraving after a daguerreotype by Antoine Claudet studio (London), 16.4 × 14.6 cm. Collection of the author, Wellington.

THE RIGHT HON. LORD BROUGHAM.—FROM A PHOTOGRAPH BY CLAUDET.

after the daguerreotypes taken by Beard's studio in its issue of 13 January 1844 (Fig. 28):

> The portraits of Master Thirlwall and of M. Baumann, are copied from photographic plates, taken by Beard's improved process, at his institution, King William Street; the portrait of Mr. Richardson is copied from an oil painting but is, in our opinion, by no means as good as the other two.[177]

Captions such as this were, if nothing else, a very helpful advertisement for Beard's photographic enterprise. Similar copies of portraits of M. Gabriel-Julien Ouvrard, 'the celebrated French financier', appeared in the issue of 14 March 1846, followed by pictures of Grand Duke Constantine of Russia on 5 June 1847; of the grand duke and some companions on 12 June 1847; of James Wilson MP on 4 December 1847; of costumes made for a ball on 15 July 1848; of the Lord Mayor, Sir James Duke, on 11 November 1848; and so on through to 1859. None of the original daguerreotypes has survived, leaving behind only these printed traces as a kind of shadow history of the Beard studio's practice.

The engraved portrait of the grand duke and his companions—Admiral Lütke, Baron Friedericks [*sic*], and Dr Haurowitch—takes up almost the whole page, showing the group in a complex pose, two seated and two standing, with the duke at the centre casually propping his right arm over the shoulder of Admiral Lütke while looking out of the picture to his left. The engraver seems to have enlarged the head of each subject, but any doubts as to the picture's veracity are dispelled by the caption: 'from a daguerreotype by Mr. Beard' (Fig. 29).[178] Printed around this picture are a number of wood engravings made after drawn sketches, a reminder that photographic images, although carefully captioned and therefore differently valued, remained a minority in the overall pictorial content of the *Illustrated London News*.

Claudet's work circulated in a similar way. A portrait of Lord Henry Brougham taken from a daguerreotype by Claudet was included in an 1843 French publication dedicated to Brougham's writings.[179] The same image returned as a wood engraving in 1858 in the *Illustrated London News* (Fig. 30) and separately as a lithograph. More exotic are the 'correct likenesses, engraved from daguerreotype plates, taken by M. Claudet', of Ojibbeway Indians that appeared in an 1844 publication dedicated to their visit to England in that year (Fig. 31).[180] Twelve years later, in July 1856, he photographed another such group from Canada's Walpole

Fig. 31
Engraver unknown (England), *The Ojibbeway Indians, now in London (from Daguerreotype portraits, taken by M. Claudet),*
c. 1844, in *Pictorial Times*, 13 April 1844.
Ink-on-paper print from wood engraving after a daguerreotype by Antoine Claudet studio (London). Collection of the
author, Wellington.

THE OJIBBEWAY INDIANS, NOW IN LONDON (from Daguerreotype Portraits, taken by M. Claudet).

Fig. 32
Engraver unknown (England), *The Walpole Islanders at the Panopticon. —From a photograph by Claudet*, 1856, in *Illustrated London News*, 12 July 1856, p. 41.
Ink-on-paper print from wood engraving after a daguerreotype by Antoine Claudet studio (London). Courtesy of Ryerson Image Centre, Toronto.

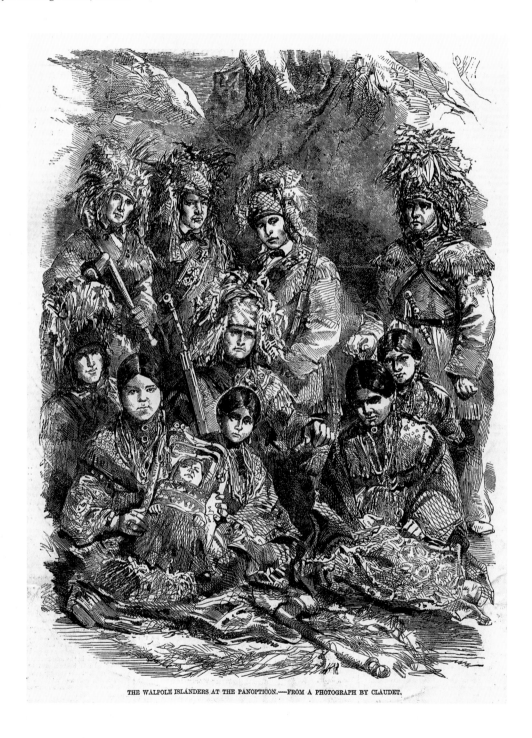

THE WALPOLE ISLANDERS AT THE PANOPTICON.——FROM A PHOTOGRAPH BY CLAUDET.

Islands while they were on exhibit at the Panopticon in Leicester Square. This image was reproduced as a wood engraving ('photographed by Mr. Claudet for our Journal') in the *Illustrated London News* on 12 July (Fig. 32).[181] By 1848 the Claudet studio was regularly supplying daguerreotypes for this purpose to this publication, beginning with a portrait of the recently deceased politician Lord George Bentinck on 30 September and rising to twenty-seven examples, along with some architectural views, seen in various issues in 1851, and another sixteen in 1852.

The *News* was especially interested in portraits of topical celebrities. The issue of 27 December 1856, for example, included a wood engraving of David Livingstone, made after a daguerreotype portrait taken by the Claudet studio. Livingstone had just completed a transcontinental journey across Africa and had returned to Britain to garner support for his ideas about how to end slavery on that continent. The print is captioned 'the traveller in Africa', an odd phrase as Livingstone was obviously photographed sitting rather glumly in London (although of course, this issue, and the image of Livingstone, could well have been seen in Africa too). And so it went on. The *Illustrated London News* was still using, and crediting, photographic images made by Claudet in 1876, long after Claudet himself had died.

Publisher Henry Vizetelly recounted an interesting anecdote about one of Claudet's portrait commissions that speaks to the sometimes ad hoc ways in which they came to feature as wood engravings in the illustrated press. According to Vizetelly's 1893 reminiscence, in mid-1843 he approached John Bright, then an up-and-coming political figure, about having Bright's portrait reproduced in the *Pictorial Times*, a rival to the *News* that had been established in this same year: 'he agreed to pay a visit to M. Claudet, and a small full-length daguerreotype portrait was the result'.[182] It seems likely that the images seen on such daguerreotypes were copied directly by an artist onto the woodblock, thus giving the engraver an already reversed image to cut out. The ink impression would then re-reverse it, showing the subject the right way around in the printed newspaper. Apparently, a proof of this particular engraving was sent to Bright for his approval. He turned up that same evening in Vizetelly's office, complaining that 'there was something about the expression of the mouth which he did not quite like'.[183] As the issue was about to be printed, Vizetelly sent for the engraved woodblock and some tools and altered it on the spot, adjusting the set of the mouth until Bright was satisfied with the result. Vanity aside, Bright was no doubt motivated by a recognition that the nature of one's appearance in the illustrated press was likely to have political as well as personal ramifications.

The emphasis in the *News* and other publications on portraits made after photographs contributed to the culture of celebrity that the illustrated press helped to manufacture, but also to the cult of the individual. Portraits gave news items a face and a name. In keeping with middle-class aspirations, they also granted a primacy to subjectivity, reducing social issues to matters of individual success or failure, making them moral rather than political questions. This helps to explain one of the Beard's studio's more curious bodies of work. Numerous engraved portraits of members of the English working class are featured in Henry Mayhew's three-volume 1851 publication *London Labour and the London Poor*. An advertisement for this publication, which was initially issued in parts, prominently stated that each part included 'engravings of the scenes and people described, copied from Daguerreotypes Taken (by BEARD) expressly for this work'. Described in its subtitle as a *Cyclopedia of the Conditions and Earnings of Those That Will Work, Those That Cannot Work, and Those That Will Not Work*, Mayhew's text provided a richly ethnological commentary on London's poor, based on interviews and social analysis.[184] This eyewitness text, replete with quotations written in vernacular English, was given added force by the addition of wood engravings based on photographs.

A number of these, including a portrait of the author placed opposite the title page, are credited as being 'from a Daguerreotype by BEARD' (Fig. 33), while others are simply designated as 'From a Photograph'. These images, most of them depictions of unnamed individuals or couples seen plying their trade in the street, present their subjects as types: 'The Baked Potato Man', 'The London Costermonger', 'The Jew Old-Clothes Man', 'The London Scavenger' and so on (Fig. 34). Obviously posed and taken with the cooperation of the subjects, most of whom look straight at the camera, these images nevertheless constitute an exceptional body of social documentary (Fig. 35). Each subject is seen front on and in a natural pose, showing their full body and tool of trade (in one case, a horse and cart), the camera's slightly low point of view giving them a monumental aspect. Unfortunately, none of the daguerreotypes survives. After a close study of the engravings, Tim Barringer has suggested that 'the visual evidence these present suggests that physiognomy, facial expression, clothing and gesture were significantly transformed during the processes of drawing onto woodblocks and engraving', so that 'details are exaggerated to intensify social and racial difference [...] in the context of a tropology of known and recognisable types'.[185] Presumably Mayhew felt that the caption 'From a Daguerreotype' added an indisputable authority to this pioneering effort at social science.

Fig. 33

Engraver unknown (England), *Henry Mayhew [from a daguerreotype by Beard.]*. c. 1851, in Henry Mayhew, *London Labour and the London Poor*, vol. 1, Griffin, Bohn, and Company, London, 1851, opposite title page. Ink-on-paper print from wood engraving after daguerreotype by Richard Beard studio (London), 19.5 × 12.0 cm (image). Collection of the author, Wellington.

HENRY MAYHEW.

[*From a Daguerreotype by* BEARD.]

Fig. 34
Engraver unknown (England), *No. 79. Costermongers in holiday-attire [from a photograph.]*, c. 1851, in Henry Mayhew, *London Labour and the London Poor*, vol. 3, Griffin, Bohn, and Company, London, 1851, opposite page 112. Ink-on-paper print from wood engraving after daguerreotype by Richard Beard studio (London). Courtesy of Alexander Turnbull Library, Wellington.

LONDON LABOUR AND THE LONDON POOR.

COSTERMONGERS IN HOLIDAY-ATTIRE.

[*From a Photograph.*]

No. 79.

I

Fig. 35
Engraver unknown (England), *No. 8. The wallflower girl [from a photograph.]* [1864], in Henry Mayhew, *London Labour and the London Poor*, vol. 1, Griffin, Bohn, and Company, London, 1851, page 113.
Ink-on-paper print from wood engraving after a daguerreotype by Richard Beard studio (London). Courtesy of Alexander Turnbull Library, Wellington.

Details of this traffic in photographic images were sometimes revealed in the press. The *Aberdeen Journal* of 28 July 1847, for example, announced that a portrait of 'the late Reverend Thomas Chalmers', to be based on a daguerreotype taken by Claudet during the minister's visit to London shortly before he died, was 'now in course of Publication'. It was to be 'engraved, to the highest style of art, by H.T. Ryall, Esq. of London, in the same manner as his Plate of the Duke of Wellington, from Claudet's Daguerreotype'. The advertisement helpfully lists the prices of the engraving for its subscribers, with the most expensive version described as 'Proofs before Letters on India Paper, with Autograph', available for two pounds and two shillings. Interestingly, it concludes by telling readers that 'the Original may be seen at Mr. Willie's [in Aberdeen], till Saturday the 31st July' (Fig. 36).[186] The recent death of Reverend Chalmers, who had also been photographed with the calotype process by Hill and Adamson in Edinburgh, was obviously a prompt for the production of this engraving, and presumably for any buyers who sought it out. Nothing encourages sales like bereavement.

The Beard and Claudet studios sought to exploit political passions in the same manner. In March 1844 a Beard operator made a daguerreotype portrait of Daniel O'Connell, the Irish politician known as 'The Great Emancipator' for his work on behalf of the Catholic majority. Showing O'Connell from the shoulders up, wrapped in a muffler and coat but hatless and staring straight into the camera, the photograph was taken while the Irishman was being detained for three months at Richmond Gaol on a charge of conspiracy. After O'Connell's death in 1847, lithographic copies of this portrait were offered for sale in the Irish press and were reproduced in the *Nation*, a newspaper founded by the leaders of the Young Irelanders.[187] Beard also advertised in publications such as the *Liverpool Mercury*, offering daguerreotype copies 'of an inimitable daguerreotype portrait of the late Liberator, with which is presented gratuitously a lithographic portrait, of a large size, by an eminent artist being a facsimile of the daguerreotype', along with daguerreotype jewellery and medallions featuring O'Connell's visage. Moreover, he announced: 'Ten percent of any profits derived from the sale of O'Connell's portraits will be appropriated to the funds of the Irish Relief Committee.'[188] Not for the last time, a photographic image taken in one context accrues different meanings in another.

Claudet also engaged in this kind of political commerce. On 23 October 1851, Lájos Kossuth, a Hungarian lawyer, journalist, politician, and regent-president of the Kingdom of Hungary during the revolution of

Fig. 36
Alonzo Chappel (engraver), *Thomas Chalmers: Likeness from a daguerreotype by Claudets* [sic], 1873.
Ink-on-paper print from steel engraving after a daguerreotype taken by Antoine Claudet studio (London) in c. 1847,
published by Johnson, Wilson & Co., New York, 18.0 × 13.3 cm (image). Collection of the author, Wellington.

1848–49, arrived as an exile at the port of Southampton in England. Over the next three weeks he toured Britain, giving lectures— often to large crowds—in support of the struggle to free Hungary from the Hapsburg Empire. During this period, he and his family (wife Teresa Meszleny and three children) visited Claudet's studio to have a number of daguerreotype portraits made. Some of these were subsequently distributed in the form of lithographs or wood engravings.

The group portraits show Kossuth standing to the right, his left hand holding his coat together. In one, he is wearing a top hat decorated with a large feather; in the other, he holds this hat in his hand. His wife sits surrounded by their children, with a sofa, a tumbling curtain and some patterned wallpaper as decorative accompaniments. A full-length portrait of Kossuth alone has him standing, feathered hat defiantly on head, one hand still holding his coat together while the other clutches a rolled document against a table top. Another daguerreotype from 1851, now in the collection of the Magyar Nemzeti Múzeum in Budapest and attributed to Claudet, shows Kossuth in profile, sitting hatless in a chair and clutching the hilt of a sword in his right hand. (A variant has him with the same sword, but looking directly at the camera.)

On 6 December 1851 Kossuth and his family arrived in New York, where they were again, for a time, feted as freedom fighters and patriots. The *International Magazine of Literature, Art and Science*, published in New York, carried a fulsome description of the visitor in its issue of 1 January 1852, including with it a wood engraving taken from Claudet's full-length portrait, referred to as 'the best portrait we have seen of the illustrious Hungarian'. The story was accompanied by another wood engraving, of Kossuth's wife and children, captioned as 'from a recent daguerreotype', but in fact from the left side of the group portrait by Claudet.[189] The complete group portrait was issued as a hand-coloured lithograph in that same year, printed by Elijah Chapman Kellogg and published by Ensign, Thayer & Co., with a caption in English and German: 'Kossuth and his Family, from Daguerreotype by Claudet of London / Kossuth und seine Familie, Von einem Dagueriotype bei Claudet in London. / 469.' Not to be outdone, Thomas Phillibrown, an English-born engraver who had come to the United States earlier in the century, issued an engraved version of Claudet's full-length portrait, complete with a facsimile of Kossuth's signature and hyperbolically captioned 'Governor of Hungary by the Peoples Choice' (Fig. 37). Amazingly, in *1958* this same portrait—ultimately derived, remember, from an 1851 daguerreotype— was reproduced on a special American first-day envelope: 'Honoring Lajos Kossuth, Champion of Liberty 1802–1894' (Fig. 38).

The nature of Claudet's stake, financial or political, in these representations of Kossuth is not known. However, he was certainly not the only one interested in being associated with this particular political celebrity. In November 1851, for example, William Henry Fox Talbot drafted a letter to newspapers in Britain (perhaps to be sent by his ex-valet Nicolaas Henneman) about a calotype portrait that Henneman's firm had taken of Kossuth in its Regent Street studio on 4 November. The letter informs editors that 'we have the pleasure of sending a copy of Kossuth's portrait which we have commenced publishing today, at the very low price of 15/ in order to bring it within the means of most of his admirers'. Talbot goes on to suggest that this is newsworthy because

> It has not been attempted before, as we believe, to publish an actual photographic portrait of any eminent individual, in a miniature case &c. At least such publication has not yet been attempted on a large scale. It would have been much easier, especially at this time of year, to have published a lithographic copy of the portrait but we presume that this would have been thought much less interesting than the actual photograph. We beg to add that the entire profits of this publication will be given to the Hungarian refugees.[190]

This last gesture was made, in fact, on the insistence of Kossuth himself as a condition of being photographed. Obviously, both he and his photographers and engravers recognised that modern politics (like modern business) is something to be waged through the circulation of images, as well as by other means.

Talbot's letter is also a reminder that the acquisition and circulation of photographic portraits was a competitive business, with celebrity sitters keenly sought after by commercial studios. On 20 April 1847, Henneman reported to Talbot (in his usual wayward spelling):

> I should have come up to day but the celebrated Authoress, Miss [Mary] Mitford, came to day and I got her to sit for her portrait, wish came out very fine considering her age, I think the negative is worth *at least* 25 pounds.[191]

At Mitford's request, he also photographed her dog, with an exposure time of four minutes. Copies of both photographs survive, although there is no evidence that Henneman was able to sell them to others. However, we know that his business (which he ran with a colleague, Thomas Augustine Malone) was at some point commissioned to make

Fig. 37
Thomas Phillibrown (engraver, USA), *L. Kossuth, Governor of Hungary by the peoples [sic] choice*, c. 1852.
Hand-coloured ink-on-paper print from engraving after a daguerreotype by Antoine Claudet studio (London),
c. November 1851. Collection of the author, Wellington.

Fig. 38
US Postal Service, *Honoring Lajos Kossuth, champion of liberty 1802–1894*, 1958.
First-day-of-issue envelope: ink-on-paper print on envelope with postage stamp, with image of Kossuth after a
daguerreotype by Antoine Claudet studio (London) in 1851, 9.2 × 16.5 cm. Collection of the author, Wellington.

a series of extraordinary salt-print photographs of ice skaters in action, all shot in a studio, which were then transformed into lithographed illustrations for an 1855 book by Lieutenant Robert Jones and William E. Cormack titled *The Art of Skating, Practically Explained*.[192]

Securing the likeness of celebrities was one way to ensure financial success. But good relations with the press were also crucial to a studio's survival and prosperity. Both Beard and Claudet frequently advertised in newspapers, at considerable cost. Beard, for example, placed no fewer than 131 notices in the *Times* between September 1846 and February 1847, as well as advertisements in local newspapers outside London.[193] Beard was also notorious for the lavish way in which he courted the good opinion of journalists. In a letter to Talbot written on 27 April 1850, Henneman's partner Malone wrote about their efforts to attract the press to their own portrait studio:

> We think of inviting the three journals just enumerated to see our Establishment. In that case the reporters must be treated liberally. Mr Beard has set a bad example on this head. He provides wine and costly viands for their refreshment and then gives them their portraits promising to take their friends into the bargain. All this is extravagant and not required.[194]

Claudet, as it happened, worked with Talbot's calotype process as well in daguerreotypy, paying Talbot a licence fee for the privilege. Among the portraits he made from a calotype negative was one listed in an album as being of 'George Pritchard in consul's uniform'.[195] Pritchard was a British missionary and diplomat who had recently returned to London from his post as consul in Tahiti, after the island had been annexed by France in 1843. He had just been appointed British consul for Samoa.[196] Claudet described the session with Pritchard in a letter to Talbot dated 20 August 1844, suggesting the often collaborative nature of their relationship. Talbot, it seems, had recently visited Claudet's studio to witness some of the Frenchman's experiments with the calotype process. Claudet told him what he had been working on since (Fig. 39):

> I am also sending you several specimens which have been made since you left. The negative (Head and shoulder shot of Miss Walter) was made using the new process & it is the only one which was a success. I have enclosed a positive of the same picture. The portrait of the man with a sword & dressed as a consul is of Pritchard. He came to have his picture taken with the Daguerreotype, & we took advantage

of the opportunity to make a Talbotype. The negative is very beautiful & we have obtained very good copies. The Turk is from life & I think that you will be satisfied with it. I still hope that it will work well but we must have time to make a name for ourselves & above all to perfect the technique.[197]

'The Turk' poses proudly in his native garb, arms crossed over chest, turban on head, looking sharply away from the camera. The hilt of a curved sword can be seen in silhouette behind him, just one more sign of his exoticism. No vintage positive print from this negative is known. The photographs taken of Pritchard, by contrast, soon reappeared in the form of an extensively coloured engraving issued by George Baxter. The engraving depicts the stalwart consul in his uniform, book in hand and sword by his side, shown as if sitting in his former residence in the royal palace in Tahiti, indicated by a scene appearing through the window behind him in which apparently grateful Tahitians return from a chapel service in an idyllic Bay of Papeete (Fig. 40).

Just in case the context was unclear, the print of Pritchard was accompanied by another, non-photographic, one, showing the celebrated Queen Pōmare of Tahiti as 'the persecuted Christian surrounded by her [surprisingly European-looking] family at the afflictive moment when the French forces were landing'. As a writer for the *Juvenile Missionary Magazine* reported, 'these two prints possess a high degree of interest at the present moment, and that interest will not soon abate'. Both these prints were, in short, of political import, as Baxter well knew. Reproducing a line engraving of the portrait of Pōmare, the same magazine continued:

> We heartily wish every Sunday-school Room and every Vestry could afford to have them. We trust they will obtain a large sale. They fully merit encouragement; and, as part of the profits is generously given by Mr. Baxter to the Boy's Mission School, Walthamstow, it will be all the more gratifying to us to find that the sale has been an extensive one.[198]

The sheet featuring Pritchard's portrait, which came with a facsimile of his signature, was designed and printed in numerous colours, via a complex process involving a combination of relief and intaglio methods, and was issued by Baxter's firm in London in 1845.[199] Many elements of the engraved image of Pritchard are very similar to the calotyped one, except that Baxter or his artists have raised and turned the consul's head a little, and given him a rejuvenating facelift. Despite these improvements, one writer claimed that 'the

Fig. 39
Antoine Claudet studio (London), *George Pritchard*, August 1844.
Salted-paper photograph from calotype negative, 11.4 × 8.9 cm (image). Courtesy of Hans Kraus Jr, New York.

Fig. 40
George Baxter (England), *George Pritchard / Her Britannic Majesty's consul. The scenery represents the Bay of Papeete, Queen Pomare's palace, the chapel, & natives returning from a week-day service. / Designed, printed in oil, & published by G. Baxter, Patentee II, Northampton Square, London*, 1845.
Coloured ink-on-paper print from an engraving based on a salted-paper photograph from calotype negative made by Antoine Claudet studio (London) in August 1844, 27.5 × 23.2 cm (image). Courtesy of Alexander Turnbull Library, Wellington.

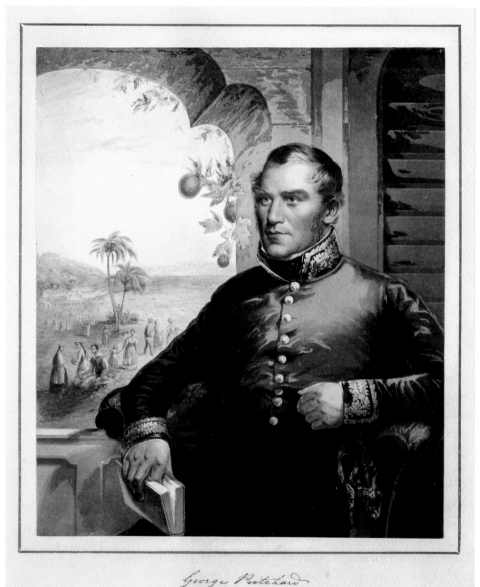

George Pritchard

HER BRITANNIC MAJESTY'S CONSUL.

THE SCENERY REPRESENTS THE BAY OF PAPEETE, QUEEN POMARE'S PALACE,
THE CHAPEL, & NATIVES RETURNING FROM A WEEK-DAY SERVICE

likeness of Mr. Pritchard is unexceptionably accurate. Every one who knows him will immediately recognize the resemblance.'[200]

It is possible that Baxter paid Claudet a fee for the use of this image, although unfortunately we have no substantial evidence regarding the nature of such transactions. Given that photographs were not yet covered by copyright legislation, it seems likely that publishers would have commissioned or bought a photograph outright and then had it traced or copied as a drawing onto a woodblock or steel plate, and the block or plate engraved. As none of these photographs has survived, it also seems likely that they were later discarded, or were destroyed by the copying process. Sometimes we get hints that a purchase of a photograph also entailed gaining some proprietary control of its image. For example, Claudet thought about exploiting the commercial possibilities of his portrait of Pritchard himself, but felt unable to do so. In a letter to Talbot dated 28 August 1844, he complained that 'the artist who brought Mr Pritchard recommended that I should not release his portrait until he has published it himself. As a consequence, I cannot make use of it'.[201]

Not long after this, Claudet decided to cut out middle-men like Baxter and become his own publisher. On 21 February 1847 Claudet sent a prospectus to his friend David Hastings, a journalist with the conservative newspaper *Morning Herald*, announcing his intentions to offer customers a gallery of daguerreotype portraits of eminent men, which would be transformed into lithographs and sold to interested members of the public. The photographer asks Hastings to 'put in a word' to promote Claudet's various portrait offerings (on occasions when he could not, Claudet jokingly calls Hastings a 'Socialist or something as bad'—the kind of joke that you only send to a close friend indeed).[202] In publishing them himself, Claudet sought to maximise any profits from his investment by exploiting the established market for pantheons of heroic portraits of public figures.

Earlier versions of this kind of series, such as William Jerdan's *National Portrait Gallery of Illustrious and Eminent Persons of the Nineteenth Century*, issued in 1829–33 and thus before photography, offered identically sized steel engravings based on paintings (by, for example, Thomas Lawrence, Henry Raeburn, and Joseph Wright of Derby) of eminent Britons from a variety of areas of accomplishment. Jerdan's series included idealised portraits of the Duke of Wellington, Lord Byron, Thomas Young, Humphry Davy, Richard Arkwright, William Wordsworth, Jeremy Bentham, Thomas Lawrence and David Brewster, among others (Fig. 41). Claudet's lithographs, in

contrast, targeted popular celebrities. According to the prospectus, his distinguished sitters were to include Lord Bentinck, the Marquess of Northampton, Lord Brougham, François Guizot, the singer Anna Thillon, Queen Victoria and other members of the royal family.

But Claudet also decided to offer a series of reproductions after his photographs of men of science. On 1 May 1849 the *Art-Journal* reported that Claudet 'has just issued a portrait of the able experimental philosopher Dr. Faraday [...] lithographed from a daguerreotype' (a photograph that had, in fact, been taken in February). 'The result', said the report, 'is a most faithful, unflattering resemblance to the celebrated original'.[203] In the daguerreotype of Faraday, we see the famous scientist seated in a chair, on which one arm rests in support, his body facing to his left but with his head looking intently to the right, towards but beyond the camera. This kind of pose, featuring a twist of the body that gives the sitter a sense of both volume and torque, works to animate an otherwise static portrait-sitting. The lithograph, drawn by William Bosley, closely follows the composition of Claudet's daguerreotype, presenting Faraday in an arched mat, lower body emerging out of darkness, face creased with lines, and hair persuasively dishevelled, all signs of photography's excessive and dispassionate capturing of information (Fig. 42).

According to the *Art-Journal*, 'We understand that Mr. Claudet intends from time to time to publish portraits of eminent scientific men from daguerreotype pictures in his possession.' And indeed, Claudet systematically photographed many of the leading figures in the sciences of his time, perhaps imagining himself to be among them. The surviving examples of these portraits (perhaps variants) were not coloured, reinforcing the idea that they were made with a view to being copied as lithographs for sale to the general public. These photographs were motivated, in other words, by a desire for their copies. Among those who came before Claudet's camera in this period were, for example, Faraday, chemist William Brande, Faraday and Brande together, astronomer George Biddell Airy, mathematician and inventor Charles Babbage, naturalist William Clift, Scottish chemist Thomas Graham, physicist William Robert Grove, visiting Danish physicist Hans Christian Ørsted, chemist Lyon Playfair, and Irish astronomer William Parsons Rosse.

Most of these daguerreotypes were converted into lithographs by Bosley, each appearing in an arched mat and looking off-camera, as if caught in mid-thought. The lithographed version of Airy shows

Fig. 41
T. Woolmoth (engraver, England), *Arthur Wellesley, Duke of Wellington*, 1829, in William Jerdan, *National Portrait Gallery of Illustrious and Eminent Persons of the Nineteenth Century*, Fisher, Son & Jackson, London, 1829–33. Ink-on-paper print from steel engraving after a painting by Thomas Lawrence, 25.5 × 20.5 cm. Collection of the author, Wellington.

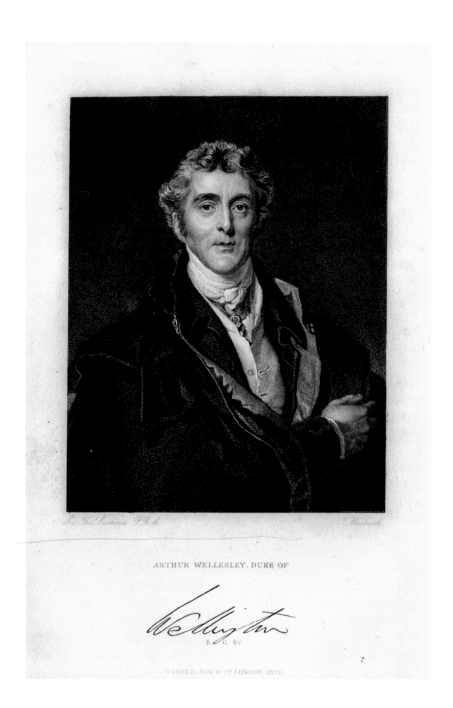

ARTHUR WELLESLEY, DUKE OF

FISHER, SON & C? LONDON, 1829.

Fig. 42
William Bosley (England), *Michael Faraday, 'from a Daguerreotype by Claudet'*, 1849.
Ink-on-paper lithograph after a daguerreotype by Antoine Claudet studio (London). Collection of Wellcome Library, London.

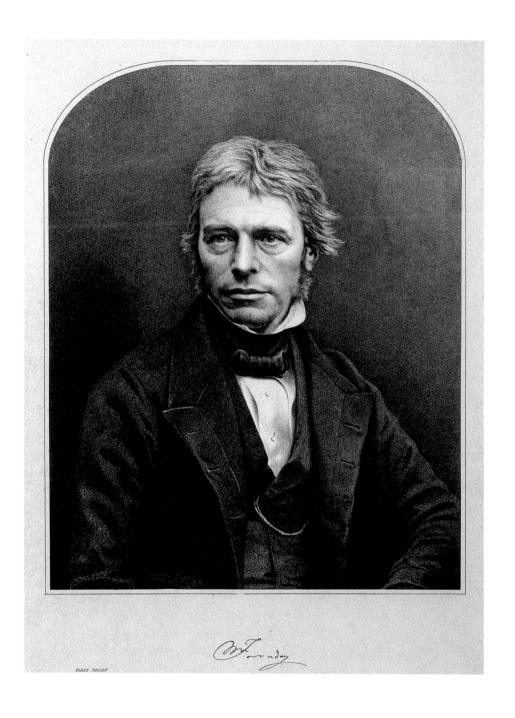

him in the kind of pose already described, looking across his body and holding a magnifying lens in his right hand. His head has been finely finished, closely matching his features as seen in Claudet's daguerreotype, but his body fades away at its extremities, thereby focusing attention on his most telling feature: the head that was the source of his intellect and exemplary character.[204] The caption underneath announces the sitter as 'Astronomer Royal'. An engraving in the same style, depicting geologist William Buckland examining a fossil shell, was published by Routledge & Co., and captioned as 'From a daguerreotype by Claudet' (Fig. 43). One could well compare the engraving to a lithograph of Buckland issued in 1849 by Thomas Herbert Maguire, also obviously based on Claudet's daguerreotype. Each iteration has its own distinctive pictorial qualities, but the presumed truth values of the source photograph are allowed to permeate them, thus proclaiming these prints to be a superior form of likeness than one dependent entirely on the traditional artist's eye and hand. Another print, this time a stipple engraving of Dr Playfair, president of the Chemical Society, is credited to both Claudet and artist Conrad Cook, and, like all these other examples, is accompanied by a facsimile of Playfair's signature, as if to underline the indexical authenticity of the photographically derived image.

As we have seen, studios actively competed to photograph celebrities, being very aware of the commercially advantageous publicity that might ensue. Charles Dickens, for example, was daguerreotyped by the first Beard studio, not long after it opened in 1841. He claimed he did not enjoy the experience, writing to his friend Angela Burdett-Coutts:

> If anybody should entreat you to go to the Polytechnic Institution and have a Photographic Likeness done—don't be prevailed upon, on any terms. The Sun is a great fellow in his way, but portrait painting is not his line. I speak from experience, having suffered dreadfully.[205]

Despite this initial suffering, Dickens was frequently photographed during his career. For example, Dickens seems to have been daguerreotyped by Claudet in about 1852, when the celebrated writer was forty years of age. Certainly, there is a daguerreotype of Dickens in a leather case stamped with Claudet's logo for the Quadrant studio, which had been established in June 1851. Dickens is standing, one hand resting on some gloves on a small round table and the other thrust into his pocket, turning as if to speak to someone just beyond the camera

(Fig. 44). Captured in a vertical half-plate image, his body visible from the knees up, a clean-shaven Dickens projects a dynamic and intellectually alert persona. Two very close variants of this portrait are known, one of them only as an engraving, both non-inverted and with only a slight difference in the position of the hand on the table to distinguish them. In about 1885, a photogravure based on one of these daguerreotypes was issued by J. Craig Annan and Donald Swan, with the sheet inscribed on its back: 'Charles Dickens—circa 1852, and, From a daguerreotype by Henri Claudet' (Fig. 45). Could this 'photo-engraved' image be based on a Claudet-made daguerreotype that was then posthumously copied by his son Henri and sold to Annan and Swan for the purposes of reproduction? We cannot know.

Given his penchant for publicity, it is strange that Claudet never spoke of having photographed Dickens, and that Dickens made no reference to Claudet. Dickens did, however, discuss sitting for a daguerreotype portrait at about that time. On 23 December 1852, he wrote to Burdett-Coutts to tell her he had again been daguerreotyped, five times in fact and by an 'artist' he considered a 'genius': 'I am disposed to think the portrait, by far the best specimen of anything in that way, I have seen.' He goes on to tell her that 'it is not come home yet, as it is waiting for a case'. Two days later, he sent her another letter, mentioning the same photograph:

> I cannot resist the temptation I feel to send you the result of the interview between myself and the Sun. I am so anxious that you should like it if you can. It came home last night.[206]

The photographer appears to have been John Jabez Edwin Mayall, whom Dickens paid £3 3s on 31 December for his trouble. The May 1853 instalment of *Bleak House* included a brochure for Mayall's two establishments, inviting the public to inspect his 'extensive Collection of Portraits of Eminent Men'. Earlier that year an issue of a journal owned by Dickens, *Household Words*, dated 19 March 1853, included an article titled 'Photography' written by William Henry Wills and Henry Morley. It recounts in detail a visit to the Regent Street studio of Mayall. Nevertheless, this essay also mentions Claudet several times:

> It is to M. Claudet that the public is indebted for the greater ease we now enjoy in photographic sittings, and it is the same gentleman who informs us that five minutes—not five-and-twenty—was the time required for the formation of a good picture on the plates prepared in the old way.[207]

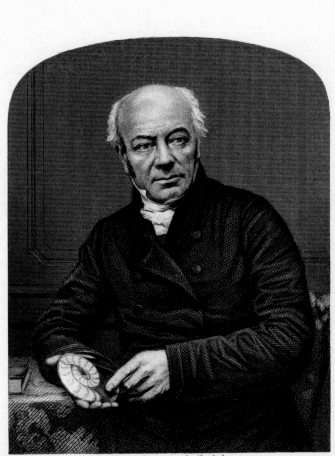

"*From a Daguerrotype by Claudet*".

London : George Routledge & C? Farringdon Street .

And so we are left with a conundrum. Could it be that the portrait attributed to Claudet was in fact taken by Mayall in late 1852, and then somehow found its way into a Claudet case? Or was Dickens a customer of the studios of both Claudet and Mayall in roughly the same period, with each producing quite different portraits? Further research needs to be undertaken to resolve the issue.[208]

The Beard studio made a portrait of at least one other prominent literary figure. At some point in the 1840s, playwright and author Douglas William Jerrold sat for a daguerreotype portrait made by a Beard operator. Much later, perhaps in 1857 when Jerrold died, the image was issued as a mezzotint engraving by John Sartain. The portrait is unremarkable, showing Jerrold seated but holding a cane and some gloves while staring obediently off-camera, a few books on the desk behind him indicating his professional accomplishments. Although hardly a great endorsement of photographic portrait-making, this transference to a print medium did, once again, allow the Beard studio's images to circulate among a wider public, in the process associating his studio with the more traditional creative arts.

In 1846, perhaps already suffering a reduction in income from his existing licensees, Beard decided to issue licences for photographers wanting to establish studios in London, studios that then competed with his own. Within a year, ten new studios had opened in the London area. The classified advertisements in the *Times* of 28 May 1846, for example, carried entries for Claudet's 'Coloured and Non-Inverted Daguerreotype Portraits' and Beard's 'Portraits, Landscapes, Copies of Paintings, &c, by the Agency of Light', but also for 'Mr. Bright's Daguerreotype Portraits' at 183 Strand and 'Mr. Joseph's Coloured Daguerreotype Portraits' at 62 Piccadilly, both 'under a licence from Mr. Beard'.[209] William Edward Kilburn opened another such studio at 234 Regent Street, London, on 9 February 1847 and soon became known for the refined poses and subtle colouring of his daguerreotype portraits. Another studio that would compete with those of Kilburn, Beard and Claudet was soon opened by John Jabez Edwin Mayall. Mayall, although born in Lancashire and claiming in later years to have made his first daguerreotype photograph in January 1840, began his professional photographic career in Philadelphia in 1842, returning to London only in June 1846. After working for a short time in one of Claudet's studios, Mayall opened his own at 433 West Strand in April 1847 under the memorable pseudonym of Professor Highschool. An essay in the *Athenaeum* of 17 April 1847 directly compared Kilburn's and

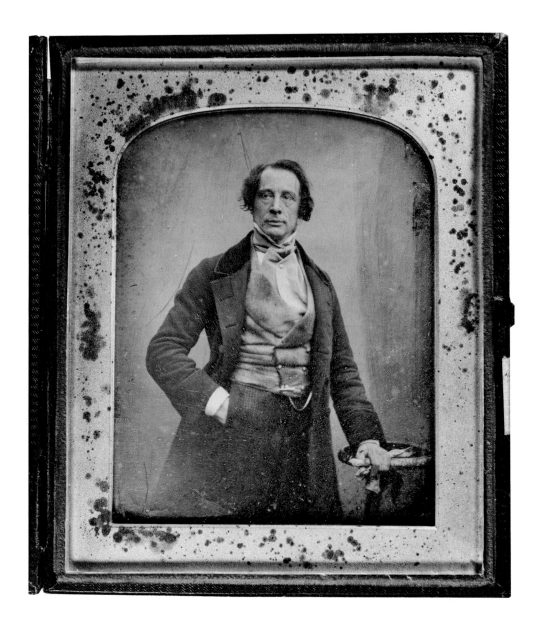

Fig. 45
J. Craig Annan and Donald Swan (engravers), *Charles Dickens*, c. 1885.
Ink-on-paper print from photogravure after a daguerreotype by the Antoine Claudet studio (London) from c. 1852.
Collection of the author, Wellington.

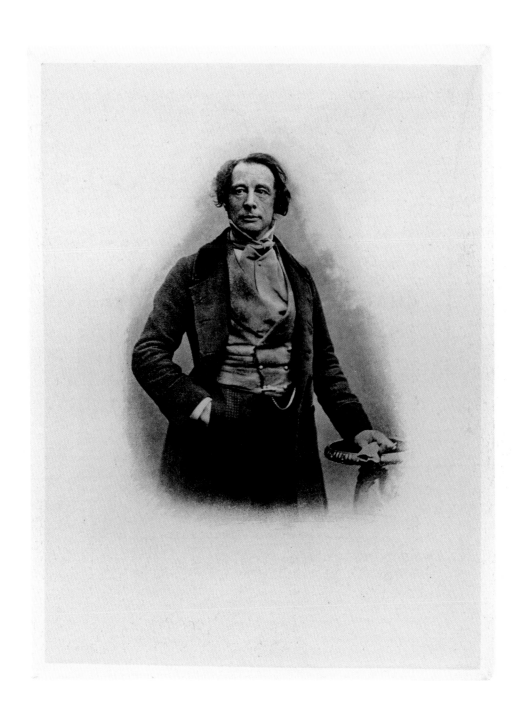

Fig. 46
Joseph John Jenkins (engraver, England), *Joseph Paxton*, c. 1851.
Ink-on-paper print from stipple and line engraving after a daguerreotype by William Edward Kilburn
studio (London), published by Peter Jackson, London & Paris, 11.5 × 8.7 cm (image). Collection of the
author, Wellington.

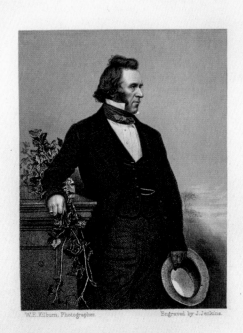

W.E. Kilburn, Photographer. Engraved by J. Jenkins.

PETER JACKSON, LONDON & PARIS.

Mayall's daguerreotypes, claiming that the 'two are conspicuous as having carried [heliographic art] to the highest perfection of which it has hitherto been deemed susceptible'.[210] Both practitioners went on to have their daguerreotypes translated into engravings (Fig. 46).

Portrait studios like those run by Kilburn and Mayall, in addition to Claudet's enterprises, must have put Beard's operations under increasing financial pressure. On 13 October 1849 the *Times* reported that Beard, who is described as a 'metallic plate manufacturer', had just declared himself bankrupt; one can only wonder at Claudet's reaction to this bit of news.[211] The declaration may well have been a ploy to escape creditors, as Beard continued in the photography business, calling himself a 'Photographic Artist' in the Census of 1851 and later trading under the name of his son, Richard Beard Jr. Indeed, Richard Jr opened a new studio in Liverpool in April 1849, advertising himself in the *Liverpool Mercury* as the 'Son of the Patentee of the daguerreotype', and another in Cheltenham on 19 October.[212] But Beard Jr had already established himself as a reputable photographer well before this. In July 1848, for example, the *Illustrated London News* published a number of wood engravings 'from daguerreotypes by Beard' of 'lords and ladies' dressed in historical costumes for a ball thrown by the Marchioness of Londonderry in aid of the Spitalfields School of Design (Fig. 47).[213] Four groups of sixteen costumed figures are featured across a double-page opening, displayed in shallow tableaux with ghostly hints of other figures and an architectural setting glimpsed behind. A review in the *Nottingham Mercury* on 6 October 1848 revealed that the photographer was Richard Beard Jr. The paper commended him for the quality of his work, calling it 'modern art combined with science' and pointing out that, in these pictures, 'swansdown on black is produced in the most exquisite style, and the finest white lace brought out in bold relief on a dress of white satin'.[214]

From this point on, many of the photographs ascribed to 'Beard' may well have been taken by or under the supervision of Richard Jr. Consider, for example, a half-plate daguerreotype depicting *The Tyrolese Minstrels: Klier, Rainer, Margreiter, Rahm, and Holaus of the St. James Theatre, London.* These players, one woman and four men, are shown in carefully tinted folkloric costumes and holding musical instruments, arrayed in the corner of a space with exposed ceiling beams, perhaps even the theatre itself. In a practice that was by now standard, a variant view was the basis of a wood engraving published in the *Illustrated London News* of 6 December 1851, captioned 'The Tyrolese Minstrels, from a photograph taken

Fig. 47
Smyth (engraver, England), *The Spitalfields Ball. Costume portraits, from daguerreotypes, by Beard*, 1848,
in *Illustrated London News*, 15 July 1848, p. 24.
Ink-on-paper print from wood engraving after daguerreotypes by Richard Beard Jr. Courtesy of
Alexander Turnbull Library, Wellington.

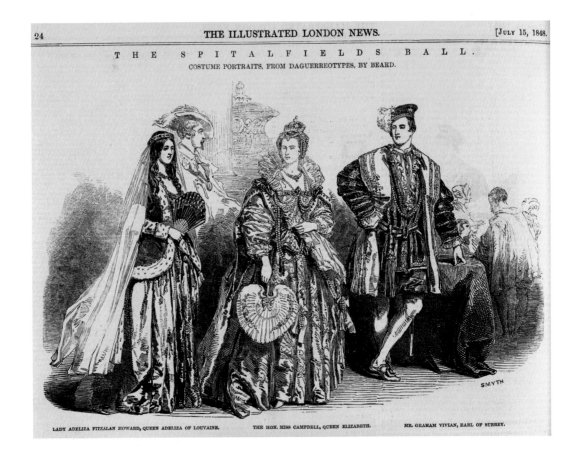

Fig. 48
Engraver unknown (England), *The Tyrolese Minstrels —From a photograph taken by Beard, by desire of H.R.H. The Duchess of Kent*, 1851, in *Illustrated London News*, 6 December 1851.
Ink-on-paper print from wood engraving after a daguerreotype by Richard Beard Jr. Courtesy of Alexander Turnbull Library, Wellington.

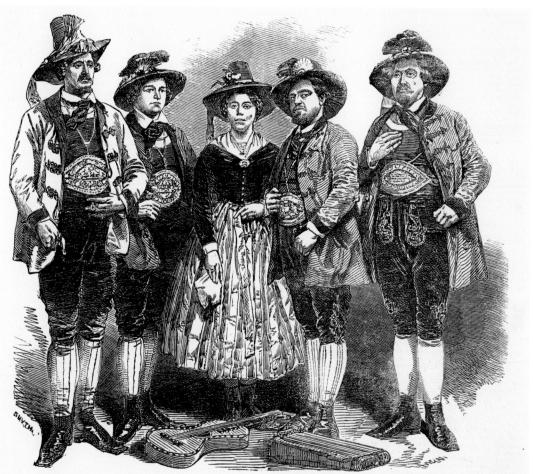

THE TYROLESE MINSTRELS.—FROM A PHOTOGRAPH TAKEN BY BEARD, BY DESIRE OF H. R. H. THE DUCHESS OF KENT.

by Beard, by desire of H. R. H. The Duchess of Kent' (Fig. 48).[215]
Apparently, Queen Victoria had first seen this troupe of Tyrolean
singers as a girl at Kensington Palace. For the Queen's birthday at
Osborne in 1852, her mother, the Duchess of Kent, arranged for the
singers to serenade her at breakfast. 'Victoria appeared very much
pleased with the surprise', the duchess wrote in her diary.[216] This
daguerreotype, enamelled according to Beard's patented formula,
was purchased by the Queen in the same year. It is signed 'R. Beard'
across the right-hand corner of the front of the plate, as if declaring
itself an artwork rather than a mere portrait.

Photography and The Great Exhibition

The Great Exhibition of 1851 was a particularly significant opportunity for photographic commerce of the kind being described here. Claudet advertised extensively in the *Official Description and Illustrated Catalogue of the Great Exhibition*, not only for his two studios, listing portraits of some of the 'Eminent Personages' he had on exhibition, but also for Claudet and Houghton's glass products, including shades, stained glass and window glass (a reminder that Claudet continued to be involved in the glass retailing business during his photographic career).[217] Both Beard and Claudet also made daguerreotypes related to the exhibition that were subsequently made into engravings and then printed in ink. These took various forms. The *Illustrated London News* printed eighteen portraits of the royal commissioners and members of the executive committee in a double-page opening on 18 October 1851, using wood engravings based on daguerreotypes taken by Claudet, Kilburn and Beard.[218] Publisher John Tallis subsequently issued a three-volume *History & Description of the Crystal Palace*, with steel-engraved illustrations taken from daguerreotypes by Beard (eight in all), Mayall and Kilburn, among others. Tallis complained in the 1852 introduction to the first volume of the substantial engravers' fees he had incurred during its production.[219] William Gaspey similarly issued a four-volume publication dedicated to the Great Exhibition, illustrated by engravings 'from daguerreotypes by Beard, Mayall, etc'.[220]

The *Illustrated London News* issued another of its commemorative panoramic prints, a *Grand Panorama of the Great Exhibition of All Nations 1851*, in this case comprising both fold-out pages in a standard issue and thirteen hand-coloured wood-engraved sheets mounted side by side on a 22-foot-long piece of linen, rolled around a wooden dowel. Each sheet was based on daguerreotypes of the interior of the exhibition, taken by an operator from the Beard studio. Published as a supplement to the *News* of 6 March 1852, the panorama showed frontal views of each side of the interior of the Crystal Palace, with distinct sections suitably captioned, and clusters of figures added to give interest to an otherwise drab

set of facades (Fig. 49). The most interesting sections, pictorially speaking, are where the transepts of the building cross the main body, resulting in deep recessions in the otherwise flat scene of the panorama. The taking of photographs of the interior of the Great Exhibition was restricted to between 6 a.m. and 9 a.m., before it opened to the public, or on Sundays, when it was otherwise closed. Dependent on good lighting conditions, photographers must have found these temporal constraints difficult to negotiate. And it means that any figures found in the resulting wood engravings have been added by the engraver.

Claudet's studio also contributed a number of striking images. An issue of the *News* dated 26 July 1851 featured a view of 'The Carriage Department—from a daguerreotype by Claudet' in which we see, as if looking from an upper storey, rows of carriages receding into the background, surrounded by admiring visitors.[221] In its issue of 6 September 1851, the *News* included two very detailed full-page wood engravings of views of the interior of the east and west naves of the exhibition, captioned as 'from a daguerreotype by Claudet' and printed on facing pages.[222] These images show the iron-and-glass structure of the Crystal Palace receding into the background, its vast interior spaces crowded with exhibits and people. The lower bays bear signs indicating the location of national displays (India, Persia, Egypt, Greece, Turkey), while the upper bays have similar signs for displays dedicated to particular materials (silk, wax flowers); both prints include signs perpendicular to these, saying 'To The Galleries', with arrows pointing to the left (Fig. 50).

These two large views were engraved on six small blocks joined together (the joins dimly discernible on the print as fine white lines). Gerry Beegan has speculated that

> the daguerreotype which was used as a reference for the building was enlarged and traced by a draftsman on to the block [...] The figures in the image may be based on drawings done at the Exhibition or more likely are drawn from imagination. What is noticeable is that figures are repeated a number of times indicating that tracings were used [... Given that the tonal range is near to that of a photograph] it may be that not only did the draftsmen trace the outlines of objects and structures in the original photographs but they may have placed areas of tonal wash for the engraver to follow.[223]

Fig. 49
Engravers unknown (England), *Grand panorama of the Great Exhibition*, 1851, in *Illustrated London News*,
24 January 1852, pp. 80–1.
Ink-on-paper print from wood engravings after daguerreotypes by Richard Beard Jr. Courtesy of
Alexander Turnbull Library, Wellington.

Fig. 50
Engravers unknown (England), *The Great Exhibition: The east nave.—viewed from the south-western gallery —(from a daguerreotype by Claudet)*, 1851, in *Illustrated London News*, 6 September 1851, p. 296. Ink-on-paper print from wood engravings after daguerreotype by the Claudet studio (London). Collection of the author, Wellington.

THE GREAT EXHIBITION.—THE EAST NAVE VIEWED FROM THE SOUTH-WESTERN GALLERY.—(FROM A DAGUERREOTYPE BY CLAUDET.)

Fig. 51
Engraver unknown (England), *The Chinese family, in the exhibition at Albert Gate. From a photograph by Beard*. 1851, in *Illustrated London News*, 24 May 1851, p. 450.
Ink-on-paper print from wood engraving after a daguerreotype by Richard Beard studio (London).
Courtesy of Alexander Turnbull Library, Wellington.

THE CHINESE FAMILY, IN THE EXHIBITION AT ALBERT GATE.
FROM A PHOTOGRAPH BY BEARD.

Indeed, Beegan suggests that the introduction of wood engravings after daguerreotypes resulted in the adoption of new 'abrupt and disjointed' codes of representation, with the earlier linear web of engraved lines being gradually replaced with 'a tonal code using shorter strokes and scratches'.[224]

Photographs from the Beard studio were also used as the basis of wood engravings of detailed scenes from the Great Exhibition in the same journal, including, for example, 'The Chinese family at the Crystal Palace Exhibition' (which appeared in the *Illustrated London News* on 24 May 1851) (Fig. 51).[225] Chung Atai, 'a Chinese professor of music', and his family were apparently visiting London from Canton specifically to take part in the Great Exhibition.[226] Charles Dickens' *Household Narrative of Current Events* reported that the family was invited to visit Queen Victoria, during which visit 'the elder consort of Chung-Atai presented her Majesty with a beautifully executed daguerreotype, by Beard, of the interesting Chinese group'.[227] A later issue of the *News*, from 25 October 1851, featured another exotic portrait: 'The Esquimaux Erasmus York—from a daguerreotype by Beard'.[228] Once again, Claudet made some similar kinds of pictures. For example, the issue of the *Illustrated London News* dated 21 June 1851 featured two wood-engraved views of exhibits, of 'Pottery—by Messrs. Minton' and of a 'Case of furs' by George Smith & Sons, 'especially the several kinds of sable', both captioned as 'from a daguerreotype by Claudet' (Fig. 52).[229] These otherwise undemonstrative frontal views have again been animated in the engraving by the addition of a throng of admirers—men, women, children and even some foreign visitors in robes—peering at the exhibits. If nothing else, Claudet's images confirm the fetishisation of the commodity that was the Great Exhibition's singular attraction, turning that spectacle into a picture to be gazed at in its turn.[230]

Perhaps the most remarkable of the exhibits daguerreotyped by Claudet at the Great Exhibition appeared as wood-engraved copies in the *Illustrated London News* on 26 July 1851.[231] Captioned 'Stuffed Cats' and 'Stuffed Frogs', and both listed as 'From Wirtemburg—From a Daguerreotype by Claudet', the images feature animals posed in unexpected juxtapositions, with the cats (really ermines, hence the elongated bodies) sipping tea while one of their number plays the piano, and the frogs shown in the act of being shaved and promenading under an umbrella (Fig. 53). These sets of animals were prepared for anthropomorphic display by Hermann Ploucquet, a taxidermist at the Royal Museum in Stuttgart. As one scholar has commented:

Fig. 52

Engraver unknown (England), *Cases of furs, showing especially the several kinds of sable.—By Smith and Sons, Watling-Street.—From a daguerreotype by Claudet*, 1851, in *Illustrated London News*, 21 June 1851, p. 599.

Ink-on-paper print from wood engraving after a daguerreotype by Antoine Claudet studio (London).

Courtesy of Alexander Turnbull Library, Wellington.

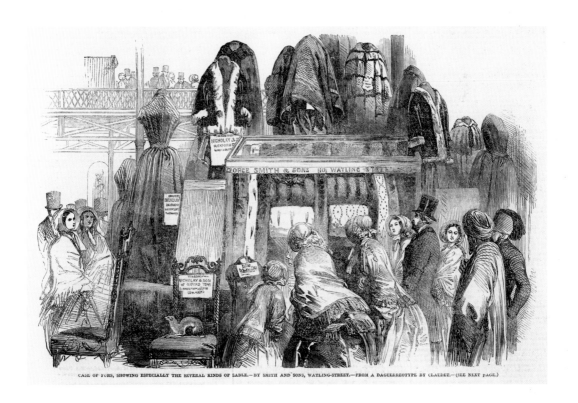

CASE OF FURS, SHOWING ESPECIALLY THE SEVERAL KINDS OF SABLE.—BY SMITH AND SONS, WATLING-STREET.—FROM A DAGUERREOTYPE BY CLAUDET.—(SEE NEXT PAGE.)

Fig. 53
Harrison Weir (engraver), *Stuffed cats—from Wirtemburg. —from a daguerreotype by Claudet*, 1851,
in *Illustrated London News*, 26 July 1851, p. 133.
Ink-on-paper print from wood engraving after a daguerreotype by Antoine Claudet studio (London).
Courtesy of Alexander Turnbull Library, Wellington.

STUFFED CATS.—FROM WIRTEMBURG

A DAGUERREOTYPE BY CLAUDET.

At the Great Exhibition commodities were always sliding from autonomy into solipsism, and each and every commodity had its cult of viewers (the German stuffed frogs were the most prominent of these commodity cults).[232]

And indeed, these displays proved to be wildly popular. The *Morning Chronicle* reported on 12 August 1851:

> We have on more than one occasion—and we have not by any means been singular in that respect—directed the attention of visitors to the Exhibition to the consummately clever collection of stuffed animals, or miniature representations of animals, engaged in performing human occupations, and seemingly influenced by human motives, hopes, and fears.[233]

The stall at which Ploucquet's creations were exhibited was apparently 'one of the most crowded points of the Exhibition', perpetually surrounded by a 'merry crowd'. Queen Victoria herself described them in her diaries as 'really marvellous'.[234]

London-based publisher David Bogue soon recognised that this popularity might be exploited for financial gain. Before the Great Exhibition had even closed, he issued a book of twenty wood engravings of Ploucquet's tableaux, titled *The Comical Creatures from Wurtemberg*. Apart from a series of accompanying texts describing the stories that the tableaux were supposed to be illustrating (the frogs were rivals for the attention of a young lady frog), Bogue contributed a preface implying that he was the one who had commissioned Claudet to take his photographs:

> That these clever productions of Ploucquet's talent may be long perpetuated, we had daguerreotypes of them taken by Mr Claudet, and engravings made from them on wood as faithfully like as possible. We must beg our readers to remember that our sketches were written to illustrate the drawings, for on this plea we claim some indulgence; but as we know full well that the pictures are the main attraction of the volume, we are not apprehensive of much criticism.[235]

Buyers eager to remember their visit to the Great Exhibition could purchase a copy at a price of 3s 6d or, for another 6s, a later edition with the plates coloured (Fig. 54). This second edition included comments on its earlier version, gleaned from the popular press,

Fig. 54
Harrison Weir (engraver), *The kittens at tea—Miss Paulina singing*, 1851, in *The Comical Creatures from Wurtemberg*, David Bogue, London, 1851.
Hand-coloured ink-on-paper print from wood engraving after a daguerreotype by Antoine Claudet studio (London) at the Great Exhibition in 1851.

THE KITTENS AT TEA——MISS PAULINA SINGING.

with the extract from the *Examiner* of 2 August noting the two-step manner of the production of its 'pleasant contents': 'It was a good notion, that of perpetuating these clever productions by means of daguerreotype and wood-engraving. They are very nicely executed in this volume, and wonderfully like.'[236] Interestingly, the version of Claudet's image in the book, captioned by Bogue 'The frogs who would a-wooing go', has had the background and its 'lady frog' reversed, now being shown through an arched doorway walking in a landscape, rather than on a roadway, as in the *Illustrated London News*. Indeed, one gets the impression that the version in the *News* is closer to the daguerreotype original, with Mr Bogue's engraver having made a number of modifications to the setting, pose and expression of the frogs in question. Once again, it appears that the rhetorical force of the phrase 'from a daguerreotype' was more important than the descriptive accuracy it implied.

By now, photographic images were a common feature of the illustrated press, even though they were always in a distinct minority. Sometimes, as we have seen, engravings after photographs were granted their own pages, or even a double-page opening, giving them a particular visual prominence. More often, though, a photographic image would find itself surrounded by engravings based on drawings, just one illustration among many others. A pioneer in this respect, the *Illustrated London News* continued to regularly display such images, not only in its pages, but also in the windows of its offices as a way of advertising each new issue. Indeed, by Christmas 1854, the *News* was advertising the fact that 'in many cases the photographic process is employed' as a source of its engravings, thereby associating these pictures with a transformative modernity:

> The means by which the Gallery of Pictures in the ILLUS TRATED LONDON NEWS is produced, present striking instances of rapidity, skill and truthful representations, such as can only be ensured in an age whose scientific triumphs, it has been said, bid fair to 'annihilate time and space.' The Steamboat, the Railway and the Daguerreotype have greatly aided the genius of Art in the execution of the enterprise which first projected the ILLUSTRATED LONDON NEWS, in which Pictures and Letterpress possess the same living interest.[237]

Photography and Empire

Photographic images from London would have been seen throughout the British Empire in the pages of the *Illustrated London News* and similar organs. But this dissemination of images flowed in both directions. Consider, for example, the fate of the work of an English-born photographer operating in Melbourne, Australia. Douglas T. Kilburn (brother of Edward Kilburn) arrived in 1847 to establish that city's second commercial photography studio, very probably having been licensed to do so by Richard Beard. Kilburn is remembered today primarily for a series of ten daguerreotypes he made of local Aboriginal people in about October of that same year (Fig. 55). At least one of those daguerreotypes was placed in a gilt brass Wharton tray of the type used by the Beard studios, and another was re-photographed to make a daguerreotype copy, again using a technology originally associated with Beard.

It is often said that these are the earliest extant photographic images of Indigenous Australians. But this is true only if you exclude from such a claim any images made *after* photographs, such as the ones titled *Bourrakooroo & Ménalarguerna* and *Guenney & Timmey* that appeared in the illustrative supplement to Jules Sébastien César Dumont d'Urville's *Voyage au pôle sud et dans l'Océanie ...* of 1842–47 (Fig. 56).[238] These particular pictures enjoy a complex lineage, involving a series of exchanges between media, maintaining their visual authenticity only through our own shared investment in the power of the indexical sign. They are lithographic reproductions of daguerreotypes made in 1841–42 by French photographer Louis-Auguste Bisson. These daguerreotypes were taken of plaster busts, usually impressed from life-casts of men and women encountered in Australia and the Pacific. The life-casts, taken from the heads of at least fifty-one people, were made by phrenologist Pierre-Marie Alexandre Dumoutier during the French explorer Jules Dumont d'Urville's last voyage through the Pacific between 1837 and 1840. The casts, equivalent to a negative or matrix, were then taken back to Paris, where they were used to generate three-dimensional plaster positive impressions, which were then photographed.[239]

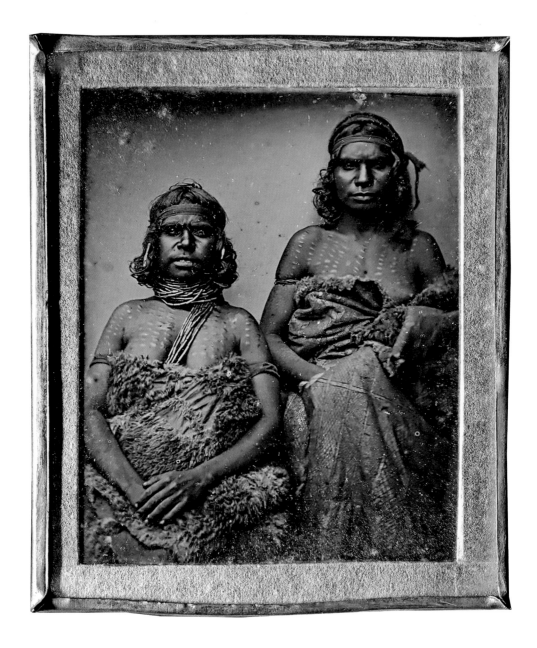

Fig. 56

August-Hilaire Léveillé (France, lithographer), *Guenney / Natif de Port-Sorelle, (Comté de Dévon.) / Côte-Nord de la terre de Van Diemen. (Mélanésie.), Timmey / Natif de la Vallée de George's River, Comté de Cornwell, / Côte-Est de la terre de Van-Diemen, (Mélanésie), Lithé. par Léveillé d'áprès les bustes modelès sur nature photographié par Bisson / sous la direction de Mr le Dr Dumoutier, Lith de Thierry Frères à Paris,* 1842–47, in Jules Dumont d'Urville, *Voyage au pôle sud et dans l'Oceanie.* Part 2, *anthropologie et physiologie humaine,* Gide, Paris, 1842–47, plate 22.

Ink-on-paper lithographs after daguerreotypes of plaster casts taken by Louis-August Bisson in Paris in c. 1842 under the direction of M. Dumoutier, 33.0 × 53.0 cm (sheet). Collection of National Gallery of Australia, Canberra.

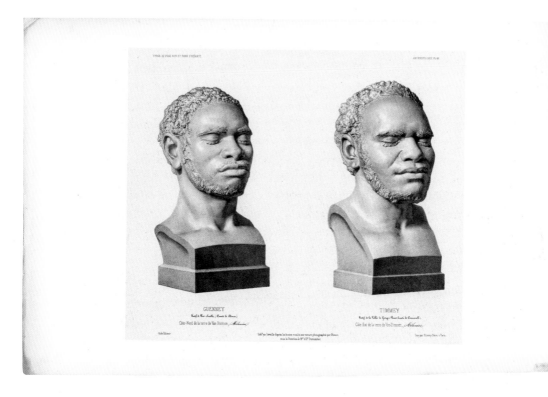

D'Urville's vessel, the *Astrolabe*, reached Hobart in Van Diemen's Land (now Tasmania) in late 1839, and thus before anyone on board would have heard of photography's invention. Perhaps finding it difficult to persuade any local Indigenous people to undergo the invasive life-casting procedure, Dumoutier acquired two portrait busts of Woureddy and Trucanini made in 1835–36 by the sculptor Benjamin Law. The images of Guenney, Timmey and other Tasmanian people may have been derived from a similar source. In Otago in New Zealand, by contrast, Dumoutier was able to persuade a Māori man and his wife (her face scratched, perhaps in a ritual display of grief) to have their heads cast in plaster in exchange for a uniform jacket; another agreed to the procedure in return for medical services (Fig. 57).

As a consequence of the life-casting process, which served as a model no matter how the plaster busts were produced, these people are all shown in a state of perpetual slumber, faces calm and eyes closed against both the onslaught of colonialism and the passing of time, as if they have been cryogenically preserved for some unknown future (the future that is now). Historical ghosts, made visible only through a dizzying series of transmutations involving a variety of dimensions and media, these lithographs remind us that a continual oscillation of blindness and insight, absence and presence, is at the heart of all photographic images. And among those absent presences are not just these long-dead men and women, but also the daguerreotypes on which the veracity of these lithographs is dependent, as they again disappeared during the process of their transformation. Eyelashes, tattoos and creases in the skin are all indiscriminately captured for posterity, probably by tracing directly over Bisson's daguerreotypes (phrenologist Emile Blanchard used the word *calquées* or 'traced' when describing the process in an accompanying text), and thereby irreparably damaging them.

Photographed in a consistent three-quarter view to facilitate comparative phrenological study, but captioned with individual names, these busts are presented as portraits as much as ethnographic exemplars. In contrast, Kilburn's series seems to have been motivated by commerce rather than by science, with the photographer having to offer bribes to get his subjects into his studio; none of them consented to come a second time. I think we can assume these daguerreotypes were taken to certify Indigenous Australia's presumed otherness, pictured for the perusal of curious European eyes precisely because Aboriginal people were believed to represent everything that civilised people were not. Kilburn's pictures show their subjects in contemporary

Fig. 57

August-Hilaire Léveillé (lithographer, France), *Taha-Tahala & Heroua: Natifs de Otago, Ile Tavaï-Pounamou, Nlle Zélande (Polynésie), Lithé par Léveillé d'après les bustes moulés sur nature photographié par Bisson sous la Direction de Mr le Dr Dumoutier, Lith de Thierry Frères à Paris*, 1842–47, in Jules Dumont d'Urville, *Voyage au pôle sud et dans l'Océanie. Part 2, anthropologie et physiologie humaine*, Gide, Paris, 1842–47, plate 13.

Ink-on-paper from lithograph after daguerreotypes by Louis-August Bisson of plaster casts of life masks made during Dumont d'Urville's visit to Otago in 1840, 33.0 x 53.0 cm (sheet). Courtesy of Alexander Turnbull Library, Wellington.

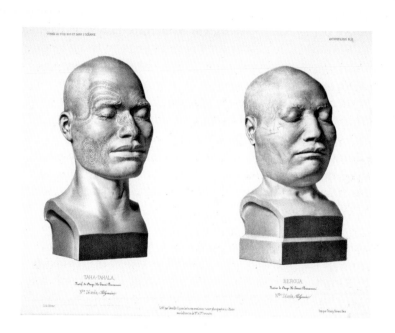

dress—a mixture of animal skins, European blankets, ornaments and scarification—holding wooden boomerangs and digging-sticks. They speak, therefore, of the complex situation of these people in 1847, forced to negotiate a new world of cameras, pastoral leases, rapid urbanisation and unfamiliar European customs—among them, the ethnographic portrait and systematic genocide.

Although daguerreotypes are unique and relatively fragile objects, these particular images were frequently circulated in other media, thus enjoying a significant afterlife and wide dispersal. The Australian painter Eugene von Guérard, for example, somehow got hold of one of these daguerreotypes and in 1854 made a watercolour sketch based on it. Similarly, one of the thirty-six drawings of Aboriginal people made between 1840 and 1848 by John Skinner Prout seems to have been informed by a Kilburn daguerreotype. But these were also images that soon travelled abroad, appearing as wood engravings in foreign publications, first in a book about Australia published in 1848 in Edinburgh (where a sex-change was engineered for one of the figures) and then, in a further translation of this first engraving, in a Danish magazine in 1849, under the heading 'Wild Australians'.[240] By 1851 illustrations after these daguerreotypes had even found their way into an Indian journal: *Orunudoi: A Monthly Magazine Devoted to Religion, Science, and General Intelligence* (Fig. 58).[241]

But these daguerreotype images perhaps found their widest audience when a number of them were reproduced as wood engravings in a 26 January 1850 issue of the *Illustrated London News*, with an accompanying text that expressed the usual racial prejudices of the time (Fig. 59).[242] This, then, is how most residents of Australia would have seen these photographic images—as engravings rather than daguerreotypes, and at the end of a temporal, spatial and representational arc that took them from Melbourne to Scotland, Denmark, the United Kingdom, India, and back to Australia, via the pages of imported copies of this popular English newspaper (which, by this time, had a circulation of 67,000 copies, soon to climb to 123,000).[243] The fate of these images highlights what this new hybrid medium of photographic engraving transmitted throughout modern culture: a continual splicing of real and copy, here and there, us and them, life and death, time and space—in short, a disintegration of all those oppositional boundaries that too many of our histories of photography continue to maintain and defend through a privileging of the singular photograph.

Fig. 58
Engravers unknown (India), *Young man and woman of Australia—from the* Illustrated London News, in
'Geography of Australia', *The Orunudoi: A Monthly Magazine Devoted to Religion, Science, and General
Intelligence*, 1851, front cover.
Ink-on-paper print from wood engraving after the *Illustrated London News*, 26 January 1850. Courtesy
of Gael Newton, Sydney.

৭ বচৰ । মোং সিৱসাগৰ, জানুআৰি, ১৮৫১ । নম্বৰ ১১

VOL. VI. SIBSAGOR, ASAM, JANUARY, 1851. NO. I.

অষ্ট্ৰেলিয়াৰ বিবৰন ।

Geography of Australia.

দক্ষিন পাচিফিক সাগৰত অষ্ট্ৰেলিয়া নামে
এখন বৰ উপদিপ আচে, পুৱা পচিমা দিঘে
২৪০০ মাইল, বহলে ২০০০ মাইল, মা-
টিৰ জোখ প্ৰায়ে ত্ৰিচ লাখ বৰ্গমাইল ।
 ১৬০৫ সঁকত হলণ্ড দেশৰ জাহাজৰ দো-
আৰাই সেই বৰ দিপ দেখা পোআ হল :

সিহঁতে তাক নুহলণ্ড অৰ্থাত নতুন হলণ্ড
নাম দিলে । পাচে ১৭৭০ সঁকত কাপ্তান
কুক চাহাবে তাৰ পুৱ ফালে উঠি ইঙ্গলণ্ড
মহা ৰজাৰ নামেৰে দেশ লৈ তাৰ নিউ চৌত
ওএলচ নাম থলে । ১৭৭৮ সঁকত ইঙ্গলণ্ডৰ
লোকে তাত চিদ্নি নামে এখান নগৰ থাপন
কৰিলে ; আৰু তাত ইঙ্গৰাজিৰ পূজা হবৰ
নিমিতে দেশান্তৰ কৰা কইদিবিলাকক তালৈ

অষ্ট্ৰেলিয়া দিপৰ আদি হাসি মুনিহ তিৰোতাৰ নকচা ।
Young Man and Woman of Australia.—From the Illustrated London News.

A ²
৫০৩

Fig. 59
Engraver unknown (England), *Aboriginal Australians—Young Men, Aboriginal Australians—Old and Young Man, Daguerreotyped in Port Phillip by Mr. Kilburn, Australia Felix*, 1850, in *Illustrated London News*, 26 January 1850, p. 53.
Ink-on-paper print from wood engravings after 1847 daguerreotypes by Douglas Kilburn (Melbourne), 40.4 × 27.5 cm (sheet). Collection of the author, Wellington.

JAN. 26, 1850.] THE ILLUSTR

ABORIGINAL AUSTRALIANS—YOUNG MEN. DAGUERREOTYPED

PHILLIP BY MR. KILBURN. ABORIGINAL AUSTRALIANS—OLD AND YOUNG MAN.

Photography and Identity

My emphasis on photography's reproducibility necessarily bears on the question of identity, on the question of what a photograph is. You would think that Claudet, of all people, would be able to answer this question for us. After all, he was a pioneering photographer who depended for his living on the making and selling of photographs. Or did he? What exactly did Claudet believe he was selling? The answer, once again, is complex, a complexity that invites us to reflect on the identity—and even on the substance—of the photographic medium itself.

Consider, for example, the journey taken by one particular photographic image of the Duke of Wellington, a daguerreotype mentioned earlier. The photograph shows the duke, then aged seventy-five, sitting against a plain background and looking to his right, beyond the camera. It was made, so the *Times* of London tells us, on the occasion of the duke's birthday—1 May 1844—at Claudet's Adelaide Gallery studio (Fig. 60).[244] Interestingly, a few months later Claudet's long-term assistant, Edward J. Pickering, claimed that *he* had taken the portrait.[245] Apparently, the duke dropped by the studio 'accidentally', without forewarning, which perhaps explains the absence of the studio proprietor on the day. But, whoever operated the camera, one can presume that a number of near-identical daguerreotypes were made during this sitting, given Claudet's habit of photographing his clients with two cameras placed side by side.[246] One daguerreotype would have been given to Wellington, and one would have been kept by the photographer for promotional purposes (a daguerreotype of Wellington was, for example, exhibited by Claudet at the *Manchester Art Treasures* exhibition in 1857).[247]

We know that another of these portraits went through various permutations, resulting in its proliferation in a variety of media. In 1845, for example, a Claudet daguerreotype of the duke was sold to publisher James Watson. Watson then lent this daguerreotype to the painter Abraham Solomon, who used it to produce an enlarged oil-painted portrait (Fig. 61). Both this painting *and* the daguerreotype were subsequently lent to Henry Thomas Ryall, who used them to make a steel

Fig. 60
Edward J. Pickering, for Antoine Claudet studio (London), *The Duke of Wellington*, 1 May 1844.
Daguerreotype in frame, 7.8 × 6.4 cm (image). Wellington Collection, Stratfield Saye House, UK.

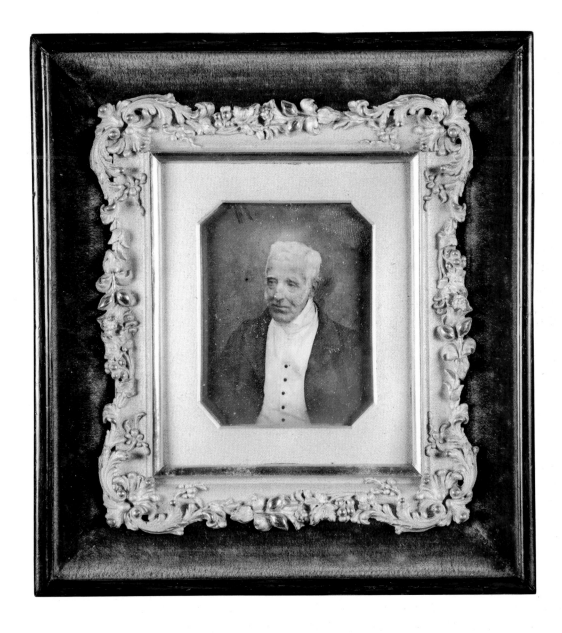

Fig. 61
Abraham Solomon (London), *The Duke of Wellington*, 1844.
Oil on canvas, 52.5 × 47.5 cm. Collection of English Heritage, Walmer Castle.

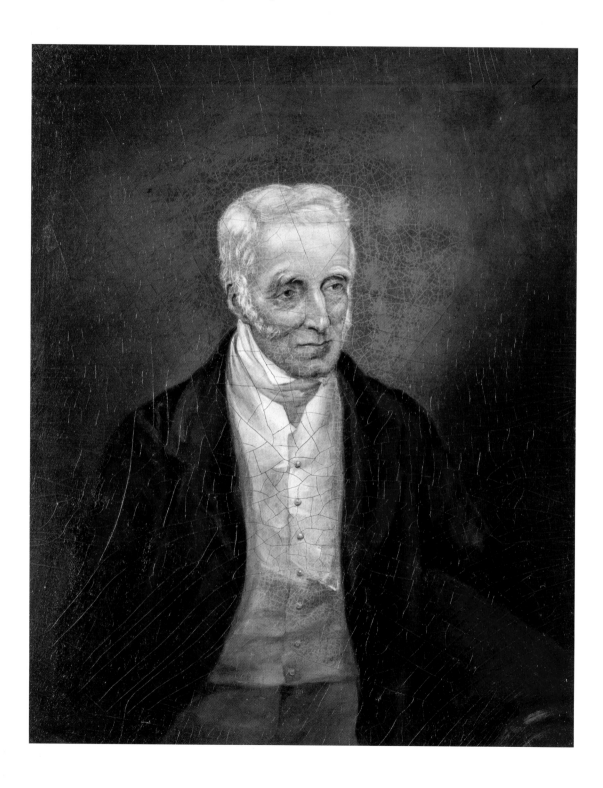

Fig. 62
Henry Thomas Ryall (engraver, London), *Field Marshall, the Duke of Wellington K.G.*, 1 May 1845.
Ink-on-paper print from stipple engraving published by J. Watson after a daguerreotype by Antoine
Claudet studio (London) and a painting by Abraham Solomon, 20.6 × 16.2 cm (image). Collection of the
author, Wellington.

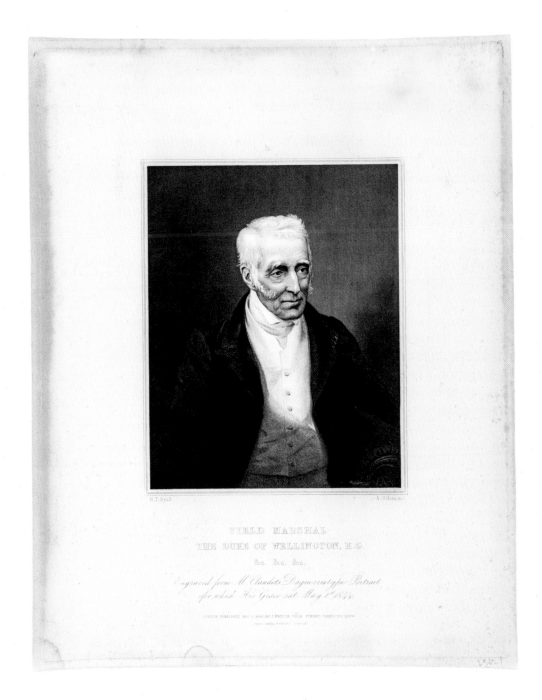

engraving. The engraving faithfully imitates the composition and details of the daguerreotype, but reverses the orientation of the duke's body, so he is now looking off to his left (Fig. 62). According to the *Times*, 'the engraving has been principally made from the daguerreotype portrait, the work of Mr Solomon being used to correct those defects which of necessity arise in all daguerreotype portraits'. Supposedly 'a simple result of the union of science with art', this particular image was described by the reporter for the *Times* as

> a likeness surpassing in fidelity both the original daguerre-
> otype and the painted copy; in short, a likeness so true to
> nature and so complete a translation of the features, charac-
> ter, and very look of the illustrious Duke, that nothing but the
> reflection of the face of his Grace in a mirror can surpass it.[248]

This stress on the veracity of the portrait, even to the point of it being unflattering, was, as already noted, in accord with the fashion for unembellished directness in public portraiture, a fashion informed by the sciences of physiognomy and phrenology. It helps to explain why it was important that a photograph be at the origin of these portraits, even if that origin was some distance away. A reporter for the *London Evening Standard* of 6 June 1845 was again enthusiastic in his description, arguing that: 'It is not too much to say, in the most emphatic language it is possible to use, that this likeness will take precedence of all others which have been published.' According to this reporter, 'the character of [the duke's] countenance is admirably preserved, and the light smile which plays upon his features recalls vividly his ordinary aspect'. The article stresses the role of the daguerreotype in the production of this print, calling for a national gallery of such portraits to be made:

> It is a matter of congratulation, that the daguerreotype
> process was in this instance so perfectly satisfactory; not
> a trait of the original man has been lost, for the image of the
> great duke has been seized and retained with a literalness
> and individuality about which there can be no dispute.[249]

Notice that, as far as these writers are concerned, the photograph is still there, its indexical fidelity embedded somewhere in the identity of the engraved print, giving that print an added veracity and value.

Claudet kept a copy of Ryall's print on the wall of his studio, as if to permanently advertise his association with the great man. A framed version of the print appears, reversed, in a stereo-daguerreotype

Fig. 63

Antoine Claudet studio (London), *The Duke of Wellington, copy daguerreotype of 1 May 1844 daguerreotype*, c. 1852. Daguerreotype, 7.8 × 6.4 cm. Collection of J. Paul Getty Museum, Los Angeles.

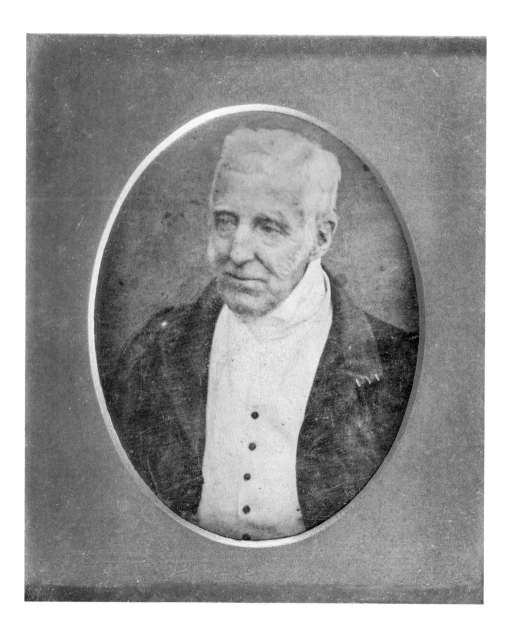

from about 1852 showing members of the Claudet family lounging about a pseudo-domestic space (the scene depicts four women and one man, possibly the photographer's son Francis George Claudet).[250] However, a story in the *Illustrated London News*, published on 13 November 1852, tells us that the duke himself was not particularly impressed by the print, perhaps because it was indeed 'so true to nature'. Apparently, 'he looked at it for a moment, shook his head, and, with a half smile and half frown of recognition, muttered "Very old! Hum!" and turned away in thought.'[251] The duke was no doubt reminded that, as an indexical trace of its subject, every photographic image marks the passage of time between the moment of its making and the moment of its viewing. Representing above all else this passing of time, it also predicts our own passing, at some time in the not-too-distant future. Every photograph is therefore both a certification of life and a prediction of death. No wonder the duke turned away with a frown!

This was by no means the end of Claudet's Wellington progeny. On 1 June 1847, Watson issued another stipple engraving based on Claudet's daguerreotype, this time showing the duke clutching the arm of his chair with his left hand.[252] A few years later, perhaps in September 1852, after the duke had died on 14 September, Claudet's own studio seems to have made at least one daguerreotype copy of the original plate, for the duke's adopted daughter, Kate Hamilton.[253] The portrait of the duke seen in this daguerreotype, now in the collection of the J. Paul Getty Museum in Los Angeles, is identical in appearance, orientation and size to the other surviving example, but is contained in a case embossed 'Claudet 107 Regent St Quadrant', a studio that Claudet began to occupy only in June 1851 (Fig. 63).[254]

Understandably, the Duke of Wellington's death inspired a renewed interest in his portraits. In November 1852 the *Illustrated London News*, for example, published a survey of them. Claudet's daguerreotype is mentioned (although misdated to 1848), as is the engraving by Ryall published by James Watson. According to this report:

> There are two versions of it; in the larger, the hands have been put in since; the original Daguerreotype and the smaller print showing the bust only. It represents the Duke sitting in ordinary dress, with a white waistcoat; three-quarter face, stooping a little, and with a bland expression.[255]

An indignant letter from Watson was published in the issue of 1 January 1853, referring to 'your critique on the portraits of the

Fig. 64
John Sartain (engraver), *The Duke of Wellington*, 1852, in *The Eclectic Magazine of Foreign Literature*, vol. 27, no. 3, November 1852, p. 362.
Hand-coloured ink-on-paper print from mezzotint, etching and aquatint engraving, 18.0 × 12.5 cm (image).
Collection of the author, Wellington.

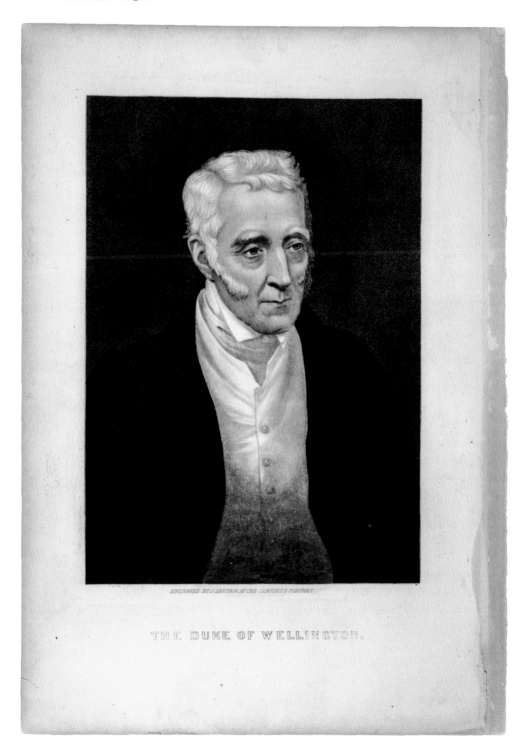

ENGRAVED BY J. SARTAIN, AFTER CLAUDET'S PORTRAIT

THE DUKE OF WELLINGTON.

Fig. 65
William Roffe (engraver, England), *Duke of Wellington*, 1852.
Ink-on-paper print from steel engraving published by William Mackenzie, London, 13.4 × 11.0 cm (image).
Collection of the author, Wellington.

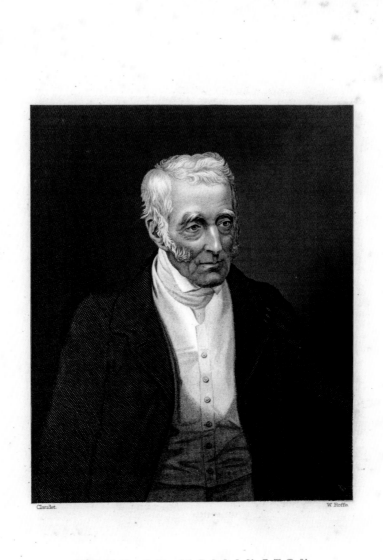

Claudet. W Roffe.

DUKE OF WELLINGTON.

WILLIAM MACKENZIE, LONDON, EDINBURGH & GLASGOW

Fig. 66
Photographer unknown (England), *The Duke of Wellington*, 1860s.
Carte-de-visite (albumen photograph on card) after engraving, 9.8 × 6.2 cm (sheet). Collection of the author,
Wellington.

late Duke of Wellington' and anxious to point out that there were in fact 'two Daguerreotype Portraits' made in 1844, 'one of which is engraved at present and has the hand introduced'. Watson claims that he

> had the honour to submit the engraved portrait for the late Duke's inspection, when his Grace remarked, 'tell Watson it is beautifully engraved.' I may also state his Grace has placed his autograph on several impressions.[256]

In this same year, 1852, John Sartain used a mixture of mezzotint, etching and aquatint to produce yet another engraved version of Claudet's daguerreotype portrait of the duke, with this image accompanying an obituary for Wellington that was published in the *Eclectic Magazine* (Fig. 64). It was reproduced again in the same magazine a few years later, in 1860.[257] Also in 1852, yet another version was engraved on steel by William Roffe and issued as a hand-coloured print (Fig. 65). Subsequently, a number of carte-de-visite copies of Ryall's print, transferred into sepia by their albumen photographs, were issued, sometimes anonymously, by various studios (Fig. 66). In 1885 a cropped version appeared on the cover of a book titled *England Under Victoria*, embossed in gold on its red cloth binding (Fig. 67).[258] A decade or so later, an advertisement for Oakey's Knife Polish again featured this picture of Wellington. All this stemming from a single, supposedly unique daguerreotype portrait made in 1844.

The account I have just given is in fact typical of the fate of many photographic images, but their proliferation seldom appears in books or exhibitions devoted to photography. We can easily understand why: for those anxious to defend photography against perceived threats to its integrity, and perhaps also anxious to defend museum and academic appointments dependent on this same integrity, all hints of impurity must be repressed. The original, singular photograph is therefore privileged over its dangerously multiple supplement, the reproducible photographic image. And there is no doubt this image is indeed dangerous. After all, our object of study has revealed itself to be disconcertingly capable of transfiguration, having become a non-medium-specific apparition detached from—even while it remains inextricably tied to—an initial photograph. This apparition depends on a palimpsestic relationship to the photograph that the reproduction replaces, valorising even while erasing it. Apparently, the photograph must die for its ghost, the photographic image, to live on.

Fig. 67
The Duke of Wellington as featured on the cover of *England Under Victoria*, Eld & Blackham, London, 1885.
Portrait of Wellington embossed in gold on red cloth binding after engraving by Henry Thomas Ryall after
daguerreotype by Claudet, 27.5 × 21.0 cm (cover). Collection of the author, Wellington.

This gives the caption 'from a daguerreotype' a particular poignance, as if the process of transference from one medium to another has taken on an organic character, a grafting of one onto the other. Certainly, engravings made 'from' photographs free the image from an otherwise static existence, unfixing it from any medium-specificity in order for the image to be passed on, in a potentially endless chain of transfers from one substrate to the next.

Although I have discussed British examples, seeking to trace in some detail the business practices of the two earliest commercial studios in London, this trade in images was equally well established elsewhere in Europe and the United States. *L'Illustration* and *Illustrirte Zeitung* began to be published in 1843 in Paris and Leipzig, respectively, just one year after the establishment of the *Illustrated London News*. However, they did not begin to use photographs as source material until the later 1840s (*Illustrirte Zeitung* in September 1845 and *L'Illustration* in July 1848, both issuing wood engravings based on daguerreotypes).[259] But the *United States Magazine and Democratic Review* had already begun publishing portrait illustrations copied from daguerreotypes in late 1842, featuring a different notable public figure each month. Frank Leslie, a wood engraver who learned his craft at the *News*, began issuing *Frank Leslie's Illustrated Newspaper* on 15 December 1855; this was followed in 1857 by the publication of a competitor, *Harper's Weekly*. By this time, all of these organs of the press featured wood engravings based on photographs.[260] These were gathered from local photographers, but also from all around the world.

Indeed, one could look at almost anywhere on the globe and trace a version of the story I have told here. Take Japan, for example. Although a daguerreotype camera had been imported to Japan in 1848 by a Nagasaki merchant, the earliest daguerreotypes that survive are from the 400 exposed there between May 1853 and August 1854 by Eliphalet M. Brown Jr, a member of the American navy expedition under Commodore Matthew Perry.[261] Nineteen of these daguerreotypes were subsequently translated into lithographic images (by four different firms) and published in January 1856 as part of the report on the expedition by the US Congress (with a second edition issued later in the same year). As many as 18,000 copies of these images may have been distributed. Two of the report's lithographs are of particular interest. One, titled *Temple at Tumai, Lew Chew* (Okinawa) and captioned as 'drawn from nature' by the expedition's draftsman, Dresden painter Wilhelm Heine, shows a village scene in Okinawa, shortly after the expedition arrived there on 26 May 1853.

Among the European figures is one operating a daguerreotype camera, assisted by a Japanese man carrying a plate-holder. The camera is being pointed at three seated Japanese men, with an American sailor standing behind them (Fig. 68). Another lithograph, titled *Afternoon gossip, Lew Chew* and captioned 'Daguerreotypes by Brown Jr.', shows these same three seated men, two of them smoking pipes and one fanning himself (Fig. 69). Thus, we witness both the taking of a daguerreotype and the end result of that taking, but each is depicted in another medium again.

In later years, a photographer like Felice Beato, born in Venice but resident in Japan between 1863 and 1884, had his photographs of that country reproduced during the 1860s as wood engravings in the *Illustrated London News*, *Le Monde illustré* and *Le Tour du monde*, as well as in several books, giving them an international audience. These engravings included, among many others, two double-page panoramas of the city of Yedo (Edo; present-day Tokyo) and the British Fleet at Yokohama that were published in the *News* on 29 October 1864.[262] Indeed, recent scholarship about photographs made in both Japan and China has revealed the degree to which images based on such Western-style photographs were widely disseminated as wood engravings in the illustrated press, allowing photographers in distant places to maintain a visual presence in the metropole.[263]

As Wendy Reaves and Sally Pierce have suggested, during this period 'the relationship between photography and printmaking was not so much competitive as interdependent and symbiotic'.[264] As a consequence, according to Michael Leja:

> Images in the 1840s and 1850s were treated as fluidly transferrable across media whenever exhibition or distribution requirements dictated. There was no conception of medium-specificity in the realm of mass-image manufacture, except as a set of characteristics that could be lent to another medium through a kind of fortification.[265]

Or, to call on yet another authority, we might well adopt the words of Michel Foucault to describe the situation in which the photographic image now found itself:

> In those days images travelled the world under false identities. To them there was nothing more hateful than to remain captive, self-identical, in *one* painting, *one* photograph, *one* engraving, under the aegis of *one* author. No medium,

Fig. 68
William Heine (artist, USA) and Rudolf Ackermann Jr (lithographer), *Temple at Tumai, Lew Chew*, 1856, in *Narrative of the Expedition of an American Squadron to the China Seas and Japan, Performed in the Years 1852, 1853, and 1854, Under the Command of Commodore M.C. Perry, United States Navy* ..., Beverley Tucker, Senate Printer, Washington, DC, 1856–58.
Hand-coloured ink-on-paper lithograph after a drawing, showing the photographer Eliphalet M. Brown at work at Lew Chew, now Okinawa, 9.0 × 11.0 cm (image). Collection of the author, Wellington.

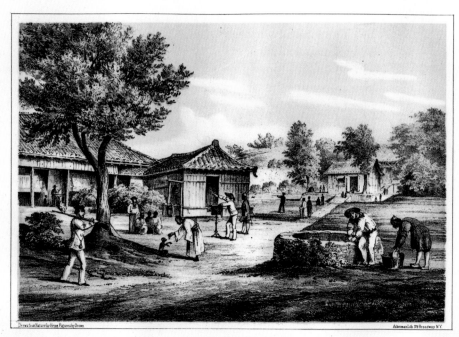

Drawn from Nature by Heine. Figures by Brown.

Ackerman Lith 379 Broadway N.Y.

TEMPLE AT TUMAI, LEW CHEW

Fig. 69
William Heine (artist, USA) and Rudolph Ackermann Jr (lithographer), *Afternoon gossip, Lew Chew*, 1856, in *Narrative of the Expedition of an American Squadron to the China Seas and Japan, Performed in the Years 1852, 1853, and 1854, under the Command of Commodore M.C. Perry, United States Navy ...*, Beverley Tucker, Senate Printer, Washington, DC, 1856–58.
Hand-coloured ink-on-paper lithograph after a daguerreotype by Eliphalet M. Brown, 9.0 × 11.0 cm (image).
Collection of the author, Wellington.

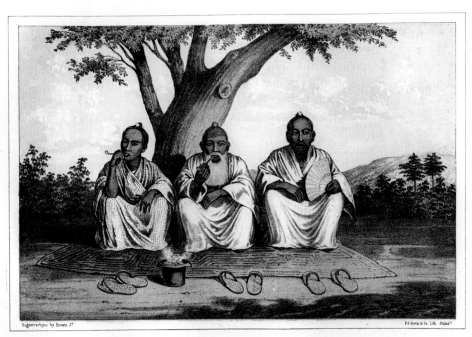

AFTERNOON GOSSIP. LEW CHEW.

no language, no syntax could contain them; from birth to last resting place they could always escape through new technologies of transposition.[266]

Photography's complexity in this regard is brilliantly staged in yet another photograph by Antoine Claudet, *The geography lesson*, a stereo-daguerreotype made in about 1851. Thanks to his own patented viewing device, Claudet asks us to see this photograph as a virtual three-dimensional mirage existing only on the back of our retinas, as an image rather than as a 'thing'. And what do we see when we so look?

The geography lesson comprises two conjoined images of six figures: a male teacher (played by the photographer's son Henri), four girls, and a boy kneeling on a chair, all beautifully composed in a tight spiral of bodies and criss-crossing gazes, leaving the man at the head of an asymmetrical pyramid (Fig. 70). Each figure is fully absorbed in what they are doing, as if the photographer is not present. The two lower girls hold open a copy of *Excursions daguerriennes*, the book of engravings made after daguerreotypes published by Claudet's friend Lerebours eleven years before and once sold in Claudet's London glass shop. Another child consults a smaller book, and others look closely at a globe, turned so that the inverted outline of Australia is visible to us (evidence that the daguerreotypes were taken with a non-reversing camera), with the teacher helping his eager charges find a particular spot on the map. A mirror at the back gives enticing glimpses of this other side of the globe and of one girl's head; when viewed in stereo this reflection entices the sensation of being able to see around these figures, as if our feet could move with our eyes and get in behind them. A basket of flowers, placed off to one side, completes the composition.

What we are being shown is a lesson being conducted for the offspring of an upper-middle-class family, a family that expects its children to read both French and English, to be visually literate, and to have a grasp of the greater world, a world at that time increasingly dominated by British political and economic interests. But we are also seeing the confirmation of a positivist and imperialist view of knowledge, a view based on a visible apprehension of the natural world, such that seeing, knowing and possessing are intimately associated.[267] Canadian scholar Joan M. Schwartz has described this particular depiction of such an apprehension as Claudet's contribution to the construction of 'imaginative geographies':

> The globe offered a scientific model; the book suggested literary images; the engravings contributed a visual rendering

Fig. 70
Antoine Claudet studio (London), *The geography lesson*, c. 1851 (detail). Stereo-daguerreotype, 8.7 × 17.6 cm
(object). Gernsheim Collection, Harry Ransom Center, University of Texas, Austin.

[...] *The Geography Lesson* merged cartography, literature and art, and inserted photography into the process by which geographical information was acquired, ordered and disseminated. [...] Embedded in it are notions about the nature of the world and how the Victorian mind came to know and represent it. [...] In it, reality is reduced to written and visual representations, and through them, the world is ordered and presented as an object for the modernist gaze.[268]

Claudet himself reiterated this idea in an essay he published in 1860:

The stereoscope is the general panorama of the world. It brings to us in the cheapest and most portable form, not only the picture, but the model, in a tangible shape, of all that exists in the various countries of the globe; it introduces us to scenes known only from the imperfect relations of travellers; it leads us before the ruins of antique architecture, illustrating the historical records of former and lost civilisations, the genius, taste, and power of past ages, with which we have become as familiarised as if we had visited them.[269]

Indeed, the two girls hold their copy of *Excursions daguerriennes* open so that we can see they are looking at Plate 15: *Maison Carrée à Nismes* (Fig. 16). In other words, the girls just happen to have chosen to examine a picture of a surviving Roman temple situated in France, Claudet's country of birth, thus showcasing the cultural riches of his homeland while also adding to this image's distinctly autobiographical cast. It also allows this scene to demonstrate a telescoping of past and present, here and there; as we've already seen, this is one of those attributes peculiar to the photographic medium.

Claudet's mastery of this illusion, demonstrated in the superb lighting of this complex scene, the naturalism of the children's facial expressions, the individual and telling gestures of their hands, and a composition almost sculptural in its sensitivity to the third dimension, encourages us to immerse ourselves in it, to become a willing party to its ideological message. One element of this message is the importance of educating young women, a relatively novel idea in the 1850s.[270] Another is the centrality of education in general, of acquiring knowledge at second or third hand, through books and images and globes, of learning through processes of abstraction, deduction and accretion. Apart from all of its other implications, Claudet's image is a glorification of the life of the mind. But it is also a telling conflation of photographs and their copies into a single,

all-encompassing optical medium. For him, it seems, a photographic picture is a virtual image conjured on the back of a viewer's retina, not a static entity made of metal or paper.

As a composite visual experience, *The geography lesson* is peculiar indeed. After all, it consists of a stereoscopic apparition, an image seen only in one's mind's eye, induced from two daguerreotypes taken of people looking at an engraving made after another daguerreotype, a daguerreotype taken by someone else some years before, of a building constructed in antiquity in another country. This is a photograph, in other words, all about the wonderful strangeness of photography as a reproductive medium. But it's also a photograph that once again presents photography as a dynamic and elusive entity, an entity as much image as object, an entity simultaneously material and immaterial.

In this sense, Claudet's composition confirms an argument put by American cultural commentator Oliver Wendell Holmes in an essay he published in 1859, where he described photography as 'the divorce of form and substance'. As a consequence of photography, Holmes said:

> Form is henceforth divorced from matter. In fact, matter as a visible object is of no great use any longer, except as the mould on which form is shaped. Give us a few negatives of a thing worth seeing, taken from different points of view, and that is all we want of it. Pull it down or burn it up, if you please. [...] Matter in large masses must always be fixed and dear; form is cheap and transportable. [...] Every conceivable object of Nature and Art will soon scale off its surface for us. [...] The consequence of this will soon be such an enormous collection of forms that they will have to be classified and arranged in vast libraries, as books are now.[271]

Holmes acknowledged that photography involves the separation of the image from its referent, making 'form', among other things, cheaper than 'matter' and therefore more easily turned into a commodity. Given the history just recounted, we might well advance this observation one step further, seeing photography as a continual process of such separations, first of form from matter and then of form from form, with this latter separation—of the photographic image from the photograph—driven above all by the demands of consumer capitalism. Although often associated with the advent of digital technologies, this double displacement—it turns out—has

always been central to the everyday experience of photography, now but also from the beginning.

And what of the photographers themselves—what of practitioners like Beard and Claudet? What did dissemination mean for them, personally? Well, as we saw, Richard Beard had decided from the outset to license the practice of daguerreotypy through a franchise system, and made almost no photographs himself, even though his name appeared on thousands of examples. Claudet ran a more traditional kind of art business, working as his studio's principal operator. However, both these men employed many assistants, such that their own names encompassed dozens of photographic workers.[272] In other words, in their determined efforts to make photography available to capitalism, Beard and Claudet found themselves simultaneously multiplying and dispersing, not only photography's identity, but also their own. As a consequence, the names 'Beard' and 'Claudet' are best regarded as trademarks rather than as signifiers of an individual person.

Claudet responded to this commodification of his identity by obsessively making self-portraits, producing them throughout his career in every medium at his disposal; Beard, by an almost complete absence of the same (except in surrogate form, via the compulsory inscription of his name on a multitude of daguerreotypes made, under his licence, by others).[273] In this sense, it could be argued that Beard, while the lesser photographer, was the more prescient contributor to photography's future—he fully embraced all the consequences of its modernity, even to the point of his own dissolution in favour of a purely corporate existence.

The division of image from photograph that I have been describing was finally given a formal legal status when legislation was passed in the British Parliament in August 1862 granting copyright protection to photographs. A bill seeking to guarantee that protection had first been canvassed in the British Parliament in 1858, but the question was revisited in 1861 in concert with arguments about photography's status in the upcoming International Exhibition. The legislation of August 1862 gave the creators or authors of

> every original painting, drawing and photograph [...] the sole and exclusive right of copying, engraving, reproducing and multiplying such painting or drawing, and the design thereof, or such photograph, and the negative thereof, by any means and of any size, for the term of the natural life of such author, and seven years after his death.[274]

Studios that profited from selling carte-de-visite portraits of celebrities, such as those run by Caldesi, Mayall and Silvy, began registering their images in that same year. Julia Margaret Cameron made extensive use of this protection, registering 508 photographs over a period of almost twelve years, starting in May 1864.[275] Given their considerable involvement in the commercial traffic in photographs, and especially in the reproduction of their work in the illustrated press, it is striking that neither Beard nor Claudet appears to have commented on the copyright legislation. Leaving aside the legal ramifications and commercial potential, its passage in 1862 no doubt merely confirmed what Beard and Claudet already took for granted in their day-to-day practice: that what they made and sold were images ('forms', as Holmes had called them), not just 'photographs'.

Photography and Photomechanical Reproduction

It is interesting to note that in 1862, the same year in which British copyright legislation for photography was passed, Claudet was involved in some experiments that were to transform the dissemination of photography completely. In about 1845 William Henry Fox Talbot had ceased making photographs of his own, instead concentrating his energies on solving the problem of the fading of his photographs by reproducing their images using a photomechanical process. As discussed, efforts along these lines were coincident with the invention of photography itself, inspired by a desire for automation that was at the heart of the Industrial Revolution. This desire also transformed the wood-engraving industry. The assembly-line system adopted to engrave Claudet's panorama of London in 1842 soon became the standard procedure and, to the chagrin of John Ruskin and others, the facsimile engraving of photographic images gradually came to supplant more highly skilled interpretive engraving methods.[276]

By the mid-1850s, a number of experimenters had developed a process whereby collodion could be applied directly to a piece of wood, allowing a photograph to be exposed there and then engraved, without any intermediate drawing. Within a decade this process had been adopted by most illustrated magazines, including the *Illustrated London News* and its competitors. But even this possibility had already been flagged in 1839; as discussed, the cover illustrations for the 27 April issue of the *Magazine of Science, and School of Arts* had been cut from photogenic drawings developed directly on pieces of boxwood.[277]

Talbot had always imagined that the reproduction of existing images, both texts and pictures, would be a major function, and even a source of lucrative commerce, for his photographic processes. But he also hoped that the calotype, with its quicker exposure times and greater capacity for multiple positive salt-print copies, could be adapted to portrait-making. Talbot made his first documented portrait with this new process, of his wife, Constance, on 6 October 1840. As he claimed in a letter to the *Literary Gazette* dated 5 February 1841,

'a better picture can now be obtained in a *minute* than by the former process in an *hour*'.[278]

After this announcement appeared, both Beard and Claudet were among those who approached Talbot about the possibility of purchasing a licence to practise the calotype process professionally.[279] Claudet had been present at the announcement of the details of Talbot's new process on 10 June 1841 at a meeting of the Royal Society, the same month in which he opened his own daguerreotype studio. By December 1842 he and Talbot were 'virtually in agreement' on a contract, but this proved to be a mirage, as they were still haggling politely over details in January 1844.[280] This was despite Claudet's assurance, in a letter dated 18 January 1843, that

> I have written to Mr Keates, my principal assistant at the Adelaide Gallery that you have granted me the right to use the Calotype procedure & I have given him the order to begin to carry out tests in order to familiarize himself with the procedure.[281]

This is one more reminder that many of the photographs being issued by 'Claudet' in these years were in fact being made in his absence by assistants.

A typically grandiose advertisement appeared in the *Athenaeum* of 6 July 1844 to inform the public that Claudet had entered into

> arrangements with H. Fox Talbot, Esq. F.R.S, for practicing his beautiful patented process, called by the inventor Calotype, but which may be more justly named Talbotype, from the same feeling which has caused the name of Daguerre to be given to his valuable discovery.[282]

No wonder that Talbot's mother, Lady Elisabeth, always keen that her son brand his invention with his own name, was so fond of Claudet. As she told Talbot in a letter dated 7 April 1844:

> I hope Claudet will see it in the same light so many others do. A *clear* distinct name would be a positive benefit to the Art; Shakspear says what's in a name? I answer a great deal, in modern times.[283]

Despite constant efforts to improve the process, outlined in periodic reassuring letters to Talbot ('I took on the Talbotype with the

intention of making it prosper & I will spare neither expense nor effort in achieving this aim. I would be ashamed if anyone could accuse me of the contrary.'), Claudet was nevertheless unable to make a profit on it, and soon returned to the daguerreotype as his primary portrait medium.[284] As he explained to Talbot in a letter dated 24 August 1844:

> Until we have succeeded in operating on a surface as even & as perfect as a silver plate, I will say that the Daguerreotype produces more delicate, better finished and more perfect images than the Talbotype. Until we have succeeded in making the Talbotype operate within a few seconds & as quickly as the Daguerreotype, I will say that, in this respect, the Daguerreotype has an advantage when it comes to obtaining an acceptable impression. But I will also say that the Talbotype has charms which the other lacks, that the prints are more portable and can be circulated more easily, sent by post or put into albums &c. &c. Finally, an unlimited number of copies can be obtained, which is not possible with the Daguerreotype.[285]

During this period, Claudet sought not only the expert guidance of the calotype's inventor but also the assistance of Henneman, Murray and Malone, all of whom worked at one time at the Reading Establishment.[286] This was a printing business founded in late 1843 in the town of Reading by Nicolaas Henneman, a Dutch immigrant who was Talbot's former valet and photographic assistant. Employing a number of part-time workers, most of them ex-shopkeepers or servants, Henneman set up a kind of factory designed to enable the manufacture (albeit by hand) of a large number of salt prints from calotype negatives (Fig. 71).[287]

Talbot was the principal client and investor in the business, although other photographers also had photographs printed there. At one point Talbot arranged for a local man, Benjamin Cowderoy, to be hired as a manager. According to Larry J. Schaaf, 'all known printed ephemera from the Reading Establishment can be traced to Cowderoy's reign in 1846'. These ephemera would include a leaflet published late in that year, claiming that

> an instrument of new power [has been] placed at the disposal of Ingenuity and of Art, and which, as in the case of the electrical machine and the galvanic trough, may be expected to suggest countless new applications and developments.[288]

It seems that Cowderoy was, like Beard and Claudet, keen to ally photography with the very latest of industrial innovations, indeed with 'industrialisation' in general.

According to Cowderoy, writing in a reminiscence published in 1895 after he had emigrated to Australia, he worked part-time for Talbot during 1846 to conduct 'all correspondence, issue licences under the patents, and attend generally to the business of supervising the distribution and sale of the pictures'. He remarks that the 'stock of pictures grew to inconvenient proportions in the hands of such a gentleman as Mr Talbot, occupying a high position in aristocratic society', reminding his readers that 'in those days' the 'younger sons of dukes' did not, due to the risk of social disapprobation, 'enter into mercantile offices'. Talbot was no duke's son, but his extended family certainly enjoyed that sort of social status. As a consequence, Cowderoy opined, Talbot experienced 'perplexity and embarrassment through the accumulation of merchantable products which the usages of society would not allow him personally to "liquidate"'.[289]

We know that customers for the salt prints produced by the Reading Establishment included London's major printsellers, who presumably sold them on to the same sort of clients who were buying engravings and other prints. In April 1846 a printseller named Henry Brooks, for example, asked Cowderoy for 'more *Trees* and Maltese Views', suggesting at least two kinds of picture that were selling.[290] On 29 May 1846, to take another example, Ernest Gambart, one of London's leading printsellers and publishers, is supposed to have bought 214 salt prints from Henneman for £29 16s 6d, 'with a further 123 on 8 June; two more orders in September and November completed the transactions for 1846'.[291] Cowderoy, however, reported to Talbot:

> As to the absolute purchase of pictures as suggested in your last, Gambart will *not* buy them. He makes a principle of having nothing of his own, lest he should be thought partial in his efforts to do business.[292]

Cowderoy mentions Gambart and Brooks, describes an interview with the manager at Ackermann's, with whom he left a few specimens, and says that he has opened accounts with 'Gardner in Regent Street and Gibbs in Titchbourne Street'.[293]

It seems that Ackermann was eventually persuaded to stock photographs, as an advertisement for the Reading Establishment issued in 1846 announced that

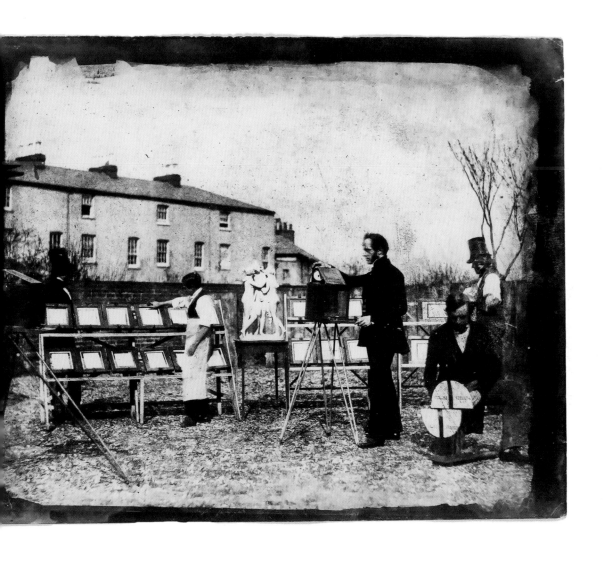

specimens may be seen at most respectable Printsellers or Stationers in the Kingdom; and an extensive assortment will be found at the Publishers, Messrs. Ackermann, Strand, and Messrs. Gambart, 25, Berners-street, London.[294]

In 1863 Wolverhampton-based photographer Oscar Rejlander presented a paper to the London Photographic Society titled 'An Apology for Art-Photography', in which he recalled 'having seen some reddish landscape photographs [in 1851] at Ackermann's, in Regent Street, but these made no impression on me'.[295] Rejlander may not have been impressed, but others were buying these photographs, or at least considering it.

Among its other activities, the Reading Establishment made numerous salt prints from calotypes to illustrate Talbot's own books *The Pencil of Nature* (1844–46) and *Sun Pictures in Scotland* (1845). But Henneman was also later commissioned by Sir William Stirling-Maxwell to make fifty sets of sixty-six calotype-based reproductions of his collection of engravings, etchings, lithographs and paintings for the presentation volumes that were published in 1848 as part of *Annals of the Artists of Spain*, the first art-history book to be illustrated with photographs.[296] Despite the efforts of Henneman, the legibility of many of the resulting salt prints quickly deteriorated. This pictorial evanescence was to be the Achilles heel of the calotype as a viable reproductive medium. In 1846, for example, the editor of the *Art-Union* journal asked Talbot to supply approximately 7000 salt prints to accompany a story about the calotype process that appeared in the June issue of that year. These were made at the Reading Establishment, using as many as seventy available negatives. Unfortunately for Talbot, the *Art-Union* project proved to be a promotional and financial disaster, with most of the photographs fading soon after publication (Fig. 72). Pale and indistinct, their limitation as illustrations was made all the more apparent by their placement in the *Art-Union*, allowing a direct comparison with the many kinds of fine engravings and other reproductions to be found there.[297]

Chastened by this experience, which led to the bankruptcy of the Reading Establishment, from this time onward Talbot worked on the possibility of transferring photographic images onto metal plates and then making permanent ink-on-paper impressions from them. By October 1852 he was able to file preliminary specifications for a patent on an engraving process of this kind. In April 1858, having found a way to introduce an aquatint ground to the process, he filed

Fig. 72
William Henry Fox Talbot (England), *View of one of the towers of Orléans Cathedral*, 1843, in *The Art-Union: Monthly Journal of the Fine Arts and the Arts, Decorative, Ornamental*, vol. 8, June 1846, p. 143. Salted-paper photograph from calotype negative taken c. 5 p.m. on 21 June 1843, printed by Nicolaas Henneman & Co. at the Reading Establishment in early 1846, 19.2 × 15.5 cm (image). Collection of the author, Wellington.

Fig. 73
Antoine Claudet studio (London), *David Brewster*, c. 1862.
Carte-de-visite (albumen photograph on card), 9.0 × 6.2 cm. Courtesy of Alexander Turnbull Library, Wellington.

Fig. 74
William Henry Fox Talbot (engraver, England), *Sir David Brewster*, 1862.
Ink-on-paper print from photoglyphic engraving on steel plate, from a carte-de-visite photograph by Antoine
Claudet studio (London) in 1862, 12.5 × 9.6 cm (plate). Private collection, image courtesy of Museum of Fine
Arts, Boston, and Hans Kraus Jr, New York.

another patent for an improved system of photogravure, which he called photoglyphic engraving.[298]

In February 1862 Claudet sent Talbot some glass positives to convert into such engravings, including one derived from a carte-de-visite portrait of David Brewster (Fig. 73). The year before, Claudet had written to Talbot to point out the commercial potential of this process:

> I will be moved to see how the portraits which I sent you turn out with your engraving, because if there was a way to make them perfect with a little retouching, it would be of great importance for the sale of cartes de visite.[299]

Talbot did indeed produce a photoglyphic engraving of Claudet's portrait of Brewster. The Scotsman is shown from a distance, standing in Claudet's studio with his hand on a chair and beside a rectangular-based column, with a picturesque landscape painting on the wall behind him (Fig. 74).[300] Having invented negative-positive photography—the system of representation that dominated the nineteenth century—Talbot (using, among other examples, an image sent to him by Claudet) now introduced photomechanical reproduction, which would similarly dominate the twentieth. He therefore made possible a culture based on the mass reproduction and distribution of photographic images, that same culture that happily disseminated the first 'papal selfie' in 2013, the culture in which we all live today.

Coda

What, then, are the consequences of a shift of analytical scrutiny from photographs to photographic images, and from the moment of production to the processes of dissemination? What happens when photography's outcast is finally offered a home?

As we have seen, this shift towards dissemination irrevocably displaces the value systems that normally underpin the published history of photography. Henceforth, this history will need to make room for the complications that accompany photography's reproducibility, and this means having to deal with photographic images as well as photographs. As this account has shown, the defining of such images is not an easy task. Both a photograph and its copy are material things, whatever their medium. But a photographic image is dependent on these material manifestations while also being detached from them. The 'intellectual object' described by Vernet— what we might today call 'intellectual property'—is an intangible entity that can be bought and sold without ever having been held or physically manifested. It is embedded in both a daguerreotype and the wood engraving traced from it, but belongs to neither in its entirety. It is a mobile entity, an entity only recognisable when it is in transit, when it is moving between one thing and another. Similarly, a photographic image is something that conjures a photograph even while not being one. Such images haunted photography even before most people had seen an actual photograph. This is just one of the many troubling ghosts with which any historian of this medium must grapple.

More pragmatically, my account has made visible the central role played by migrants and migration in the early development and distribution of photography, both literally and metaphorically. The medium is revealed as a vehicle of dynamic exchange back and forth between individuals, between countries, and between metropolitan centres and colonial peripheries. This dynamic, among others, gives us a way to associate photography with a type of history that insists on being politically navigable. As we have seen, photography's reproductions gave the medium a global profile,

closely associating it with the processes of industrialisation, capitalism and colonisation, as well as with the advent of the illustrated press and therefore with a popular culture mediated by images. In a historical account of its reproducibility, photography is therefore firmly embedded in—is inseparable from—the political economy in which it finds itself.

The story of photography that follows is about the medium's subservience to, or deviation from, this economy's particular logics and value systems. This story tells us that the price for a remunerative place for photography within those systems was the displacement of the photograph in favour of the processes of its reproduction, ensuring that photography would pervade modernity as an entity always simultaneously absent and present. In other words, once it was harnessed to the engine of reproducibility, photography could not help but be continually confronted with the spectral presence of its other. It became an entity forever alienated from itself. And the same could be said for those subjects who submitted themselves to photography, which is to say everyone. Among all its other consequences, photography has commodified one's relationship to one's own image, instituting a mode of representation that simultaneously reassures and alienates, secures and divides, all who are subjected to it. In short, the photographic experience embodies the processes and effects of capitalism in their entirety.

The history of photography's reproducibility therefore bears out, not only Benjamin's complex commentary on reproduction and commodity fetishism, but also Derrida's identification of dissemination as an activity that circumscribes and dissipates in equal measure. Accordingly, even while an acknowledgement of the photograph as image exponentially expands the purview of photography's history, it simultaneously complicates our notion of what that history should encompass. It requires us to devise an understanding of photography as a haunted entity, eternally oscillating between material and immaterial manifestations, between physical objects grounded in specific configurations of space and time and apparitional images floating free of any particular substrate and capable of endless reproduction in a variety of media and formats. Photography, it seems, is always there but not there, resting only for a moment in any particular image form before passing on to something/somewhere else. That image echoes the photograph from which it was derived, even while signalling its demise. It is the trace of a photograph that came before it, a photograph that continually returns in apparitional form to tell us it is no longer here.

Any history of this process must necessarily reflect on what is distinctive about the practice of photography, even while we situate that medium in a broader account of reproductive procedures. If it does so, such a history cannot help but displace our usual obsession with moments of origin in favour of a more complex mode of analysis. To adopt the words of Roland Barthes, the history of photography needs to become a discourse that 'traces a field without origin—or which, at least, has no other origin than language itself, language which ceaselessly calls into question all origins'.[301]

The question is, can we indeed dare to undertake that tracing? Can we now devise a history for photography built around the logic of movement and transformation, migration and dissemination, instead of that of origin and singularity? Can we at last abandon the familiar safety of a history restricted to the photograph alone, and allow the structure of our narratives to emulate the sometimes illicit flow back and forth across boundaries and identities that has always characterised both the photographic image and modern life and culture? Writing a story worthy of this dynamic—a history *for photography* rather than a history *of photographs*—is, I believe, the challenge that historians like me now face. This book is a fledgling attempt to take up that challenge.

Notes

1 The phrase comes from Roland Barthes, *Camera Lucida: Reflections on Photography*, Hill and Wang, New York, 1981, p. 77. See Mette Sandbye, 'It Has Not Been—It Is: The Signaletic Transformation of Photography', in Joanna Zylinska (ed.), *Photomediations: A Reader*, Open Humanities Press, London, 2016, pp. 95-108.

2 See, for example, Harriet Alexander, 'Pope Francis and the First "Papal Selfie"', *Telegraph* (London), 31 August 2013; and 'Pope Francis Takes Twitter by Storm in the First Papal Selfie', *Independent* (UK), 31 August 2013.

3 Benjamin established the contradictory logic of his argument in his first paragraph: 'Going back to the basic conditions of capitalist production, [...] what could be expected, it emerged, was not only an increasingly harsh exploitation of the proletariat but, ultimately, the creation of conditions which would make it possible for capitalism to abolish itself.' Walter Benjamin, 'The Work of Art in the Age of Its Technological Reproducibility' (1935-36), in Brigid Doherty, Michael W. Jennings, Edmund Jephcott and Thomas Y. Levin (eds), *The Work of Art in the Age of Its Technical Reproducibility, and Other Writings on Media*, trans. Edmond Jephcott, Rodney Livingston, Howard Eiland and others, The Belknap Press of Harvard University Press, Cambridge, MA, 2008, pp. 19-55.

4 Not unreasonably, McCauley, for example, concludes that 'Benjamin failed to see that the aura, as he defined it, was untouched by mechanical replication.' Pointing out that visitors still flock to see original paintings, despite their reproduction in other media, she asserts that 'their aura certainly remains intact'. Elizabeth Anne McCauley, *Industrial Madness: Commercial Photography in Paris, 1848-1871*, Yale University Press, New Haven and London, 1994, p. 300. Although Benjamin's essay remains richly ambiguous, it is important to note that he investigated the effects of reproduction while also arguing that the 'mode of perception' of human beings changes through history (Benjamin, 'The Work of Art', p. 23). What, then, if we imagine that the aura of authenticity he identified is a supplementary quality, rather than an inherent one, something embedded in the original but equally something that we bring to it—an expectation, an ideological investment, a mode of perception? Could it be that this mode of perception is what changes in an era of mass reproduction? If so, it would shift the emphasis of Benjamin's essay from the 'authenticity of the thing' (p. 22) to the authenticity of our *experience* of the thing. This kind of mutually constitutive dynamic was also figured in Roland Barthes' *Camera Lucida*, when he talked about the 'punctum' of a photograph: 'whether or not it is triggered, it is an addition: it is what I add to the photograph and *what is nonetheless already there*' (p. 55 , author's emphasis). As Barthes said a little earlier in his book: 'it animates me, and I animate it' (p. 20). See the full argument in Barthes, *Camera Lucida*. The complexities of the term 'punctum' are discussed in more detail in Geoffrey Batchen, 'Palinode: An Introduction to *Photography Degree Zero*', and '*Camera Lucida*: Another Little History of Photography', in Geoffrey Batchen (ed.), *Photography Degree Zero: Reflections on Roland Barthes's* Camera Lucida, MIT Press, Cambridge, MA, 2009, pp. 3-30, 259-73.

5 Benjamin, 'The Work of Art', p. 23.

6 Karl Marx, *Capital, Volume 1, A Critique of Political Economy* (1867), trans. Ben Fowkes and David Fernbach, Penguin, London, 1990, p. 165.

7 Paul Wood, 'Commodity', in Robert S. Nelson and Richard Shiff (eds), *Critical Terms for Art History*, University of Chicago Press, Chicago, 1996, pp. 263-4.

8 See, for example, Trevor Fawcett, 'Graphic Versus Photographic in the Nineteenth-Century Reproduction', *Art History*, vol. 9, no. 2, June 1986, pp. 185-212; McCauley, 'Art Reproductions for the Masses', in *Industrial Madness*, pp. 265-300, 402-9; Stephen Bann, 'Ingres in Reproduction', *Art History*, vol. 23, no. 5, December 2000, pp. 706-25; Stephen Bann, *Parallel Lines: Printmakers, Painters, and Photographers in Nineteenth-Century France*, Yale University Press, New Haven, 2001; Stephen Bann, 'Photography, Printmaking, and the Visual Economy in Nineteenth-Century France', *History of Photography*, vol. 26, no. 1, Spring 2002, pp. 16-25; Dominique de Font-Réaulx, 'Reproducing Paintings', in *Painting and Photography: 1839-1914*, Flammarion, Paris, 2012, pp. 84-107, 299-300; Stephen Bann, *Distinguished Images: Prints and the Visual Economy in Nineteenth-Century France*, Yale University Press, New Haven, 2013.

9 Stephen Bann, *The Clothing of Clio: A Study of the Representation of History in Nineteenth-Century Britain and France*, Cambridge University Press, Cambridge and New York, 1984, p. 133.

10 Stephen Bann, 'Against Photographic Exceptionalism', in Tanya Sheehan and Andrés Mario Zervigón (eds), *Photography and its Origins*, Routledge, New York, 2015, p. 100.

11 See the 'casual phenomenology' of the photographic experience offered in Barthes, *Camera Lucida*.

12 This paragraph is derived from my contribution to 'Afterword' with Lisa Gitelman, in Nicoletta Leonardi and Simone Natale (eds), *Photography and Other Media in the Nineteenth Century*, Pennsylvania State University Press, University Park, 2018, p. 207.

13 Benjamin again located this assertion in a bigger political argument: 'From a photographic negative, for example, one can make any number of prints; to ask for the "authentic" print makes no sense. But as soon as the criterion of authenticity ceases to be applied to artistic production, the whole social function of art is revolutionized. Instead of being founded on ritual, it is based on a different practice: politics.' Benjamin, 'The Work of Art', pp. 24–5.

14 Jacques Derrida, 'Interview with Jean-Louis Houdebine and Guy Scarpetta' (1971), in *Positions*, trans. Alan Bass, University of Chicago Press, Chicago, 1981, p. 45. See also Jacques Derrida, *Of Grammatology* (1967), trans. Gayatri Chakravorty Spivak, Johns Hopkins University Press, Baltimore, 1976, p. 143; and Jacques Derrida, *Dissemination* (1972), trans. Barbara Johnson, University of Chicago Press, Chicago, 1981.

15 Daguerre's invention was announced in Paris on 7 January 1839. It is probable that Talbot first heard of this announcement from reading about it in the *Literary Gazette* of 12 January 1839. Spurred to action, Talbot exhibited some samples of his own photographic experiments at the Royal Institution in London on 25 January and had his first paper on photogenic drawing read in his absence by Michael Faraday at a meeting of the Royal Society on 31 January. The details of this process were revealed at another meeting of the society on 21 February. The definitive account of Talbot's invention of photogenic drawing remains Larry J. Schaaf, *Out of the Shadows: Herschel, Talbot, & the Invention of Photography*, Yale University Press, New Haven, 1992. However, see also *Huellas de luz: El arte y los experimentos de William Henry Fox Talbot* [Traces of light: The art and experiments of William Henry Fox Talbot], ed. Catherine Coleman, exhibition catalogue, Museo Nacional Centro de Arte Reina Sofía/Aldeasa, Madrid, 2001.

16 These are, however, hardly stable origin points. I have argued elsewhere, for example, that even Talbot's most canonical photographs are fraught with the deconstructive logic of dissemination. See Geoffrey Batchen, 'A Philosophical Window', *History of Photography*, vol. 26, no. 2, Summer 2002, pp. 100–12.

17 For an overview, see Larry J. Schaaf, 'Revelations & Representations', 27 May 2016, blog post in Larry J. Schaaf (project director), *The William Henry Fox Talbot Catalogue Raisonné*, University of Oxford, http://foxtalbot.bodleian.ox.ac.uk/2016/05/27/revelations-representations/, accessed 12 August 2018.

18 The earliest extant example of a positive salt print being made from a photogenic drawing negative dates from April 1839 and is one of four that Talbot made from one negative (showing the inside of a window in the South Gallery of his home, Lacock Abbey). See Larry J. Schaaf, *The Photographic Art of William Henry Fox Talbot*, Princeton University Press, Princeton, 2000, p. 50. However, Talbot had perceived the potential of this procedure long before. He made a note about the possibility of using silver nitrate to create photogenic drawings (although he did not yet use that term) in an entry in his Notebook 'L' (p. 73) on 5 October 1833. He made a written record of his notion of negative-positive photography in Notebook 'M' (entry #141) on 28 February 1835. He mentioned the possibility again in his first published paper (1839) about photogenic drawing: William Henry Fox Talbot, 'Some Account of the Art of Photogenic Drawing, or, The Process by Which Natural Objects May Be Made to Delineate Themselves Without the Aid of the Artist's Pencil' (1839), in Beaumont Newhall (ed.), *Photography: Essays & Images: Illustrated Readings in the History of Photography*, Museum of Modern Art, New York, 1980, p. 30. Interestingly, Talbot did this in the context of a discussion of the photographic reproduction of engravings: 'I propose to employ this for the purpose more particularly of multiplying at small expense copies of such rare or unique engravings as it would not be worth while to re-engrave, from the limited demand for them.'

19 *Mirror of Literature, Amusement, and Instruction*, 'The New Art: Photography', 27 April 1839, p. 262.

20 Conrad Martens, 'Photogenic Process', in Conrad Martens, 'Notes on Painting: A Commonplace Book 1835–1856', Dixson Library, Sydney, Ms 142, pp. 16–19. The next entry is dated 5 August 1840. The first photograph to be taken in Australia, a daguerreotype, was reportedly made in Sydney on about 14 May 1841, using a camera that had landed on board a French ship named the *Justine* on 29 March 1841. See Geoffrey Batchen, 'Antipodean Photography: An Itinerant History', in *The Photograph and Australia*, ed. Judy

Annear, exhibition catalogue, Art Gallery of New South Wales, Sydney, 2015, pp. 260–5.

21 *Magazine of Science, and School of Arts*, vol. 1, no. 4, 27 April 1839, front cover.

22 Apart from visibly demonstrating the capacities of industrial mass-production techniques, lace-making, as Friedrich Engels pointed out, was a prime example of capitalism's alienating division of labour: 'The manufacture of lace is greatly complicated by a rigid division of labor, and embraces a multitude of branches.' Friedrich Engels, *The Condition of the Working-Class in England in 1844*, Allen & Unwin, London, 1920, p. 9. I have argued elsewhere that Talbot's own photographs of lace are related to the invention of computing; see Geoffrey Batchen, 'Electricity Made Visible', in Wendy Hui Kyong Chun and Thomas Keenan (eds), *New Media, Old Media: A History and Theory Reader*, Routledge, New York, 2006, pp. 27–44.

23 As quoted in Schaaf, 'Revelations & Representations'.

24 ibid.

25 Louis Jacques Mandé Daguerre, *Historique et description des procédés du daguerréotype et du diorama*, Alphonse Giroux et Cie, Paris, August 1839. See also Helmut Gernsheim and Alison Gernsheim, *L.J.M. Daguerre: The History of the Diorama and the Daguerreotype*, Dover, New York, 1968, pp. 106–7.

26 The English translation was published as *An Historical and Descriptive Account of the Various Processes of the Daguerréotype and the Diorama* and promoted in the *Art-Union* (London) under the title 'The Secret of Mr. Daguerre', September 1839, pp. 132, 139, 143: 'Daguerre Manual in the Press, and will be published in a few days, price three shillings. Daguerre's process of Daguerreotype; or, Philographic Drawing. The only work written by M. Daguerre himself. With six plates, representing the entire process, for which a pension of 10,000 francs a year has just been settled by the French Government upon M. Daguerre. Persons wishing to secure early copies are recommended to give their orders immediately. London: W. Strange, Paternoster Row; and orders received by all booksellers.' Thanks to Karen Hellman for these details. For a listing of and a commentary on the various editions of this publication, see Beaumont Newhall, 'Bibliography of Daguerre's Instruction Manuals', in Gernsheim and Gernsheim, *L.J.M. Daguerre*, pp. 198–205; and Grant Romer, 'Daguerre in the Library', in Sheila J. Foster, Manfred Heiting and Rachel Stuhlman, *Imagining Paradise: The Richard and Ronay Menschel Library at George Eastman House, Rochester*, George Eastman House, Rochester, NY, and Steidl, Göttingen, 2007, pp. 27–33.

27 See Beth Saunders, '*The Bertoloni Album*: Rethinking Photography's National Identity', in Sheehan and Zervigón (eds), *Photography and its Origins*, pp. 145–56. For more on the reproduction of daguerreotype images in Italy, see Maria Francesca Bonetti, 'D'après le Daguerréotype …': L'immagine dell'Italia tra incisione e fotografia', in *L'Italia d'argento, 1839–1859: Storia del dagherrotipo in Italia*, eds Maria Francesca Bonetti and Monica Maffioli, exhibition catalogue, Fratelli Alinari, Florence, 2003, pp. 31–47.

28 See Beth Saunders, Developing Italy: Photography and National Identity during the Risorgimento, 1839–1859, PhD, City University of New York, 2016, p. 50.

29 These images were reproduced in *Westminster Review*, 'Electrotype and Daguerreotype', vol. 34, no. 2, September 1840, pp. 434–60; the name of the lithographer was given as A. Friedel. Writing in this issue, Alexander Bain reported that 'For some reason which we are unable to explain, an impression can be obtained by the hydro-oxygen light in less than five minutes, which would require five-and-twenty with the camera and the light of the sun.' As quoted in Kate Flint, *Flash! Photography, Writing and Surprising Illumination*, Oxford University Press, Oxford, 2017, p. 19. See also Brenda Weeden, *The Education of the Eye: History of the Royal Polytechnic Institution, 1838–1881*, The History of the University of Westminister, Pt. 1, Granta Editions, Cambridge, 2008, pp. 37–8.

30 As reported in Larry J. Schaaf, 'Invention and Discovery: First Images', in Ann Thomas (ed.), *Beauty of Another Order: Photography in Science*, Yale University Press, New Haven, 1997, p. 56; and Larry J. Schaaf, '"Splendid Calotypes" and "Hideous Men": Photography in the Diaries of Lady Pauline Trevelyan', *History of Photography*, vol. 34, no. 4, November 2010, p. 331. David Brewster also reported having four of these engravings in his possession in 1843. See his anonymously written review article in the *Edinburgh Review* of January 1843, as transcribed in Vicki Goldberg (ed.), *Photography in Print: Writings from 1816 to Present*, University of New Mexico Press, Albuquerque, 1981, p. 66.

31 *Athenaeum*, 'Our Weekly Gossip', no. 669, 22 August 1840, p. 663.

32 William Buckland to John Franklin, as quoted in Alan Davies and Peter Stanbury, *The Mechanical Eye in Australia: Photography 1841–1900*, Oxford University Press, Melbourne, 1985, p. 6. See also *Shades of Light: Photography and Australia, 1839–1988*, ed. Gael Newton, exhibition catalogue, Australian National Gallery, Canberra, 1988, pp. 2–3.

33 As quoted in Weeden, *Education of the Eye*, p. 38.

34 *Colonist* (Sydney), 'Light Pictures',
1 June 1839, p. 4.

35 *Launceston Advertiser*, 'New Discovery:
Drawing by Solar Light', 19 September 1839, p. 1;
Colonist, 'The Daguerreotype', 18 January 1840, p. 4.

36 *Hobart Town Courier and Van Diemen's Land
Gazette*, 'Cape of Good Hope', 27 March 1840, p. 3.

37 See Jeremy Maas, *Gambart: Prince of the
Victorian Art World*, Barrie & Jenkins, London, 1975,
p. 20. Gordon Fyfe similarly reports that in 1822
the painter Thomas Lawrence was paid £3000
per year by print publisher Hurst and Robinson
for the exclusive right to engrave his paintings.
He also mentions that Edwin Landseer was paid
more than £60,000 per year by Henry Graves for
his copyrights. See Gordon Fyfe, *Art, Power and
Modernity: English Art Institutions, 1750-1950*,
Leicester University Press, London, 2000, p. 102.

38 As reported in Bann, *Parallel Lines*, p. 36.

39 Apart from Bann, a number of scholars
have surveyed this print culture and the place
of photography in it. McCauley, for example,
devotes a chapter of her book *Industrial Madness*
to the trade in photographic art reproductions,
a trade that has suffered, she says, 'a virtual
dismissal [...] from histories of the medium'.
Her analysis of the situation in France during
the 1850s and 1860s leads her to conclude that
such reproductions were very popular and that
'something as innocuous as a photograph of a
painting struck at the very foundations of imperial
control over the dissemination of culture'.
McCauley, 'Art Reproductions for the Masses',
in *Industrial Madness*, pp. 265-6. Joy Sperling
takes an even broader sweep in her essay about
the visual culture of Victorian England, seeking
to show how 'prints and photographs crossed
almost seamlessly between overlapping visual
cultures', such that 'print and photographic
cultures were symbiotically interconnected;
ideas, themes, and materials were exchanged
and recycled continuously'. Joy Sperling,
'Multiples and Reproductions: Prints and
Photographs in Nineteenth-Century England:
Visual Communities, Cultures, and Class', in Jane
Kromm and Susan Benforado Bakewell (eds), *A
History of Visual Culture: Western Civilisation From
the 18th to the 21st Century*, Berg, Oxford and New
York, 2010, p. 296.

40 See Paul Jay, *Niépce: Genèse d'une invention*,
Société des amis du Musée Nicéphore Niépce,
Chalon-sur-Saône, 1988; and the essays in *Photo-
Historian: Niépce in England*, no. 165, Winter
2012-13.

41 See Gernsheim and Gernsheim,
L.J.M. Daguerre, pp. 60-2; Robert Hunt,
Researches on Light, Longman, Brown, Green and

Longmans, London, 1844, pp. 29-30; and Larry
J. Schaaf, 'Daguerre's Waterloo: Niépce and the
British Response to Photography, 1827-1839',
Photo-Historian: Niépce in England, no. 165, Winter
2012-13, pp. 13-15.

42 Charles Chevalier, *Nouvelles instructions sur
l'usage du daguerréotype*, Paris, 1841, as quoted
in Françoise Reynaud, 'Le daguerreotype comme
objet', in *Le daguerréotype français: Un objet pho-
tographique*, eds Quentin Bajac and Dominique
de Font-Réaulx, exhibition catalogue, Musée
d'Orsay, Paris, 2003, p. 98. As Reynaud also tells
us, François Arago in his report to the Chamber of
Deputies of 3 July 1839 had similarly warned that
touching the surface of a daguerreotype was like
'brushing the wings of a butterfly'.

43 Nicéphore Niépce to his son Isidore Niépce,
as quoted in Font-Réaulx, *Painting and Photography:
1839-1914*, p. 43; Nicéphore Niépce to engraver
Augustin François Lemaître, 2 February 1827,
as quoted in Gernsheim and Gernsheim,
L.J.M. Daguerre, p. 55.

44 Stephen C. Pinson, *Speculating Daguerre:
Art & Enterprise in the Work of L.J.M. Daguerre*,
University of Chicago Press, Chicago, 2012, p. 136.
Pinson points out that the introduction of the
daguerreotype in France in 1839 occurred amidst
continuing debates—centred on the Académie des
beaux-arts and involving Vernet, Delacroix and
many others—about the nature of reproduction
rights. Legislation on this question was considered
from January 1839 through 1841, and was therefore
a source of considerable public discussion.

45 See Gernsheim and Gernsheim,
L.J.M. Daguerre, pp. 181-2. The reproductive
engraving (a copy of Chapelle des Feuillants, a
painting exhibited by Daguerre in the Salon of
1814) was produced by Augustin François Lemaître
in 1827, for a series published in 1828 by Augustin
Liébert under the title *Galerie du Luxembourg, des
musées, chateaux royaux de France*.

46 See *Mirror of Literature, Amusement, and
Instruction* (London), 'View of Roslin Chapel at
the Diorama', 4 March 1826, front cover; *Mirror
of Literature, Amusement, and Instruction*, 'The
Diorama—Ruins in a Fog', 30 June 1827, front
cover; and *Mirror of Literature, Amusement, and
Instruction*, 'The Diorama, Regent's Park, The
Village of Unterseen, in Switzerland', 19 April 1828,
front cover. See also Arthur T. Gill, 'The London
Diorama', *History of Photography*, vol. 1, no. 1,
January 1977, pp. 31-6.

47 *Christian Register* (Boston), 'The Daguerrotype
[*sic*], or Solar Engraving', vol. 18, no. 982, 27 July
1839, n.p.

48 Von Berres first announced his experiments
with 'a very simple method of printing' from

daguerreotype plates in a short note in *Wiener Zeitung* on 18 April 1840. A longer article in the same journal followed on 3 May 1840. See Martin Jürgens, 'Metal and Ink', in *New Realities: Photography in the Nineteenth Century*, eds Mattie Boom and Hans Rooseboom, exhibition catalogue, Rijksmuseum, Amsterdam, 2017, pp. 112–19. For more on the work of Josef von Berres, see *Points of View: Capturing the 19th Century in Photographs*, eds John Falconer and Louise Hide, exhibition catalogue, British Library, London, 2009, pp. 12–13; and Gernsheim and Gernsheim, *L.J.M. Daguerre*, p. 110.

49 *Times*, 5 October 1839, p. 3, as quoted in *Sun Pictures: Catalogue Nineteen: Silver Anniversary*, eds Larry J. Schaaf and Russell Lord, exhibition catalogue, H. P. Kraus, Jr, New York, 2009, pp. 12–13. A similar overview was offered in the *Athenaeum*: 'Attempts at Engraving the Daguerreotype Pictures', October 1839, pp. 780–1. See also Stephen Pinson, 'Photography's Non-reproducibility, or, the Rhetoric of Touch', in Kathleen Stewart Howe (ed.), *Intersections: Lithography, Photography and the Traditions of Printmaking*, University of New Mexico Press, Albuquerque, 1998, p. 6.

50 For an overview of Fizeau's work, see Malcolm Daniel, 'The Beginnings of Photogravure in Nineteenth-Century France', in Mark Katzman (ed.), *Art of the Photogravure: A Comprehensive Resource Dedicated to the Photogravure*, 1995, https://photogravure.com/resources/texts, accessed 1 August 2018; Kathleen Stewart Howe, 'Hippolyte Louis Fizeau', in *University of New Mexico Art Museum: Highlights of the Collection*, ed. Peter Walch, exhibition catalogue, University of New Mexico Art Museum, Albuquerque, 2001, p. 66; and Maria Francesca Bonetti, 'Daguerreian Pictures: From Silver to Paper', *Daguerreotype Journal*, no. 1, June 2014, https://issuu.com/daguerreobase/docs/daguerreotype_journal_issue_n_0_jun, accessed 15 September 2018.

51 Charles-Marie Duchâtel, as quoted in Bonetti, 'Daguerreian Pictures', note 1.

52 Daguerre, in *Comptes rendus*, 30 September 1839, p. 423, as quoted in Gernsheim and Gernsheim, *L.J.M. Daguerre*, p. 110. As the *Athenaeum* reported in October 1839, Daguerre himself had already made some experiments along these lines: 'I [...] commenced a series of experiments with the aid of acids, and I obtained various results; [...] but the results were defective, and always for the reason before mentioned— namely, the impossibility of biting with acid, without the intervention of the engraver's art: besides, I knew that silver is too soft to give even a small number of impressions.' See Pinson, 'Photography's Non-reproducibility', p. 6.

53 Cited in Bonetti, 'Daguerreian Pictures', note 9.

54 From *Le Lithographie*, 1839, as quoted in Jeff Rosen, 'Lithophotographie: An Art of Imitation', in Howe (ed.), *Intersections*, p. 27.

55 From *Le Lithographie*, 1839, p. 318, as translated and quoted in Russell Lord, 'An Experience of Photography: *Excursions daguerriennes* and the Printed Photograph', lecture delivered at the Metropolitan Museum of Art, New York, 2010. A few years later, Noël-Marie Paymal Lerebours offered another method of making lithographs from daguerreotypes, in his *Treatise* of 1843: 'A great many researches have been made on the possibility of transferring Daguerreian images upon the lithographic stone. Up to the present time, these inquiries have been fruitless, and the only results which have attended them, consist in a method of transferring the image depicted on the plate, by means of a press, to a sheet of black paper covered with a coating of gelatin in a moist state. It is left in the press for about half an hour, and at the expiration of that time, dried in the sun; the paper then separates from the plate, and tracings of the Daguerreian image, more or less complete, will be seen on its surface.' N. P. Lerebours, *A Treatise on Photography: Containing the Latest Discoveries and Improvements Appertaining to the Daguerreotype*, trans. J. Egerton, Longman, Brown, Green & Longmans, London, 1843, as quoted in Bonetti, 'Daguerreian Pictures', n.p.

56 See the summary of the situation in *Impressed by Light: British Photographs from Paper Negatives, 1840–1860*, ed. Roger Taylor, exhibition catalogue, Metropolitan Museum of Art, New York, 2007, pp. 5–8. For an overview of the development of the Beard and Claudet studios, see Bernard Heathcote and Pauline Heathcote, *A Faithful Likeness: The First Photographic Portrait Studios in the British Isles, 1841–1855*, B. & P. Heathcote, Lowdham, 2002.

57 Daguerre to Isidore Niépce, October 1835, as quoted in *The Silver Canvas: Daguerreotype Masterpieces from the J. Paul Getty Museum*, eds Bates Lowry and Isobel Barrett Lowry, exhibition catalogue, J. Paul Getty Museum, Los Angeles, 1998, p. 45.

58 There has been considerable debate whether Daguerre was able to make daguerreotype portraits in 1839, or perhaps even earlier. This debate has concentrated on a small daguerreotype portrait said to be of a M. Nicolas Huet, a painter with the Museum of Natural History in Paris, and supposedly taken by Daguerre in 1837. However, the subject, date and attribution of this portrait are all in dispute. Quentin Bajac seems to believe it is by Daguerre. He reproduces the portrait in his booklet *The Invention of Photography: The First Fifty Years*, Thames & Hudson, London, 2002, with the following comment: 'in his correspondence Daguerre mentions some "quite successful" attempts at portraiture carried out between 1835 and 1837, including the recently

discovered plate, from around 1837' (pp. 28–9). Other scholars, however, have expressed some doubts about the date, as well as the identity of both the author and the subject. R. Derek Wood, for example, has pointed out that the painter Nicolas Huet died in Paris in 1830, seven years before Daguerre is supposed to have taken his portrait. For discussions of this image and its attribution, see André Gunthert, 'Daguerre ou la promptitude: Archéologie de la réduction du temps de pose', *Études photographiques*, no. 5, November 1998, pp. 4–25; Jacques Roquencourt, 'Daguerre et l'optique', *Études photographiques*, no. 5, November 1998, pp. 26–49; R. Derek Wood, 'A Note on the Daguerreotype Portrait said to be of "M. Huet, 1837"', *Midley History of Early Photography: R. Derek Wood's Articles on the History of Early Photography, the Daguerreotype and Diorama*, http://midley.co.uk/articles/Huet.htm; Jacques Roquencourt and André Gunthert, 'Note sur le portrait de M. Huet', *Études photographiques*, no. 6, May 1999, pp. 138–43. The possibility of taking portraits nevertheless haunts the earliest discussions of the daguerreotype. As mentioned, in October 1835 Daguerre wrote to Isidore Niépce to say that if photographic portraits could be made using their process, then 'it would sell itself for us'. Daguerre wrote again on 17 January 1838, to tell him 'I have made some experiments with portraiture, which succeeded well enough, so that I have the desire to show one or two of them in our exhibition. For complete success, however, a special apparatus is necessary.' A later letter backtracks a little: 'As to portraits, of which I told you that according to my experiments I am certain to be able to take them, this was solely to ascertain the possibility, for one must assume that people who would make quite nice pictures would also have luck with portraits [...] I am solely concerned to show that it is possible' (*The Silver Canvas*, p. 45). When asked about portraits on 24 January 1839 in an interview with Jules Pelletan, a correspondent for *La presse*, Daguerre said that 'he had not yet succeeded [...] to his satisfaction.' But in another interview with the Parisian art critic Jules Janin, published in *L'Artiste* on 28 January, Daguerre claimed that portraits would soon be possible and without requiring the preliminary studies that even such celebrated painters as Ingres relied upon (ibid, p. 45). During his announcement of Daguerre's invention on 7 January 1839, François Arago made no mention of portraiture. In his second report, in July 1839, Arago said that portraits required only a 'slight advance beyond' the daguerreotype's current state of development. But he was much less optimistic in his address of 19 August, when he declared that 'there is little ground for believing [... it] will ever serve for portraiture', despite what he said were Daguerre's continued experiments towards that end. In addition to these sometimes contradictory reports, we have the reminiscence of American inventor and pioneer photographer Samuel Morse, who had met Daguerre in Paris on 7 March 1839 and looked over some of the first daguerreotypes, including the earliest to have inadvertently included human figures. As Morse recalled in 1855: 'In my intercourse with Daguerre, I specifically conversed with him in regard to the practicality of taking portraits of *living persons*. I well remember that he expressed himself somewhat skeptical as to its practicality, only in consequence of the time necessary for the person to remain immovable.' As quoted in Sarah Catherine Gillespie, *Samuel F. B. Morse and the Daguerreotype: Art and Science in American Culture, 1835–55*, PhD, City University of New York, 2006, p. 153.

59 Sir John Robison, 'Part III. Perfection of the Art, as Stated in "Notes on Daguerre's Photograph"', *American Journal of Science and Arts*, vol. 37, no. 1, July 1839, pp. 183–5. Developments in France were closely reported in the English press, including information about photography. See, for example, 'Sun-Paintings', *Art-Union* (London), March 1839, p. 24, and 'New Discovery in Art', *Art-Union*, July 1839, p. 106. A sceptical author subsequently wrote: 'This is an invention of a lithographer, [yet] the wonder-working Daguerreotype, which was to send a host of engravers to parish workhouses, we have of late heard nothing; and we fancy, for all that was said, they may not be justified in meeting starvation half-way.' 'The Daguerreotype', *Chambers Edinburgh Journal*, no. 8, 24 August 1839, pp. 243, 327.

60 Arago's lecture of 19 August 1839 was not published, but detailed reports of it appeared in the press, including in *Galignani's Messenger*, the English-language newspaper of Paris, on 20 August 1839. This concise report was reprinted, minus some details, only three days later (23 August) in the *Globe* of London (p. 3) and then again in the *Art-Union*, vol. 1, no. 8, 15 September 1839, pp. 132–3.

61 See Louis Jacques Mandé Daguerre, *Historique et description des procédés du daguerréotype et du diorama, par Daguerre*, Nouvelle Edition, Alphonse Giroux et Co., Paris, November 1839, as quoted in Gernsheim and Gernsheim, *L.J.M. Daguerre*, p. 117.

62 Gernsheim and Gernsheim, *L.J.M. Daguerre*, pp. 116–17.

63 As quoted in Beaumont Newhall, *The Daguerreotype in America*, Dover, New York, 1975, p. 27.

64 See *Le daguerréotype français*, p. 161.

65 ibid, p. 162.

66 See Gernsheim and Gernsheim, *L.J.M. Daguerre*, p. 118.

67 Lerebours is reputed to have opened a daguerreotype portrait studio in Paris in 1841, as did Louis-Auguste Bisson (ibid, p. 121). For a history

of professional daguerreotype portrait studios in Paris, see Quentin Bajac's informative essay, '"Une branche d'industrie assez importante": L'économie du daguerréotype à Paris, 1839-1850' ['An industrial sector of considerable size': The economics of the daguerreotype in Paris, 1839-1850], in *Le daguerréotype français*, pp. 41-54.

68 See R. Derek Wood, *The Arrival of the Daguerreotype in New York*, American Photographic Historical Society, New York, 1994.

69 See William Welling, *Photography in America: The Formative Years, 1839-1900*, Thomas Y. Crowell Co., New York, 1978, p. 9.

70 Johnson's account of this event was published in 1846, and is reproduced in ibid, p. 10.

71 For more on the activities of this first studio, see Welling, *Photography in America*, pp. 13-14, 17-20; and *The Origins of American Photography: From Daguerreotype to Dry-Plate, 1839-1885: The Hallmark Collection of the Nelson-Atkins Museum of Art*, eds Keith F. Davis and Jane L. Aspinwall, exhibition catalogue, Nelson-Atkins Museum of Art, Kansas City, 2007, p. 18.

72 Richard Beard, Royal Letters Patent No. 8546, 13 June 1840. See Arthur T. Gill, 'Wolcott's Camera in England and the Bromine-Iodine Process', *History of Photography*, vol. 1, no. 3, July 1977, pp. 215-20; and Keith I. P. Adamson, 'Early British Patents in Photography', *History of Photography*, vol. 15, no. 4, Winter 1991, p. 315. The exact dates of the two transactions that Beard made with Wolcott and Johnson remain uncertain. In a diatribe against Claudet published in 1868, John Johnson claimed that 'on the 3rd of February, 1840, William S. Johnson (the father of John) sailed for London, and reached there about the close of the month, and immediately thereafter had an interview with Richard Beard, Esq., and with whom an agreement was entered into for the patenting of the mirror camera (the invention of Wolcott) in England.' He went on to say that 'Richard Beard, Esq., paid £200 and expenses for one-half of the American invention; the remaining half, with all profits, he purchased for £7000 at twelve months from the issuing of the American patent in London.' This would date Beard's purchase of one-half of the rights to the camera to about 1 March 1840, and the buying of the full rights to 13 June 1841. See John Johnson, 'A Chapter in the Early History of Photography', *Photographic News*, no. 12, 21 August 1868, p. 404.

73 See Bernard V. Heathcote and Pauline F. Heathcote, 'Richard Beard: An Ingenious and Enterprising Patentee', *History of Photography*, vol. 3, no. 4, October 1979, p. 314. See also Floyd Rinhart and Marion Rinhart, 'Wolcott and Johnson: Their Camera and Their Photography', *History of*

Photography, vol. 1, no. 2, April 1977, pp. 129-34; and Gill, 'Wolcott's Camera in England', pp. 215-20.

74 *Times*, 'Daguerreotype or Photographic Miniatures', 25 August 1840, p. 4e.

75 See Welling, *Photography in America*, p. 24.

76 The formula for Wolcott's Mixture, as remembered by John Johnson in 1852, is reproduced in ibid, p. 27.

77 Alexander Simon Wolcott and John Johnson, Royal Letters Patent No. 9672, issued 18 March 1843. By this time, Wolcott was living in Middlesex and Johnson was a Beard licensee in Manchester. On 9 November 1842, Johnson had acquired a licence for the daguerreotype process in the counties of Lancashire, Cheshire and Derbyshire, and took control of Beard's Photographic & Daguerreotype Portrait Gallery in Manchester. He returned to the United States in 1844.

78 On Goddard's experiments, see Antoine Claudet, 'Accelerating Process: Question of Priority Respecting the Discovery of the Accelerating Process in the Daguerreotype Operation', *Daguerreian Journal*, vol. 1, no. 6, 1 February 1851, p. 168; Jabez Hughes, 'The Discoverer of the Use of Bromine in Photography: A Few Facts and an Appeal', *Photographic Journal*, vol. 8, 15 December 1863, pp. 417-18; Jabez Hughes, 'The Bromine Question and Mr. J. F. Goddard', *Photographic News*, 13 May 1864, pp. 232-3; Gill, 'Wolcott's Camera in England', pp. 215-20. On 10 June 1841, for example, Claudet announced to the Royal Society that he had discovered a means of accelerating the sensitivity of a daguerreotype plate through the addition of a combination of chlorine and iodine vapour. Notwithstanding Goddard's experiments along the same lines, Claudet also had a report on his discovery read by Arago to the Académie des sciences in Paris. As a consequence of these declarations, Claudet would henceforth often be identified as one of the progenitors of photography. Claudet made a brief statement about his discovery at a meeting of the Royal Society on 10 June 1841 (the same meeting where Talbot described his calotype process); this was published in London in the *Proceedings of the Royal Society*, no. 315, and then reprinted in the *Athenaeum*, 17 July 1841, p. 541. Grand claims were made about the effects of this discovery: 'The momentary quickness with which the likeness is taken prevents the necessity for retaining a fixed look and posture for a certain time: this is not only more agreeable to the sitter, but gives a life-like ease and vivacity to the photographic portraits: thus the objections made to their stern and gloomy expression are obviated to a great degree; the most transient smile being reflected in the polished surface of the plate as in a mirror.' *Spectator*, 'Daguerreotype Portraits at the Adelaide Gallery', 16 April 1842, p. 379, as quoted in Adamson 'Early British Patents in Photography',

p. 318. The piece from the *Spectator* was also published under the same title in the *Bradford Observer*, no. 427, 21 April 1842, p. 1. In a letter to the editors of the *Philosophical Magazine and Journal* dated 23 February 1848, Claudet claimed to have communicated his discovery to the Académie des sciences on 22 June 1841. See *London, Edinburgh, and Dublin Philosophical Magazine and Journal*, vol. 32, no. 214, February 1841, pp. 215–16. As a consequence of Claudet's expert self-publicity, the history of photography recounted in the 1852 *Reports by the Juries* for the 1851 Great Exhibition credits 'the introduction of M. Claudet's accelerating process [...] (an invention which he liberally gave to the public through the medium of the Royal Society and the Académie des sciences)' for making it possible for 'two Daguerreotype establishments' to be formed in London. See *Reports by the Juries on the Subjects in the Thirty Classes into Which the Exhibition was Divided*, William Clowes & Sons, London, 1852, p. 276.

79 *Morning Chronicle*, 'Daguerreotype Portraits', no. 22090, 12 September 1840, as quoted in Gill, 'Wolcott's Camera in England', p. 215.

80 Patentees were required to give a full description of their invention within six months of the granting of their patent, so this 9 December document fulfilled that requirement for Beard's Royal Letters Patent No. 8546, of 13 June 1840. He was therefore able to include discoveries that had been made by Goddard in the intervening period.

81 From notes by John Frederick Goddard deposited with the Royal Society on 4 March 1841, as reproduced in Gill, 'Wolcott's Camera in England', p. 217.

82 ibid, p. 217.

83 Charles Wheatstone to William Henry Fox Talbot, 24 February 1841, doc. no. 4198, in Larry J. Schaaf (project director), *The Correspondence of William Henry Fox Talbot*, De Montfort University and University of Glasgow, http://foxtalbot.dmu. ac.uk/letters/letters.html.

84 The green labels on the back of the 1841 portraits of Talbot describe them as having been taken by 'Wolcott's Reflecting Aparatus' [*sic*]. The portrait of John Children, despite being mounted in the same frame as one of the Talbots, has a different green label on the back, this time describing the camera used as 'Wolcott's Reflecting Apparatus'. Given the early date of the Talbot photograph, this correction in the spelling suggests that the mistake was noticed after the first batch of labels was printed, and that the Children portrait, although still probably from 1841, came *after* the Talbot one. The same incorrect spelling can be seen on a label described in Stephen L. Odgers, 'A Labelled Wolcott Daguerreotype', *History of Photography*,

vol. 2, no. 1, January 1978, pp. 19–21; see also Arthur T. Gill, 'Further Discoveries of Beard Daguerreotypes', *History of Photography*, vol. 3, no. 1, January 1979, pp. 94–7.

85 John Johnson to William Henry Fox Talbot, 10 March 1841, doc. no. 4206, *The Correspondence of William Henry Fox Talbot*, http://foxtalbot. dmu.ac.uk/letters/letters.html, accessed 17 January 2019.

86 Talbot conceived of the calotype process following his observations of some chemical reactions in his studio on 23 September 1840. After further experiments and refinements, he announced this discovery in a letter (written on 5 February 1841) to the *Literary Gazette*, which was published in the issue of 13 February 1841. He took out a patent (no. 8842) on the process on 8 February 1841, under the title *Certain Improvements in Photography*. Interestingly, the patent also included his proposal for a means of transferring an image from paper to metal. The details of the calotype process were presented in a paper titled 'An Account of Some Recent Improvements in Photography', read at the 10 June 1841 meeting of the Royal Society. They were published two days later as part of a summary titled 'Fine Arts. Calotype (Photogenic) Drawing', *Literary Gazette*, no. 1273, 12 June 1841, p. 379. See Schaaf, *Photographic Art of William Henry Fox Talbot*, p. 236.

87 Goddard's lecture is described in some detail in Jehangeer Nowrojee and Hirjeebhoy Merwanjee, *Journal of a Residence of Two Years and a Half in Great Britain*, W. H. Allen & Co., London, 1841, pp. 362–4. See also Noel Chanan, 'The Daguerreotype in London: An Account by Two Visitors from India', *History of Photography*, vol. 5, no. 2, April 1981, pp. 155–6.

88 The lecture was published as 'On the Application of the Daguerreotype to the Taking of Likenesses from the Life', *Polytechnic Journal*, vol. 4, nos 1–6, April 1841, pp. 248–50; and in *Chemist*, vol. 2, May 1841, pp. 142–3.

89 *Times*, 'The Photographic or Daguerreotype Miniatures', 24 March 1841, p. 6d.

90 See Gill, 'Wolcott's Camera in England', pp. 216–17, 219.

91 Miles Berry, Royal Letters Patent No. 8194, 'Method of Obtaining the Spontaneous Reproduction of All the Images Received in the Focus of the Camera Obscura', issued in London on 14 August 1839, p. 1, lines 14–16, as quoted in Adamson, 'Early British Patents in Photography', pp. 313, 322. Berwick-on-Tweed is mentioned in patent documents of this period because it was an English–Scottish border town. See Heathcote and Heathcote, 'Richard Beard', p. 328.

92 These agreements are listed in the Chancery Proceedings for *Beard vs Holland*, 1842; see Heathcote and Heathcote, 'Richard Beard', pp. 315, 328. In addition to these various legal arrangements, Beard took out two Scottish patents to cover the Wolcott camera and Goddard's improvements to the process, no. 144 in December 1840 and no. 148 in November 1841, and also an Irish patent, no. 229, in April 1841. This meant that practitioners in those countries could use Daguerre's process without penalty, but not those aspects of photographic practice claimed by Beard. See 'Richard Beard (1801–1885)', in John Hannavy (ed.), *Encyclopedia of Nineteenth-Century Photography*, Routledge, New York, 2008, p. 126. It is interesting to note that, as soon as the Claudet studio was established, Claudet and Houghton also solicited Irish and Scottish customers: 'Parties residing in Ireland and Scotland furnished with the perfect apparatus, and instructed in the art of taking likenesses by Messrs. Claudet and Houghton.' See *Morning Post*, 'Under Her Majesty's Royal Letters Patent', 28 June 1841, p. 1d.

93 There is some uncertainty about who exactly was the proprietor of the business during its first year. Keith Davis, for example, states that 'while this business always operated under Beard's name, there is considerable evidence that it was, in fact, a Wolcott and Johnson enterprise, with Beard as an investor-partner'. *The Origins of American Photography*, p. 273, note 72. However, the only evidence Davis offers is the not-always-reliable reminiscences of John Johnson. It is true that the *Times* reported on 25 August 1840 (p. 4e) that Wolcott 'conjointly with Mr. Beard, an Englishman, has secured a patent for his invention for Great Britain'. Nevertheless, the patent issued on the Wolcott camera on 13 June 1840 was in the name of Richard Beard alone. So perhaps the business operated under joint control until Beard bought out the full patent on 13 June 1841. Certainly, by March 1841 all advertisements for the studio stressed that Richard Beard was the sole patentee. In any case, the situation remained confused; John Herschel wrote to Talbot about it on 22 March: 'I see a Mr Wollcott [*sic*] has taken out a patent for photographic portraits in 25 sec by a reflecting apparatus. He has opened rooms at the Polytechnic Institution Regent Street. I do not know the nature of his process. Probably some travestie or piracy of Daguerre's.' John Frederick William Herschel to William Henry Fox Talbot, 22 March 1841, doc. no. 4222, *The Correspondence of William Henry Fox Talbot*, http://foxtalbot. dmu.ac.uk/letters/letters.html, accessed 20 September 2018.

94 Opening in August 1838, it had become the Royal Polytechnic Institution only in 1841, after a visit on 9 December 1840 by Prince Albert, and his subsequent agreement to become its patron. See Weeden, *Education of the Eye*, p. 36.

95 These details are taken from a poster printed in 1840 to advertise the Polytechnic Institution's attractions, as reproduced in Weeden, *Education of the Eye*, p. 31, and from a typical advertisement for the Institution found in the *Art-Union*, vol. 4, no. 42, 1 July 1842, p. 149. At this time it cost a shilling to enter, thus adding this expense to the cost of a daguerreotype portrait made in the Beard studio.

96 This claim is made in, among other places, a letter written by Claudet to Peter Le Neve Foster, secretary of the Society of Arts, on 23 August 1865, and thus about forty-five years after the events being recalled. The information in it is therefore not entirely reliable. For example, Claudet appears to have compressed several events into a single swift and misleading opening paragraph. It is entirely possible that he saw Daguerre when he went to Paris in 1839, and that he took instruction from him at the Conservatoire national des arts et métiers, where, from September, Daguerre was offering regular demonstrations of his process. Claudet could very well have bought daguerreotypes made by Daguerre's pupils at these demonstrations. However, there is not much corroborating evidence to support the unlikely claim that Claudet bought a licence to practise directly from Daguerre himself. Nevertheless, Claudet did repeat the claim several times. In an advertisement in the *Times* of 23 June 1846, for example, he stated that he had 'purchased in the year 1839 from Mr. Daguerre himself the right of exercising his patented invention' (p. 1d). But when Claudet said in 1865 that he 'bought from him the first license to work out his process under the patent he had taken in England', he was presumably projecting forward to 25 March 1840, when he acquired a limited licence to sell or practise the daguerreotype in England from Daguerre's London-based patent agent, Miles Berry. Beard did not acquire such a licence for another year, purchasing the patent from Berry in June 1841. See Johnson, 'A Chapter in the Early History of Photography', p. 404. As it happens, Claudet took the only known photographic portrait of Peter Le Leve Foster, a carte-de-visite, at about the same time as he wrote this letter. See Arthur T. Gill, 'Peter Le Neve Foster and Cleopatra's Needle', *History of Photography*, vol. 3, no. 4, 1979, p. 289.

97 Claudet, in Johnson, 'A Chapter in the Early History of Photography', p. 404.

98 It seems that the licence was only a provisional arrangement (perhaps covering just the sale of daguerreotypes). Much later, in 1868, John Johnson claimed that Claudet's 'limited' licence 'was for the use of three cameras anywhere in England'. See Johnson's statement in 'A Chapter in the Early History of Photography', p. 404. Claudet recalled, again much later, in 1865, that his business partner, Houghton, had refused to allow him to buy the patent outright, at a cost of £800 (Claudet, in Johnson, ibid., pp. 404–5). He therefore sought to persuade others to bear the

cost and make the daguerreotype process freely available to all, as was the situation in France. This was also tried by Daguerre's own agent: on 30 March 1840, Miles Berry wrote to the Board of Treasury on Daguerre's behalf to inquire whether the British government would be interested in purchasing the rights to the daguerreotype process and making it available to all 'for the benefit of the public'. The offer was declined. See R. Derek Wood, 'The Daguerreotype Patent, the British Government, and the Royal Society', *History of Photography*, vol. 4, no. 1, January 1980, pp. 53–9, and the addendum in 'R. Derek Wood's Articles on the History of Early Photography, the Daguerreotype and Diorama', *Midley History of Early Photography*, http://midley.co.uk, accessed 14 August 2018. At the request of Sir John Lubbock, himself an amateur daguerreotypist, on 14 March 1840 Claudet lent some of his French daguerreotypes to a soirée at the residence of the Marquess of Northampton, who was president of the Royal Society. On the same day, Claudet wrote a letter to Lubbock, in French, suggesting that perhaps 300 wealthy Englishmen could be persuaded to each contribute £10 towards the purchase of the patent (thus putting its cost at £3000). His plea was ignored. Claudet subsequently wrote a letter to Isidore Niépce, the son of Nicéphore and also Daguerre's business partner, complaining about this outcome, with the comment that 'the English are little interested in what is not purely art'. As reported by Geoff Blackwell, 'Historical Group Visit to Paris 2011', *PhotoHistorian*, no. 165, Winter 2012-13, p. 47. In his 1865 letter to Peter Le Neve Foster, Claudet remembered that he had 'sent to the Royal Society's soirées the best specimens, after having submitted a collection of them to the Queen, who kept the best of them'. This letter was published in Johnson, 'A Chapter in the Early History of Photography', pp. 404–5. Contemporary evidence to support this claim includes an advertisement that appeared in the *Times* on 10 April 1840 (p. 2): 'Her Majesty and Prince Albert having been graciously pleased to purchase some specimens produced by the DAGUERREOTYPE, and to express their highest admiration of this wonderful discovery, it is under such excited patronage that CLAUDET and HOUGHTON beg to announce that they have on hand for sale a collection of beautiful specimens.' The same advertisement was repeated three more times in three different journals during this same month. Would Claudet and Houghton have made such a claim in the press, and risked a disastrous royal disclaimer, if it was not true? An advertisement for the sale of Lerebours-derived daguerreotypes issued by Claudet and Houghton that appeared in the *Athenaeum* on 14 September 1840 is similarly confidently headed 'Under the Patronage of Her Majesty'. On the basis of this evidence, Claudet's claim has been repeated as a fact by Helmut and Alison Gernsheim and other scholars. However, no corroborating evidence for this transaction has been found. There are, for example, no records of these daguerreotypes or their purchase in the Royal Collections. See

the sceptical investigation of Claudet's claim by R. Derek Wood in a series of letters exchanged with Helmut Gernsheim and others between 12 April 1993 and 17 January 1994: 'Correspondence', *Midley History of Early Photography*, http://.midley.co.uk, accessed 10 February 2018.

99 *Times*, 'The Daguerreotype', 3 March 1840, p. 3a.

100 ibid. It seems that Welshman John Dillwyn Llewelyn was an early customer at Claudet and Houghton's, and a surviving example of these daguerreotypes may have been bought by him and then later given to Talbot. It is mounted in a mat with pen inscriptions on its front: 'Daguerréotype Lerebours à Paris' underneath the plate, and its title, 'Campo Vacino à Rome', surrounded by flourishes, above. On the back are two paper labels, one advertising Claudet & Houghton's 'Sheet Crown Window Glass' and the other declaring this to be a 'Daguerreotype, Under Her Majesty's Royal Letters Patent'. This second label is marked as 'No. 91' in pen, along with the handwritten names of the proprietors: 'Claudet Houghton'. According to the memoir of John Llewelyn's daughter, Thereza, written in 1923 at the age of eighty-nine: 'My father, who went to London on purpose, was present at the first unpacking of the cases containing them when he bought a specimen, a beautiful specimen, representing Paris and the Bridges over the Seine.' As quoted in Noel Chanan, *The Photographer of Penllergare: A life of John Dillwyn Llewlyn 1810-1882*, Impress, London, 2013, p. 77. At least four Lerebours plates with Claudet and Houghton labels on the back found their way into the hands of the Llewelyn family, with one of them, bought for six guineas, depicting *Ste. Marie Majeure, Rome*. Thereza also remembers that the case at Claudet's included plates made by Daguerre himself. In a letter written in 1911, she recalled that 'My Father knew that Daguerre had sent them to London (to I think Claudet in Regent St.) and he was greatly excited about the work—and went there to try and get a specimen.' As quoted in Chanan, *Photographer of Penllergare*, p. 77. An advertisement in the *Times* of 28 October 1839 for the Adelaide Gallery claimed to have on show 'the only specimens of the DAGUEEREOTYPE [sic] in England executed by M. Daguerre himself'. See 'Royal Gallery of Practical Science', *Times*, 28 October 1938, p. 1. A letter sent by Talbot on 25 November 1839 duly recommends to his wife that she 'pay a visit to the Adelaide Gallery in Lowther's Arcade, and see M. Daguerre's pictures there, which are executed by himself. There is no extra charge – Let Nicole [Henneman] know of them in case he should like to spend his shilling in viewing them, & tell him they are not the same as what he saw when in Town with me last month'. Henry Talbot to Constance Talbot, 25 November 1839, doc. 3974, http://foxtalbot. dmu.ac.uk/letters/letters, accessed 10 August 2018. This may help to explain why plates by 'Daguerre' were apparently exhibited in Edinburgh in 1839 (listed as *View of the Tuilleries*, 'taken by

M. Daguerre'), London in 1841, and Glasgow in 1859. See Roger Taylor (ed.), *Photographic Exhibitions in Britain 1839-1865: Records from Victorian Exhibition Catalogues*, De Montfort University, Kraszna-Krausz Foundation and National Gallery of Canada, http://peib.dmu.ac.uk/indexphotographer.php?-thegroup=a, accessed 10 December 2017. Llewelyn himself made a number of daguerreotypes, including both family portraits and pictures of orchids, some of which he sent to William Hooker at the Royal Botanical Gardens in 1842. See Richard Morris, 'The Daguerreotype and John Dillwyn Llewelyn (1810-1882)', *Daguerreian Annual*, 1997, pp. 161-73.

101 As Lerebours claimed in his introduction to this publication: 'Thanks to the precision of the Daguerreotype, locations will no longer be reproduced after a drawing, which is always more or less modified by the taste and imagination of the painter.' For more on Lerebours' *Excursions daguerriennes, vues et monuments les plus remarquables du globe*, Rittner & Goupil, Paris, 1840-42, see Janet E. Buerger, *French Daguerreotypes*, University of Chicago Press, Chicago, 1989, pp. 27-49; *Le daguerréotype français*, pp. 356-7; and Foster, Heiting and Stuhlman, *Imagining Paradise*, pp. 34-7. I thank Russell Lord for sharing his research on *Excursions daguerriennes*.

102 *Le National*, 'Académie des sciences, séance du 13 janvier', 15 January 1840, p. 1, as quoted (in translation) in Theresa Levitt, 'Biot's Paper and Arago's Plates: Photographic Practice and the Transparency of Representation', *Isis*, vol. 94, no. 3, September 2003, p. 467.

103 Vernet, as quoted in Gernsheim and Gernsheim, *L.J.M. Daguerre*, 109.

104 See A. D. Bensusan, *Silver Images: History of Photography in Africa*, Howard Timmins, Cape Town, 1966, p. 7.

105 ibid, pp. 7-8.

106 See Bonetti, 'Daguerreian Pictures', pp. 38-9.

107 In 1869, another publisher, M. Dusacq, reissued *Excursions daguerriennes*, but with a new subtitle: 'The most remarkable views and monuments of the universe' (*Excursions photographiques: Vues et monuments les plus remarquables de l'univers ...*). In this publication, the words 'Daguerreotype Lerebours' have been replaced under each print with 'Photo. Dusacq et Cie.' Lerebours' publication was quickly joined by others that featured prints based on photographs, including *Album du daguerreotype reproduit* (1840), *Collection de vues de Paris, prises au daguerréotype, gravures en taille douce sur acier par chamouin* (c. 1849), *Recueil de vues principals de la Toscane* (c. 1854) and *Album de Touraine d'après le*

daguerreotype (1853). The earliest English example of such a book is Alexander Keith, *Evidence of the Truth of the Christian Religion, Derived from the Literal Fulfillment of Prophecy*, T. Nelson and Sons, London, 1849.

108 Lord, 'An Experience of Photography', n. p. Lerebours' publication was also discussed in some detail by David Brewster in the *Edinburgh Review* of January 1843: ' These Daguerreotype pictures, of which it is impossible to speak too highly, are engraved in *aqua tinta*, upon steel, by the first artists; and they actually give us the real representation of the different scenes and monuments at a particular instant of time, and under the existing lights of the sun and the atmosphere. The artists who took them, sketched separately the groups of persons, &c., that stood in the street, as the Daguerreotype process was not then sufficiently sensitive to do this of itself; but in all the landscapes, which shall now be reproduced by this singular art, we shall possess accurate portraits of every living and moving object within the field of the picture.' As transcribed in Goldberg (ed.), *Photography in Print*, p. 66.

109 Antoine François Jean Claudet, Royal Letters Patent No. 9957, issued 21 November 1843.

110 See Bonetti, 'Daguerreian Pictures', p. 39.

111 On Pattinson, see Graham Garrett, 'Canada's First Daguerreian Image', *History of Photography*, vol. 20, no. 2, Summer 1996, pp. 101-3, and 'Daguerreotypes: The Story of the Making of the Images', Newcastle University Library, 1997, http://ncl.ac.uk/library/specialcollections/collections/daguerreotypes/making.php, accessed 20 November 2017. Russell Lord's research has shown that Pattinson recorded in his diary that he made his initial daguerreotype of Niagara Falls on 3 April 1840, using a 20-minute exposure time, and that this was the first of at least eleven attempts on his part to capture it. I thank Russell Lord for sharing his paper, 'Canada's First Photograph?', delivered on 20 January 2012 at a conference titled 'About Photographic Collections: Definitions, Descriptions, Access', held at Ryerson Image Centre, Ryerson University, Toronto.

112 This acknowledgement accompanies Claudet's text, in French, with Plate 3, *Excursions daguerriennes*, n.p.

113 'This magnificent cataract is, without a doubt, one of the wonders of nature. It is impossible to contemplate its greatness without being filled with astonishment and admiration. The sublime effect produced by this immense curtain of water, which falls with majesty in such a deep abyss, raises the spirit toward the power that created such phenomena for man's contemplation, and makes him feel at the same time so weak and inferior. The view was taken from the Clifton Hotel, one mile

below the cataract, on the Canadian side or left bank of the Niagara River. This point of view is the most favorable because the spectator is precisely in front of the cataract, and, from there, all its vastness can be embraced at once.' An extract from Pattinson's text, as translated by Sylvie Penichon and Roger Watson; see 'Daguerreotypes: Excursions daguerriennes', Newcastle University Library, 1997, http://ncl.ac.uk/library/specialcollections/collections/daguerreotypes/excursions.php, accessed 20 November 2017.

114 These surviving plates are now in the collection of Newcastle University in the UK. See 'Daguerreotypes: Images of the Daguerreotypes', Newcastle University Library, 1997, http://ncl.ac.uk/library/specialcollections/collections/daguerreotypes/images.php, accessed 20 November 2017.

115 Talbot himself had acquired a daguerreotype camera from Paris and purchased an example from John Cooper at the Polytechnic Institution by 15 November 1839, and reported to John Herschel that 'Mr Lubbock has been very successful in his attempts'. See Talbot to Herschel, doc. 3971, 15 November 1839, http://foxtalbot.dmu.ac.uk/letters/letters.html, accessed 15 August 2017. The month before, Talbot had taken the trouble to meet with a Frenchman making daguerreotypes in London: 'I have made acquaintance with M. St. Croix who exhibits the Daguerre process at the Adelaide Gallery—He certainly makes bungling work some times, but at other times he succeeds, enough to let one see that it is not very difficult to execute it very well but the chief embarras [sic] is, that London plated copper will not answer (nobody knows why) & that it is therefore necessary at present to import the plates from Paris—If M. Arago knew this, he would say that it was a new proof that the invention was "vraiment Français" since the Art itself evinced an antipathy to England. The Daguerotype [sic] plates which I have seen, require to be held in a particular light; in some lights the picture vanishes almost entirely; but they are very perfect, if viewed in the proper way—They are rather too faint to adorn the walls of a picture gallery, but their chief merits come out when viewed by a magnifying glass, for then a variety of minutiæ are found to be represented which no artist could [illegible deletion] ever have time or skill enough to introduce.' Talbot to Elisabeth Feilding, 5 October 1839, doc. 3949, http://foxtalbot.dmu.ac.uk/letters/letters.html, accessed 10 August 2018. Apart from Sir John Lubbock's efforts, we could point to the example of Dr J.P. Simon of Dover, who translated Daguerre's Historique et description, gave several demonstrations of daguerreotypy, and in September 1840 claimed to be able to take portraits from life despite an exposure time of 15 minutes. See Adamson, 'Early British Patents in Photography', p. 314. John Dillwyn Llewelyn, related to Talbot by marriage and daguerreotyped by Claudet in the 1840s, was an enthusiastic

photographer, making his earliest daguerreotype in 'about 1840', with several more dated '1841' and '1843'. See Richard Morris, 'John Dillwyn Llewelyn 1810–1887', History of Photography, vol. 1, no. 3, July 1977, pp. 222–3, and Chanan, Photographer of Penllergare, pp. 89–92. We also have the evidence of the diaries of Lady Pauline Trevelyan, which suggest that daguerreotypes were being made by a number of amateur British photographers around this time. For example, she mentions seeing some pieces at the meeting of the British Association for the Advancement of Science, held in Glasgow in September 1840: 'The most beautiful thing here by far was a Daguerotype [sic] (the best I ever saw. It is a group of vases sculpture etc—having a piece of carpet for the background every stitch of which is quite visible with a microscope—the vases etc are arranged with taste & it is really a beautiful thing [...] a great quantity of different things. Among those I most remember were [...] a good many Daguerotypes [sic]—some views in Edinburgh excellent—there were one or two attempts at portraits—but they were indifferent.' The year before, on 8 November 1839, Trevelyan and her husband saw a daguerreotype of 'one of the Quais at Paris—the minutest objects beautifully defined', which was owned by Edinburgh optician John Adie. On 26 December in the same city the couple visited Dr David Reid's Exhibition of Arts and Practical Sciences, where she saw 'some Daguerotypes [...] none so good as that which Adie had'. In Edinburgh on 18 April 1840 she attended a lecture by Reid in which he demonstrated the daguerreotype process and showed 'one Daguerotype done here', as well as a still life of a group of marble statues made in Paris. In December 1840 she saw some more daguerreotypes at the home of Sir David Brewster, 'executed by Davidson of Edinburgh, there were views of Edinburgh'. By April 1841 she had begun to collect daguerreotypes herself, buying some from James Howie in Edinburgh: 'saw some portraits not very good'. She also mentions seeing daguerreotypes made by 'John Fonblanque' in London in June 1841 and in December, in Rome, by Allan Maconochies. As quoted in Schaaf, '"Splendid Calotypes"', pp. 326–41. John Ruskin, writing some forty-five years later, recalled receiving some French daguerreotypes in 1840: 'My Parisian friends obtained for me the best examples of his [Daguerre's] results; and the plates sent to me in Oxford were certainly the first examples of the sun's drawing that were ever seen in Oxford, and, I believe, the first sent to England.' Two surviving French daguerreotypes held in an Oxford collection bear the label of a French framer (rather than the label of Claudet and Houghton), perhaps confirming Ruskin's story. See Ken Jacobson and Jenny Jacobson, Carrying Off the Palaces: John Ruskin's Lost Daguerreotypes, Bernard Quaritch, Ltd., London, 2015, pp. 2, 216–17. Even earlier than these examples is the photograph referred to in a letter published in the Freeman's Journal in Dublin on 24 August 1839, five days after the details of the daguerreotype were released in Paris:

'I send you the enclosed specimen, but our days of late having been cloudy, you cannot expect it to be as perfect as I would wish.' The unnamed writer also claimed to be making 'silver on paper' photographs. See Peter Walsh, 'Dublin's First Look into the Camera: Some Daguerreotype Portrait Studios of the 1840s', *Dublin Historical Record*, vol. 62, no. 1, Spring 2009, p. 36.

116 The Adelaide Gallery is thus described in *Mogg's New Picture of London and Visitor's Guide to Its Sights* (1844), as quoted in Lee Jackson (ed.), *The Dictionary of Victorian London*, http://.victorianlondon.org/entertainment/adelaidegallery.htm, accessed 10 February 2017.

117 The advertisement appeared in the *Times*, 18 January 1839, p. 4b.

118 V. Staněk, in *Ceska vcela*, 8 March 1839, as quoted in *Co Je Fotografie: 150 Let Fotografie* [What is photography: 150 years of photography], ed. Daniela Mrázková, exhibition catalogue, VideoPress, Prague, 1989, p. 27. This analogy was repeated by later commentators, including David Brewster, who claimed in an essay in the *Edinburgh Review* in 1843 that photography was 'as great a step in the fine arts, as the steam-engine was in the mechanical arts'. This claim was subsequently quoted as the opening to a short essay of unknown authorship titled 'Further Improvements in Photography', which discusses the introduction of colour to daguerreotypes and is followed by an advertisement for all three of Beard's London studios, along with a selection of extracts from press reports about these same studios. Brewster's words were also quoted, without using his name, on a large trade card, printed in colour, used to advertise the Beard studios, probably issued in about 1843. Claudet also compared photography to the steam engine in essays published in 1845 and 1852. In 1845, for example, he wrote an essay titled 'The Progress and Present State of the Daguerreotype Art', offering a history of its development since 1839. In it he suggests (perhaps channelling Brewster's words again) 'that the discovery of the daguerreotype was as great a step in the fine arts as that of the steam engine in the mechanical arts'. The essay finishes with some remarks about various efforts to engrave the image formed by light on a daguerreotype plate by means of a chemical operation, thus allowing a multitude of permanent ink-on-paper copies of that image to be made. He particularly praises the process developed by French photographer Hippolyte Fizeau. See Antoine Claudet, 'The Progress and Present State of the Daguerreotype Art', *Transactions of the Society for the Encouragement of Arts, Manufactures and Commerce*, no. 55, 1 July 1845, p. 89; and Steve Edwards, *The Making of English Photography: Allegories*, Pennsylvania State University Press, University Park, 2006, pp. 54, 311.

119 The *Times* reported on 14 September 1839 that a 'M. St. Croix' had just arrived from Paris with a camera and was exhibiting samples of the daguerreotypes he had made in London's Piccadilly: 'the picture produced was a beautiful miniature representation of the houses, pathways, sky, etc.' (p. 1). This is thought to have been among the first daguerreotypes made in England. See R. Derek Wood, 'Ste Croix in London, 1839', *History of Photography*, vol. 17, no. 1, Spring 1993, pp. 101–7; Peter James, 'Ste Croix and the daguerreotype in Birmingham', *History of Photography*, vol. 17, no. 1, Spring 1993, pp. 107–15; and R. Derek Wood, 'Preliminary Research on the Daguerreotype in Liverpool in 1839: Ste Croix, A. Abraham and J. B. Dancer; With an Addendum Letter by Frederic Luther (1915–2000)', *Midley History of Early Photography*, http://midley.co.uk, accessed 10 July 2017. It seems that St. Croix operated and lectured without permission from Miles Berry, Daguerre's English patent agent. Cooper, on the other hand, announced that 'under a licence from the Patentee, Mr. J. T. Cooper will exhibit pictures and all particulars connected with this beautiful and important art by means of a lecture, in the Theatre of the Polytechnic Institution […] on Tuesdays, Thursdays and Saturdays, at 2 o'clock.' *Times*, 8 October 1839, p. 2. A number of correspondents wrote to tell Talbot that they had heard one of Cooper's lectures. On 7 October 1839 Thomas Bonney, for example, told Talbot: 'I was one day at the Polytechnicon, and heard a Lecture upon Photogenic Drawing, in which of course your name as Inventor was frequently mentioned.' Thomas Kaye Bonney to William Henry Fox Talbot, 7 October 1839, doc. no. 10030, *The Correspondence of William Henry Fox Talbot*, http://foxtalbot.dmu.ac.uk/letters/letters.html, accessed 16 September 2017. John Lubbock similarly reported on 2 November 1839 that 'I saw Cooper at the Polytechnic taking a drawing with the Oxy hydrogen Microscope in three minutes.' John William Lubbock to William Henry Fox Talbot, 2 November 1839, doc. no. 3968, *The Correspondence of William Henry Fox Talbot*, http://foxtalbot.dmu.ac.uk/letters/letters.html, accessed 16 September 2017. By 15 November Talbot had purchased a daguerreotype from Cooper: the whole-plate view of All Souls Church, Langham Place, London, already described—Talbot had been married in that church.

120 *Mirror of Literature, Amusement, and Instruction*, 'M. Daguerre's Process of Engraving', vol. 34, no. 973, 19 October 1839, pp. 257–8. See also *London Saturday Journal*, 'The Daguerreotype', November 1839, pp. 283–5.

121 Nowrojee and Merwanjee, *Journal of a Residence*, p. 362.

122 ibid, pp. 112–13; 126–7.

123 See Edwards, *The Making of English Photography*, for an extended history of English photography along these lines.

124 On silhouette machines and the physionotrace, see Gernsheim and Gernsheim, *L.J.M. Daguerre*, pp. 114–16; Penley Knipe, 'Shades and Shadow-Pictures: The Materials and Techniques of American Portrait Silhouettes', *The Book and Paper Group Annual*, vol. 18, American Institute for Conservation, 1999, http://cool.conservation-us.org/coolaic/sg/bpg/annual/v18/bp18-07.html, accessed 10 January 2017; and Victor I. Stoichita, 'Man and his Doubles', and 'Of Shadow and its Reproducibility During the Photographic Era', in *A Short History of the Shadow*, Reaktion Books, London, 1997, pp. 153–99, 253–6.

125 Johnson, 'A Chapter in the Early History of Photography', p. 404.

126 ibid. On the supplier of plates, see R. Derek Wood, 'Daguerreotype Case Backs: Wharton's Design of 1841', *History of Photography*, vol. 4, no. 3, July 1980, pp. 251–2.

127 *Spectator*, 'Sun Limned Portraits', 20 March 1841, pp. 283–4.

128 The cartoon and poem appeared in Laman Blanchard (ed.), *George Cruikshank's Omnibus: Illustrated with One Hundred Engravings on Steel and Wood*, Tilt and Bogue, London, 1842, pp. 29–32. For an account of the later association of blue light with therapeutic properties, see Tanya Sheehan, '"Panes Curing Pains": Light as Medicine in the Photographic Studio', *Doctored: The Medicine of Photography in Nineteenth-Century America*, Pennsylvania State University Press, University Park, 2011, pp. 81–105, 170–5.

129 In one essay, Steve Edwards states unequivocally that 'it is a representation of Jabez Hogg'. Steve Edwards, '"Beard Patentee": Daguerreotype Property and Authorship', *Oxford Art Journal*, vol. 36, no. 3, 2013, p. 381. It certainly looks like Hogg, based on surviving daguerreotypes of the man. For more on the career of Jabez Hogg, see Robert B. Fisher, 'The Hogg Connection', *Daguerreian Annual*, 1990, pp. 101–13. Fisher reports that 'no documentation has come to light (through directories or other literature) to show that Hogg was ever an employee of the Beard studios [...] It is much more likely that he was an ardent amateur photographer' (p. 104). However, Steve Edwards quotes an affidavit sworn by Hogg on 5 September 1842 in which Hogg states that he was an 'assistant to Richard Beard at the Photographic establishment, 34 Parliament Street'. Edwards, '"Beard Patentee"', p. 380. Hogg, eventually an ophthalmic surgeon, also published a booklet titled *Photography Made Easy* in which he commented on Beard's lawsuit against Egerton, remarking on 'the injustice and validity of the patent' and offering

'suggestions for rendering such a patent a virtual dead letter'. See Helmut Gernsheim and Alison Gernsheim, *The History of Photography from the Earliest Use of the Camera Obscura in the Eleventh Century Up To 1914*, Oxford University Press, London, 1955, p. 106.

130 Francis Beatty has left us with a usefully detailed description of the operation of the Wolcott camera: 'The apparatus used was a rectangular box; at one end inside was fixed the concave mirror, the other end being open to the sitter; the focus of the reflecting mirror was 16 inches, its diameter 6 inches. About the focus of the mirror a little pedestal carrying the two sides of a small frame was standing, capable of being moved forward and backward; this pillar was fixed at its base to a piece of brass sliding in a slot screwed to the bottom of the box. This pedestal and little frame was so adjusted that the middle of it was directly in the true focus of the mirror; consequently, when the focusing-glass was in the frame, the slot and pedestal resting on it could, by an arrangement on the outside, be moved as desired by the operator to procure the focus. On the two sides and at their back were two little springs, so that the focusing-glass or plate would be firmly held during the operation that was required. The operator having made all his arrangements, not forgetting the posing of his sitter, the sensitive plate was handed to him out of the dark-room; he tells the sitter what he is going to do, throws a dark cloth over the open end of the rectangular box, opens a small door in it opposite the pedestal, introduces his hand, with the box and plate, he lifts the focusing-plate out of the frame, puts the silver tablet in its place, withdraws his hand with empty box, closes the door, withdraws the cloth from the front of the box, and exposes.' Francis S. Beatty, 'Some Historical Recollections of the Application of Photography to Portraiture', in *The Year-Book of Photography and Photographic News Almanac*, Piper & Carter, London, 1884, p. 78.

131 The Polytechnic was open in the afternoons, followed by a short closure, and then opened again for a second evening session. It was closed on Saturday evenings and on Sundays. Weeden, *Education of the Eye*, p. 23. Wolcott mentioned in a letter in 1843 that the studio sometimes took forty portraits a day. Alexander Wolcott, 'Photography in its Infancy', *American Journal of Photography*, vol. 3, no. 8, 15 September 1860, pp. 142–3.

132 Walter Benjamin, 'Little History of Photography' (1931), trans. Edmund Jephcott and Kingsley Shorter, in Jennings, Doherty and Levin, *Work of Art in the Age of Its Technical Reproducibility*, pp. 279, 280.

133 For more on Maria Edgeworth and her portraits, see Michael G. Jacob, 'A Visit to Mr. Beard's', *Daguerreian Annual*, 1994, pp. 154–65. In about 1799 Edgeworth had enjoyed some

contact with Humphry Davy, co-author of the first published account of photographic experiments in 1802, when she visited Dr Thomas Beddoes' Pneumatic Institute (she was the sister of Beddoes' wife). Davy, who then worked at the Institute, was administering visitors with nitrous oxide and recording the results; apart from Edgeworth, these visitors included Tom Wedgwood, Robert Southey and Samuel Taylor Coleridge. Davy described the experience as 'thrilling': 'Trains of vivid visible images rapidly passed through my mind, and were connected with words in such a manner, as to produce perceptions perfectly novel. I existed in a world of newly connected and newly modified ideas. I theorized—I imagined I made discoveries.' Joan Digby and Bob Brier (eds), *Permutations: Readings in Science and Literature*, Quill, New York, 1985, pp. 250–4. Edgeworth offered a tart, corrective view: 'I have seen some of the adventurous philosophers who sought in vain for satisfaction in the bag of *Gaseous Oxyd*, and found nothing but a sick stomach and a giddy head.' As quoted in T. E. Thorpe, *Humphry Davy: Poet and Philosopher*, Cassell & Co., London, 1896, p. 49.

134 Maria Edgeworth to Fanny Wilson, 25 May 1841, as quoted in Christina Colvin (ed.), *Maria Edgeworth: Letters from England 1813–1844*, Clarendon Press, Oxford, 1971, pp. 593–4.

135 Maria Edgeworth to Fanny Wilson, 28 May 1841, as quoted in Jacob, 'A Visit to Mr. Beard's', pp. 156–7.

136 John Tagg, 'A Democracy of the Image: Photographic Portraiture and Commodity Production' (1984), in *The Burden of Representation: Essays on Photographies and Histories*, University of Massachusetts Press, Amherst, 1988, p. 37.

137 ibid.

138 For a more thorough discussion of the various cases offered by the Beard studio, see Robert B. Fisher, 'The Beard Photographic Franchise in England: An Overview of Richard Beard's Licensed Daguerreotype Portrait Galleries and Their Products in the 1840s', *Daguerreian Annual*, 1992, pp. 73–95.

139 Thomas Sutton, 'Reminiscences of an Old Photographer', *British Journal of Photography*, 30 August 1867, p. 413.

140 ibid.

141 This early portrait of Claudet sold at an auction run by Special Auction Services in the UK on 15 May 2013; it was listed as 'Antoine Francois Jean Claudet (1797–1867), ninth plate self portrait daguerreotype, seated in profile, writing with quill pen, painted backdrop behind, in folding Morocco case, with gilt stamp "Claudets Daguerreotype

Process, Adelaide Gallery Strand", 1841–1844, G, case hinge broken.'

142 On page 73 of *Historique et description des procédés du daguerréotype et du diorama*, Daguerre referred to the problem of the lateral reversal of images: 'This camera obscura has the defect of transposing objects from right to left, which is of little or no consequence, with a great number of objects; but if the operator is desirous of obtaining a view according to nature, a parallel glass should be added in front of the diaphragm [...] But as this reflection occasions a loss of light, one-third more time should be reckoned upon to make the drawings.' The diagram that accompanies this suggestion shows such a 'parallel glass' in place. On 11 November 1839 a Parisian optician named Cauche exhibited a prism lens capable of producing an image that was not laterally reversed, thereby doing away with the need for an added 'parallel glass' or re-reversing mirror. Théodore Maurisset's lithograph derisively titled *Daguerreotypomania* and published in December 1839 features a crowd trying to get into the studio of Susse Frères. Over the entrance is a large sign proclaiming that 'non-inverted pictures can be taken in 13 minutes without sunshine'. Despite the handicap of longer exposure times, in July 1841 Charles Chevalier introduced a version of his portable 'Photographe' camera that included a mirror prism fixed in front of the lens. After Daguerre moved to Bry-sur-Marne in January 1841, he took to using the superior Chevalier camera rather than the one marketed by himself and Giroux. For a brief discussion of French daguerreotype cameras and their evolution, see Gernsheim and Gernsheim, *L.J.M. Daguerre*, pp. 103, 110, 120.

143 *Spectator*, 'Photographic Miniatures', 4 September 1841, pp. 860–61, as transcribed in http://archive.spectator.co.uk/article/4th-september-1841/20/photographic-miniatures, accessed 10 June 2017.

144 Antoine François Jean Claudet, 'Photographic Miniatures: To the Editor of The Spectator', *Spectator*, no. 689, 8 September 1841, pp. 877–8. Claudet subsequently wrote a letter to the *Literary Gazette* to offer a theory as to how the electrotype process worked. It was published as 'Daguerreotype and Electrotype', *Literary Gazette*, no. 1301, 25 December 1841, p. 838. Although we have yet to identify any examples of etchings pulled from daguerreotype plates by Claudet, he did exhibit a number of them at the 1845 British Association exhibition in Cambridge. These included several portrait etchings (including portraits of both Claudet himself and of Justus von Liebig, whose engraving was shown next to his daguerreotype portrait) as well as an impression of the Theseus figure from the Parthenon Marbles. Interestingly, Claudet also exhibited an etching from a daguerreotype copy of a calotype-derived image that he and Talbot had made, of a boy

189

with parrot and cage. Talbot mentioned their collaboration in a letter to his mother dated 18 April 1845: 'Today I made a picture of a boy with a cage and a grey parrot at Claudet's—It will make a very pretty tableau Flamand. The parrot *sat* beautifully, evidently understanding what we were doing.' The parrot, being stuffed, had no choice but to sit still, and did so uncomplainingly in a number of later interior daguerreotypes taken in Claudet's studio. But Talbot's reference to Flemish genre pictures is a reminder that this kind of art was in fashion in mid-nineteenth-century Britain, a fashion that perhaps both Talbot and Claudet were keen to exploit. William Henry Fox Talbot to Elisabeth Theresa Feilding, 18 April 1845, doc. no. 5231, *The Correspondence of William Henry Fox Talbot*, http://foxtalbot.dmu.ac.uk/letters/letters.html, accessed 10 March 2016.

145 See *Mechanic's Magazine, Museum, Register, Journal and Gazette*, 'Important Combination of the Electrotype with the Daguerreotype Process', vol. 35, 3 July – 25 December 1841, p. 223. Grove's paper was also reported in *New Zealand Gazette and Wellington Spectator*, 'Drawn by Light and Engraved by Electricity', vol. 3, no. 158, 13 July 1842, p. 2. A more detailed description of the process, including the claim that the copper facsimile looked like a 'beautiful sienna-coloured drawing of the original design', can be found in W. Strange (ed.), 'Etching Daguerreotype Plates by a Voltaic Process (Read at the Electrical Society)', *Bradshaw's Manchester Journal*, vol. 1, October 1841, pp. 294–5. Unfortunately, none of Claudet's electrotyped copies has come to light. Perhaps due to Claudet's efforts at promotion, Grove's process also features in Lerebours, *A Treatise on Photography*, pp. 127–36.

146 Antoine François Jean Claudet, Royal Letters Patent No. 9193, issued 18 December 1841. A report in the *Spectator*, 16 April 1842, p. 379, claimed that 'the addition of a background of trees, architecture, or a library, takes away from the metallic effect of the plate; and gives to the miniature the appearance of an exquisitely finished mezzotint engraving'. It seems that Claudet had also adopted Fizeau's gold-toning process: 'The fixing process, too, imparts a warm brownish tinge to the miniature; substituting the tone of a sepia drawing for the livid coldness of the metallic surface.' As quoted in Adamson, 'Early British Patents in Photography', p. 318.

147 Michael Pritchard, 'Artificial Lighting', in Hannavy (ed.), *Encyclopedia of Nineteenth-Century Photography*, p. 84.

148 Richard Beard, Royal Letters Patent No. 9292, issued 10 March 1842.

149 Heathcote and Heathcote, 'Richard Beard', pp. 313–29, and Heathcote and Heathcote, *A Faithful Likeness*.

150 Licensees could also call on the expert assistance of Beard's team of operators. For example, Lewis Weston Dillwyn recorded in his diary on 18 September 1841 that he and his daughter 'had our likenesses taken at a new Photographic Institute which within these days has been opened [in Cheltenham], and I afterwards attended a lecture by Mr. Goddard on photography'. He also recorded that other friends visited this new studio, run by licensee John Palmer, on 20 and 21 September. The studio had taken out an advertisement in the *Cheltenham Looker-On* on 11 September, two days before it opened, appealing to 'The Nobility, Gentry, and Inhabitants of Cheltenham, Gloucester, and their vicinities' as potential customers: 'These unerring likenesses are produced by the agency of light in a few seconds, and are as exquisite in detail as they are undeviating in fidelity to their originals; in both respects they stand pre-eminent over every effort of the human hand.' For reproductions of the daguerreotypes taken of Lewis Dillwyn (father of John Dillwyn Llewelyn) and his daughter Mary, see Morris, 'The Daguerreotype and John Dillwyn Llewelyn', pp. 162–3.

151 F.S. Beatty, 'Some Historical Recollections of Photography', *Photographic News*, 8 August 1879, pp. 382–3.

152 ibid.

153 ibid.

154 *Times*, 19 April 1842, p. 5.

155 George Goodman, 'Photographic Portraits', *Australian*, 9 December 1842, as reproduced in Davies and Stanbury, *The Mechanical Eye in Australia*, p. 123.

156 Jack Cato, *The Story of the Camera in Australia*, Georgian House, Melbourne, 1955, pp. 4–5; *Shades of Light*, pp. 6–9, 174; and Sandy Barrie, 'G.B. Goodman, Australia's First Daguerreotypist', *Daguerreian Annual*, 1995, pp. 173–8. On 8 November 1845, the *South Australian Register* reported that an Adelaide-based painter and illustrator, Samuel Thomas Gill, had imported daguerreotype equipment from Beard, along with specimens of work, which Gill then exhibited next to his own. The reporter claimed: 'the specimens we have seen far surpass those of the patentee, Mr. Beard'. As quoted in Cato, pp. 170–1. Thanks to Gael Newton and Marcel Safier for sharing their research and expertise.

157 'Daguerreotype', *Sydney Morning Herald*, 4 May 1846, p. 2; Davies and Stanbury, *The Mechanical Eye in Australia*, p. 8.

158 'Daguerreotype', *Sydney Morning Herald*, 13 April 1843, p. 3. In one advertisement that Goodman placed in the *Sydney Morning Herald*

of 28 November 1844 he reported that 'he has just received from the Patentee in England, the new process, lately discovered, of colouring the Daguérréotype [sic] Portraits' (p. 3). On 14 January 1846, Goodman advertised in the *South Australian Register* his 'special advantage of obtaining from the patentee in England every recent improvement of the art of the Daguerreotype'—yet further evidence that he remained part of the Beard franchise system.

159 The advertisement was headed 'Coloured Daguerreotypes!!!' and appeared on page 3 of the *Sydney Morning Herald* of 28 November 1844.

160 Wolcott, 'Photography in its Infancy', pp. 142–3.

161 The number of letters is referred to in Heathcote and Heathcote, 'Richard Beard', p. 320, with the information coming from the documents accompanying the Chancery Proceedings for *Beard vs Holland* in 1843.

162 For more on these legal actions, see Heathcote and Heathcote, 'Richard Beard', pp. 313–29; R. Derek Wood, 'The Daguerreotype in England: Some Primary Material Relating to Beard's Lawsuits', *History of Photography*, vol. 3, no. 4, October 1979, pp. 305–9; R. Derek Wood, 'Daguerreotype Shopping in London in February 1845', *British Journal of Photography*, vol. 126, no. 6224, 9 November 1979, pp. 1094–5.

163 Alexander Wolcott, letter to associates in New York, dated 15 November 1841, reproduced in *American Journal of Photography*, 15 September 1860, p. 143. Interestingly, a John Edwards, 'who served his apprenticeship in London with Antoine Claudet', opened a studio in Glasgow in 1842, 'perhaps attracted to Scotland because it was outside the daguerreotype patent'. Roddy Simpson, *The Photography of Victorian Scotland*, Edinburgh University Press, Edinburgh, 2012, p. 15. Edwards advertised a studio in Dumfries in March 1843; on 7 September that year he published an advertisement in the *Stirling Observer*, in which he claimed to be 'Mr Edwards of the Royal Adelaide Gallery, London'.

164 Claudet, in a letter to Talbot dated 18 January 1843, referred to 'mon concurrent & ennemi acharné Mr Beard'. Antoine François Jean Claudet to William Henry Fox Talbot, doc. no. 4700, *The Correspondence of William Henry Fox Talbot*, http://foxtalbot.dmu.ac.uk/letters/letters.html, accessed 15 July 2017.

165 *Literary Gazette, and Journal of Belles Lettres, Arts, Sciences*, July 1841, p. 494. Thanks to Karen Hellman for this reference.

166 Herbert Ingram, 'Our Address', *Illustrated London News*, no. 1, 14 May 1842, p. 1a.

167 In his 1893 memoir, Henry Vizetelly recalled that Ingram approached him for advice about publishing a newspaper illustrated with wood engravings; Vizetelly 'pointed out the facilities which the recent discovery of daguerreotype gave for the publication of portraits of political and other celebrities'. Nevertheless, most of the illustrations in early issues were drawn directly onto boxwood blocks by artists like John Gilbert, using only written descriptions as a guide. One picture of Hamburg was drawn from an antique print found in the British Museum. See Henry Vizetelly, *Glances Back Through Seventy Years: Autobiographical and Other Reminiscences*, vol. 1, Kegan, Paul, Trench, Trubner & Co., London, 1893, p. 226.

168 For histories of wood engraving as a means of illustration, see Gerry Beegan, 'Wood Engraving: Facsimile and Fragmentation', in *The Mass Image: A Social History of Photomechanical Reproduction in Victorian England*, Palgrave MacMillan, New York, 2008, pp. 47–71; John Buchanan-Brown, 'Wood Engraving in Britain', in *Early Victorian Illustrated Books: Britain, France and Germany 1820–1860*, British Library and Oak Knoll Press, London, 2005, pp. 286–91; and Robert Taft, 'Photography and the Pictorial Press' (1938), in *Photography and the American Scene: A Social History, 1839–1889*, Dover, New York, 1964, pp. 419–50. For an account of wood engraving from the perspective of a practitioner, illustrated with a photograph of the author at work as an apprentice wood engraver, see Paul Martin, 'Victorian Wood-Engraving', in *Victorian Snapshots*, Country Life Ltd, London, and C. Scribner's Sons, New York, 1939, pp. 1–18.

169 The commentary was published by the *Drogheda Argus* (along with a helpfully detailed description of the production of the print) and then reproduced in *Illustrated London News*, no. 12, 30 July 1842, p. 192.

170 The figures come from Gerry Beegan, 'The Mechanization of the Image: Facsimile, Photography, and Fragmentation in Nineteenth-Century Wood Engraving', *Journal of Design History*, vol. 8, no. 4, 1995, p. 258.

171 *Morning Post*, 12 January 1842, as quoted in *Illustrated London News*, 30 July 1842, p. 192.

172 For more on this and other panoramic prints from this period, see *Gilded Scenes and Shining Prospects: Panoramic Views of British Towns, 1575–1900*, ed. Ralph Hyde, exhibition catalogue, Yale Center for British Art, New Haven, 1985, pp. 192–3. Interestingly, Jacques Charles said that the first panorama painting to be made in France, *View of Paris from the Tuileries*, produced by Pierre Prévost and others in 1799, was created using a 'special camera obscura, which revolved on a pedestal, from the top of the dome of the Tuileries. In this manner, a series of twelve drawings were produced and then joined together as preparation

for the final painting'. See Pinson, *Speculating Daguerre*, p. 76. Prévost went on to produce a similarly ambitious panoramic painting of London in 1815, based on drawings he made while perched in the tower of St Margaret's Church in Westminster. The painting, which was 30 metres long, was exhibited in Paris in 1817. See Maeve Kennedy, 'Museum Snaps Up Panorama of Lost London Landscape', *Guardian*, 11 July 2018, http://theguardian.com/culture/2018/jul/11/museum-snaps-up-panorama-of-lost-london-landscape, accessed 16 August 2018.

173 Australians, for example, were avid readers of the *Illustrated London News*; a Dr Maberley of Market Street, Sydney, had a complete run of 200 volumes auctioned with the effects of his house in 1849. *Sydney Morning Herald*, 13 February 1849, p. 4 (thanks to Alan Davies for this reference). By 1851, when Harden Melville completed a painting titled *Australia: News from home*, it seems that even itinerant workers in the Australian bush were able to get copies. A reclining man in a tent in the outback is shown perusing his copy of the *Illustrated London News* dedicated to the Great Exhibition, which had opened in London in May of 1851. During that year's issues, such a man would have encountered no fewer than twenty-seven wood engravings made after daguerreotypes by the London photography studio of Antoine Claudet alone. British artist John Dalbiac Luard's 1857 painting *A welcome arrival 1855* shows British soldiers in their hut in the Crimea, the hut lined with wood engravings cut from the *Illustrated London News*. The same paper features in a number of *trompe l'oeil* drawings created in New Zealand by Harry Wrigg in 1867 and William Gordon in 1878 and by Wooldridge Frankcom in Australia in 1889 and 1893. See *Stray Leaves: Colonial Trompe l'Oeil Drawings*, ed. Roger Blackley, exhibition catalogue, Adam Art Gallery and Victoria University Press, Wellington, 2001. The *Illustrated London News* was, in other words, a ubiquitous presence throughout the British Empire.

174 For more details, see William J. Schulz, 'Images of Colonial Empire: British Military Daguerreotypes, Part 1: The British Sea Services', in *Daguerreian Annual*, 2005, pp. 161–8.

175 Thanks to Russell Potter for much of the information repeated here. See the blog researched by Potter and Huw Lewis-Jones, *Visions of the North: The Terrors of the Frozen Zone, Past and Present*, http://visionsnorth.blogspot.com/2017/06/seeing-double.html, accessed 18 September 2017.

176 *Illustrated London News*, 'The Arctic Searching Expedition', vol. 22, no. 555, 24 April 1852, p. 322: 'By desire of the naval authorities, Mr. Watkins, manager of Mr. Beard's photographic establishment, sent one of the operators to Greenwich during the day, for the purpose of taking portraits of the officers of the Expedition, and the following had their portraits taken on the deck of the *Assistance*, under highly favourable circumstances, by the photographic process, the sun shining with unclouded brilliancy:—Captain Sir Edward Belcher, C.B., Commander of the Expedition; Commander George H. Richards, Lieutenant Walter W. May, Lieutenant John P. Cheyne, Master John F. Loney, Surgeon David Lyall, M.D., Clerk-in-Charge James Lewis, and Midshipmen Pym and Groves. The officers of the *Resolute*, the *North Star*, the *Intrepid*, and the *Pioneer* were also taken by the photographic process [by Kilburn] previous to their departure[...] The Admiralty ordered a calotype apparatus for the Arctic ships, the construction of which has been superintended by Mr Kilburn, of Regent-street. Dr. Domville, of the *Resolute*, takes charge of the instrument.' A later issue featured an engraved montage of portraits of members of the squadron, all taken by a Beard operative. See *Illustrated London News*, 'Departure of the Arctic Searching Expedition', vol. 20, no. 556, 1 May 1852, p. 336. Thanks also to Elisa deCourcy for the information about an exhibition of 'likenesses' in Calcutta in 1854, information she found in the *Bengal Hurkaru and the India Gazette*, 21 January 1854, p. 1.

177 *Illustrated London News*, 'Julien's Concerts', vol. 4, no. 89, 13 January 1844, p. 29.

178 *Illustrated London News*, 'We This Week Present Our Readers with a Fac-simile of an Interesting Group, Taken, a Few Days Since, at the Polytechnic Institution, by Mr. Beard's Patent Photographic Process', vol. 10, no. 267, 12 June 1847, p. 372. Another interesting commission for the Beard studio helped illustrate this article: *Illustrated London News*, 'Fast-Day Sermons: The Day of Humility and Prayer', vol. 24, no. 680, 29 April 1854, pp. 398–402. The report included twenty-one portraits of ministers, among them nine that were credited as 'From a Daguerreotype by Beard'. One was after a daguerreotype by Claudet.

179 Lord Henry Brougham, *Discours de Lord Brougham sur le droit de visite, par Lord Brougham, traduit par A. Claudet*, Comptor des imprimeurs-reunis, Paris, 1843. In a letter to John Dillwyn Llewelyn dated 21 May 1852, Talbot reported that 'Ld Brougham assured me once that he sat for his Daguerreotype portrait half an hour in the sun and never suffered so much in his life—I don't know whether his Lordship exaggerated—This was in 1839 or 1840 before the time of M. Claudet's improvements.' See Morris, 'The Daguerreotype and John Dillwyn Llewelyn', p. 167. A wood-engraved portrait of Brougham 'from a photograph by Claudet' was also reproduced in the *Illustrated London News*, no. 943, 30 October 1858, p. 407. For more on Brougham's involvement with photography, see Geoffrey

Batchen, 'The Photographic Speculations of Henry Brougham', *History of Photography*, vol. 15, no. 3, Autumn 1991, pp. 240-1.

180 George Catlin, *A Short History and Description of the Ojibbeway Indians Now on a Visit to England. With Correct Likenesses, Engraved from Daguerreotype Plates, Taken by M. Claudet*, Vizetelly Bros. and Co., London, 1844. A group portrait of nine of these visitors, resplendent in their native costumes and holding weapons, 'from Daguerreotype portrait, taken by M. Claudet', was used to illustrate a story titled 'The Indian Marriage at St. Martin's Church', *Pictorial Times*, 13 April 1844, p. 233. The story concerned the wedding of Notennaakam to a Miss Sarah Haynes, but the image was taken elsewhere by Claudet for use in the book compiled by Catlin. See also Sadiah Qureshi, *Peoples on Parade: Exhibitions, Empire, and Anthropology in Nineteenth-Century Britain*, University of Chicago Press, Chicago, 2011, pp. 66-8.

181 *Illustrated London News*, 'Ojibeway and Potawatamie Indians', no. 810, 12 July 1856, p. 41. The image was also reproduced in 'Ojibeway and Potawatamie Indians', *Frank Leslie's Illustrated Newspaper*, vol. 3, no. 58, 17 January 1857, p. 104.

182 Vizetelly, *Glances Back*, p. 259.

183 ibid, p. 260. A wood-engraved portrait of John Bright, apparently not made from a photograph, appeared in the pages of the *Illustrated London News* of 7 October 1843, perhaps as a response to that published by the *Pictorial Times*. See *Illustrated London News*, 'Popular Portraits—No. XLIII: John Bright, M.P.', 7 October 1843, p. 228.

184 Henry Mayhew, *London Labour and the London Poor: A Cyclopedia of the Condition and Earnings of Those That Will Work, Those That Cannot Work, and Those That Will Not Work: The London Street-Folk; Comprising, Street Sellers. Street Buyers. Street Finders. Street Performers. Street Artizans. Street Labourers. With Numerous Illustrations from Photographs, Volume One*, Griffin, Bohn, and Company, London, 1851.

185 Timothy Barringer, 'The Ethnological Image and the Urban "Nomade": The Role of the Visual in Henry Mayhew's *London Labour and the London Poor*', in Representations of Labour in British Visual Culture, 1850-1875, PhD, University of Sussex, 1994, pp. 288-9.

186 The advertisement appears in *Aberdeen Journal*, 28 July 1847, p. 4. The engraving of Reverend Chalmers, captioned 'Likeness from a daguerreotype by Claudet', was still being issued thirty years later.

187 See Justin Carville, *Photography and Ireland*, Reaktion Books, London, 2011, p. 23. See also Peter Walsh, 'Dublin's First Look into the Camera: Some Daguerreotype Portrait Studios of the 1840s', *Dublin Historical Record*, vol. 62, no. 1, Spring 2009, pp. 36-61. Apart from the Beard studio's portraits of Irish writer Maria Edgeworth, another early customer was Vere Foster, son of Viscount Oriel of Tallanstown and a lifelong activist working on behalf of the Irish poor. Walsh reports that Claudet also tapped the Irish market, daguerreotyping several prominent Irish sitters and also the death masks of Robert Emmet and James O'Brien for Richard Robert Madden's *The United Irishman: Their Lives and Times*, published by Duffy, Dublin, in 1846.

188 On O'Connell's portrait, see *Liverpool Mercury*, 11 June 1847, p. 1d, as quoted in Heathcote and Heathcote, 'Richard Beard', p. 323. Beard's likeness of O'Connell competed in the marketplace with one by Frenchman Alexandre Doussin-Dubreuil, also taken when O'Connell was in gaol in 1844, and subsequently published in Paris, Vienna and Rome. Dubreuil, who ran a daguerreotype studio in Dublin, advertised that he could supply copy daguerreotypes of O'Connell's portrait, 'adapted for lockets or broaches [sic]' and 'coloured by Beard's improved process'. He too claimed that '10 per cent of any profits derived from the sale of O'Connell's portraits will be appropriated to the funds of the Relief Committee'. Walsh, 'Dublin's First Look into the Camera', p. 47. Walsh suggests that both Dubreuil and his main Dublin competitor, another Frenchman named Champeaux, had previously worked at Claudet's studio in London. Champeaux apparently arrived in Dublin with the latest French equipment, including a camera designed by Lerebours.

189 *International Magazine of Literature, Art and Science*, 'Kossuth', vol. 5, no. 1, 1 January 1852, pp. 1-3.

190 William Henry Fox Talbot, 'Letter to the Editor', 4 November 1851 or later, doc. no. 6497, *The Correspondence of William Henry Fox Talbot*, http://foxtalbot.dmu.ac.uk/letters/letters.html. Although no copy is currently known, Henneman's portrait of Kossuth was first advertised on 31 December 1851 as being available in a case under glass. A little later, *Humphrey's Journal* of 15 April 1852 says that Henneman was publishing a paper photograph of Kossuth, again enclosed in a case, but this time it was a copy of a Mayall daguerreotype of Kossuth. Thanks to Larry J. Schaaf for this information.

191 Nicolaas Henneman to William Henry Fox Talbot, 20 April 1847: see Larry J. Schaaf, 'Aztecs, Ice Skating, & Miss Mitford's Dog', 29 April 2016, blog post in Schaaf (project director), *The Talbot Catalogue Raisonné*, University of Oxford, http://foxtalbot.bodleian.ox.ac.uk/aztecs-ice-skating-miss-mitfords-dog/, accessed 25 October 2017.

192 See Schaaf, ibid.

193 See Heathcote and Heathcote, *A Faithful Likeness*, p. 44. Throughout their careers, Beard and Claudet sought to counter any publicity gained by one studio with a competing story about their own. For example, in July 1846 the *Literary Gazette* ran a favourable report on Claudet's studio, a report obviously prompted by its owner: 'Having already noticed Mr. Beard's improvements in photography, we accepted Mr. Claudet's invitation to inspect his collection of daguerreotypes, his mode of operation, and the results of his labours.' *Literary Gazette*, 'Photography', no. 1537, 4 July 1846, p. 601c. Sometimes, however, the organs of the press became weary of being used to promote one studio over another. In June 1847, for instance, the *Athenaeum*'s editors attached a parenthetical comment to one of Claudet's many published letters: 'We give the following—which is the essential—portion of a further letter that we have received on this subject from M. Claudet: and having done so, the rival experimentalists must be left to establish their claims by their actual works rather than through the medium of our columns.' Antoine Claudet, 'Photographic Experiments', *Athenaeum*, no. 1023, 5 June 1847, p. 602.

194 Thomas Augustine Malone to William Henry Fox Talbot, 27 April 1850, doc. no. 6316, *The Correspondence of William Henry Fox Talbot*, http://foxtalbot.dmu.ac.uk/letters/letters.html.

195 The calotype portrait is reproduced in D. B. Thomas, *The First Negatives: An Account of the Discovery and Early Use of the Negative-Positive Photographic Process*, Science Museum, London, 1964, p. 29. It was included in an album possibly put together by Calvert Richard Jones around 1844, which featured photographs by Talbot, Claudet and Hippolyte Bayard. See the Sotheby's auction catalogue *Photographic Images and Related Material*, Sotheby's, London, 14 April 1989, pp. 44–9; and *Sun Pictures: Catalogue Five: The Reverend Calvert R. Jones*, ed. Larry J. Schaaf, exhibition catalogue, H. P. Kraus, Jr, New York, 1990, pp. 17–29.

196 See Pritchard's own unpublished 1844 manuscript, now available as George Pritchard, *The Aggressions of the French at Tahiti and Other Islands in the Pacific*, ed. Paul de Deckker, Auckland University Press, Auckland, 1983. A copy of George Baxter's print of Pritchard adorns the cover of this edition.

197 Antoine François Jean Claudet to William Henry Fox Talbot, 20 August 1844, doc. no. 5037, *The Correspondence of William Henry Fox Talbot*, http://foxtalbot.dmu.ac.uk/letters/letters.html, accessed 20 January 2018.

198 *Juvenile Missionary Magazine*, 'Mr Baxter's Two New Pictures', September 1845, pp. 195–6. Thanks to Martyn Jolly for this reference.

199 For more details, see Max E. Mitzman, *George Baxter and the Baxter Prints*, David & Charles, London, 1978. As far as is known, the portrait of Pritchard is the only Baxter print made after a photograph. Nevertheless, it does seem likely that a daguerreotype was made of Queen Pōmare at some stage. An English-born photographer named John William Newland opened a studio at the corner of King and George Streets in Sydney, Australia, in March 1848, having arrived there from New Orleans in the United States. Newland apparently exhibited hundreds of daguerreotypes in Sydney and elsewhere that he had brought with him, taken in Europe, South America and the Pacific. They represented, he claimed in the *Sydney Morning Herald*, 'the principal inhabitants of two thirds of the Globe' and included 'the only correct likenesses ever taken of Pomare, Queen of Otaheite, the King, the Royal Family, Chiefs, and several other Natives, Beautiful specimens of the New Zealanders, Feejeans [*sic*], Peruvians, Chilenos, Grenadians and panoramic views of the City of Arequipa, Peru etc'. The story appeared in the *Sydney Morning Herald*, 23 May 1848, and again as 'The Daguerrean Gallery', *Colonial Times* (Hobart), 27 October 1848, p. 3.

200 *Evangelical Journal and Missionary Chronicle*, 'Baxter's Portraits of Queen Pomare and Mr Pritchard', vol. 23, 1845, p. 533. Thanks to Martyn Jolly for this reference.

201 Antoine François Jean Claudet to William Henry Fox Talbot, 28 August 1844, doc. no. 5046, *The Correspondence of William Henry Fox Talbot*, http://foxtalbot.dmu.ac.uk/letters/letters.html, accessed 15 July 2017.

202 Antoine Claudet to D. Hastings, 3 April 1847 and 9 June 1849, Special Collections, #840174, Getty Research Institute, Los Angeles, http://hdl.handle.net/10020/cat76838, accessed 15 August 2016.

203 *Art-Journal*, 'Portrait of Faraday', 1 May 1849, p. 163a. A July 1846 report about Claudet's studio in the *Literary Gazette* mentions that 'an admirable likeness of Faraday had just been taken, also one of Faraday and Brande together. We should much like to see the latter engraved: it would be greatly prized'. See *Literary Gazette*, 'Photography', no. 1537, 4 July 1846, p. 601c. Faraday was also photographed by Henry Collen in 1842–43, using the calotype process, and by one of Beard's operators in the early 1840s (a daguerreotype now in the collections of the Royal Institution). He was photographed by the Beard studio again some time later, with a lithograph of this image being issued by Conrad Cook showing Faraday sitting before documents on his desk, spectacles in hand.

204 For a juxtaposition of the lithograph of Airy and a variant daguerreotype portrait of the same man by Claudet, see René Perret, *Kunst und Magie*

der Daguerreotypie: Collection W. + T. Bosshard, BEA + Poly-Verlags AG, Brugg, 2006, p. 29.

205 Charles Dickens to Angela Burdett-Coutts, 23 May 1841, as quoted in Edgar Johnson (ed.), *Letters from Charles Dickens to Angela Burdett-Coutts, 1841–1865*, Jonathan Cape, London, 1955, p. 31.

206 Charles Dickens to Angela Burdett-Coutts, 23 and 25 December 1852, cited in 'Portraits of Charles Dickens (1812–1870)', in David Simkin (ed.), *Sussex PhotoHistory Home Page*, http://photohistory-sussex.co.uk/DickensCharlesPortraits.htm, accessed 12 March 2018.

207 William Henry Wills and Henry Morley, 'Photography', *Household Words*, vol. 7, no. 156, 19 March 1853, p. 57. See also Arlene M. Jackson, 'Dickens and "Photography" in "Household Words"', *History of Photography*, vol. 7, no. 2, 1983, pp. 147–9.

208 For more on these portraits of Dickens, see John Hannavy, 'Henry Morley, Charles Dickens and the J.J.E. Mayall Studio', *Daguerreian Annual*, 2001, pp. 110–19; Craig Schneider, 'That Mayall is a Claudet: Half-plate Daguerreotype of Charles Dickens at the Library Company of Philadelphia', *Daguerreian Society Newsletter*, vol. 15, no. 3, May–June 2003, pp. 4–7; Steven Herbert, *The Dickens Daguerreotype Portraits*, The Projection Box, Hastings, UK, 2011; and 'Portraits of Charles Dickens (1812–1870)', in David Simkin (ed.), *Sussex PhotoHistory Home Page*, http://photohistory-sussex.co.uk/DickensCharlesPortraits.htm, accessed 25 June 2017.

209 See Anne M. Lyden, *A Royal Passion: Queen Victoria and Photography*, exhibition catalogue, J. Paul Getty Museum, Los Angeles, 2014, p. 15.

210 *Athenaeum*, 'Fine Arts. Daguerreotype Studies—Messrs. Kilburn and Highschool', no. 1016, 17 April 1847, p. 416. For a summary of Kilburn's career, see Hannavy (ed.), *Encyclopedia of Nineteenth-Century Photography*, pp. 797–8. For an overview of Mayall's career, see Léonie L. Reynolds and Arthur T. Gill, 'The Mayall Story', *History of Photography*, vol. 9, no. 2, April–June 1985, pp. 89–107. The claim that Mayall worked for a short time in an Adelaide Gallery studio (presumably Claudet's) was first made in 1890 in John Werge, *The Evolution of Photography. With a Chronological Record of Discoveries, Inventions, etc., Contributions to Photographic Literature, and Personal Reminiscences Extending over Forty Years*, Piper & Carter and John Werge, London, 1890, pp. 54–5.

211 *Times*, 13 October 1849, p. 4a. Beard declared himself an insolvent debtor on 6 October 1849, with the case coming before the Bankruptcy Court on

23 October 1849. See Heathcote and Heathcote, 'Richard Beard', p. 324.

212 Heathcote and Heathcote, ibid, p. 324.

213 *Illustrated London News*, 15 July 1848, p. 24.

214 *Nottingham Mercury*, 6 October 1848, as quoted in Heathcote and Heathcote, 'Richard Beard', pp. 323–4. On 23 February 1850, the *London Standard* also praised the photographic skills of Beard Jr.: 'Mr Richard Beard, jun., one of the most accomplished proficients in this highly-interesting application of the sciences of chemistry and optics to the fine arts, has recently been called upon to exercise the skill for which he has attained a merited pre-eminence upon the dead body. A case has recently come within our knowledge in which the features of a child that met with its death in consequence of an accident by fire were truly and beautifully rendered by Mr Beard, jun.' *London Standard*, 'Novel Application of Photography', 23 February 1850, p. 3.

215 *Illustrated London News*, 6 December 1851, p. 69.

216 See the website for The Royal Collection (UK), https://royalcollection.org.uk/collection/2932501/tyrolese-singers, accessed 20 July 2018.

217 Robert Ellis (ed.), *Great Exhibition of the Works of Industry of all Nations, 1851. Official Descriptive and Illustrated Catalogue*, Spicer Brothers, London, p. 65. Claudet submitted more exhibits to the Great Exhibition than any other single photographer, showing photographs, cameras, screens, gadgets, plates, frames, dark-boxes and chemicals. He even submitted an ornamental table to the Fine Arts section, the surface of which was embedded with nine hand-coloured daguerreotypes comprising eight oval individual portraits of young ladies and a central circular group portrait of children. An engraving of Claudet's table was published in *The Illustrated Exhibitor: A Tribute to the World's Industrial Jubilee; Comprising Sketches, by Pen and Pencil, of the Principal Objects in the Great Exhibition of the Works of Industry of all Nations 1851*, John Cassell, London, 1851, p. 485. See also Charles W. Mann, 'Photo-meubles', *History of Photography*, vol. 4, no. 2, April 1980, pp. 95–6.

218 *Illustrated London News*, 18 October 1851, pp. 508–9. The issuing of portraits of eminent persons associated with the Great Exhibition was a competitive business. On 15 November 1851 the *Literary Gazette* announced the availability of a lithographic portrait of Sir Joseph Paxton, designer of the Crystal Palace building, 'drawn on Stone by J.H. Lynch, from a daguerreotype by Mr. Kilburn' and published by Hering and Remington (at 153 Regent Street).

The paper reported that the portrait was 'a most intense profile likeness of the distinguished architect of the Crystal Palace, though wanting somewhat in the genial expression of the original' (p. 779).

219 John Tallis, *Tallis's History and Description of the Crystal Palace and the Exhibition of the World's Industry in 1851, Illustrated by Beautiful Steel Engravings, from Original Drawings and Daguerreotypes by Beard, Mayall etc.*, 3 vols, John Tallis & Co., London, 1852; See also Anthony Hamber, 'Facsimile, Scholarship, and Commerce: Aspects of the Photographically Illustrated Art Book (1839-1880)', in Stephen Bann (ed.), *Art and the Early Photographic Album*, National Gallery of Art, Washington, 2011, p. 131.

220 William Gaspey, *The Great Exhibition of the World's Industry held in London in 1851: Described and Illustrated by [...] Engravings, from Daguerreotypes by Beard, Mayall, etc.*, 4 vols, John Tallis & Company, London, 1852-61.

221 *Illustrated London News*, 26 July 1851, p. 128.

222 *Illustrated London News*, 6 September 1851, pp. 296-7.

223 Beegan, 'The Mechanization of the Image', pp. 260-1.

224 ibid, p. 257.

225 *Illustrated London News*, 'The Chinese Family', 24 May 1851, p. 450.

226 ibid.

227 'Personal Narrative', *The Household Narrative of Current Events* (for the year 1851), p. 187; see Terry Bennett, *History of Photography in China, 1842-1860*, Bernard Quaritch, London, 2009, pp. 76-7.

228 *Illustrated London News*, 25 October 1851, p. 1.

229 *Illustrated London News*, 'Majolica Vases, Patent Wall Tiles, and Mosaics.—By Herbert Minton and Co', 21 June 1851, p. 599.

230 For more on this aspect of the Great Exhibition, see Steve Edwards, 'Photography, Allegory, and Labor', *Art Journal*, vol. 55, no. 2, Summer 1996, pp. 38-44.

231 *Illustrated London News*, 26 July 1851, p. 135.

232 Thomas Richards, *The Commodity Culture of Victorian England: Advertising and Spectacle, 1851-1914*, Stanford University Press, Stanford, 1991, pp. 59-60.

233 *Morning Chronicle*, 12 August 1851, as quoted in Rachel Youdelman, 'Iconic Eccentricity: The Meaning of Victorian Novelty Taxidermy', *PsyArt*, 21 (2017), p. 46.

234 ibid.

235 David Bogue, 'Preface', *The Comical Creatures from Wurtemberg, Including the Story of Reynard the Fox; With Twenty Illustrations, Drawn from the Stuffed Animals Contributed by Herrmann Ploucquet of Stuttgart to the Great Exhibition*, David Bogue, London, 1851, p. 9.

236 ibid, p. 4.

237 *Illustrated London News*, 'To the 1,000,000 Readers', vol. 25, no. 719, 23 December 1854, p. 681, as quoted in Beegan, 'The Mechanization of the Image', p. 260.

238 Jules-Sébastien-César Dumont d'Urville, *Voyage au pôle sud et dans l'Océanie [...] 1838-1842. Atlas—Anthropologie*, A. Gide, Paris, 1846.

239 For more on these life-casts, see Fiona Pardington, *The Pressure of Sunlight Falling*, Otago University Press, Dunedin, 2011, especially p. 98; and Moya Lawson, 'Real Spectres', in Geoffrey Batchen (ed.), *Apparitions: The Photograph and its Image*, exhibition catalogue, Adam Art Gallery Te Pātaka Toi, Wellington, 2017, pp. 14-17. On the Bisson daguerreotypes, see *Le daguerréotype français*, pp. 369-70.

240 See Isobel Crombie, '*Australia Felix*: Douglas T. Kilburn's Daguerreotypes of Victorian Aborigines, 1847', *Art Bulletin of Victoria*, no. 32, 1991, pp. 21-31; Isobel Crombie, 'The Sorcerer's Machine: A Photographic Portrait by Douglas Kilburn, 1847', *Art Bulletin of Victoria*, no. 40, 1999, pp. 7-12; and Isobel Crombie, '*Australia Felix*: Douglas T. Kilburn's Daguerreotype Portraits of Australian Koories, 1847', *Daguerreian Annual*, 2004, pp. 34-46.

241 Thanks to Gael Newton for this reference.

242 *Illustrated London News*, 'Australia Felix', 26 January 1850, p. 53.

243 Beegan, 'The Mechanization of the Image', p. 258. Given this mobility of photographic images between the metropolitan centre and the periphery of the British Empire, as Helen Ennis has argued, 'colonial photography therefore calls for a different approach that admits the centrality of colonialism in determining the nature of photographic production, and colonization itself as the primary contextualizing factor'. Helen Ennis, 'Other Histories: Photography and Australia', *Journal of Art Historiography*, no. 4, June 2011, p. 11.

244 *Times*, 'Claudet's Portrait of the Duke of Wellington', 22 May 1845, p. 7.

245 Reported in the *Glasgow Examiner*,
25 January 1845, p. 3c, as quoted in Heathcote and
Heathcote, *A Faithful Likeness*, p. 39.

246 A practice noted in the *Spectator*,
'Photographic Miniatures', 1 September 1841,
pp. 860–61, http://archive.spectator.co.uk/
article/4th-september-1841/20/photographic-
miniatures, accessed 14 March 2018.

247 See Taylor (ed.), *Photographic Exhibitions
in Britain 1839–1865: Records from Victorian
Exhibition Catalogues*, http://peib.dmu.ac.uk/
indexphotographer.php?thegroup=a, accessed
21 November 2017.

248 *Times*, 'Claudet's Portrait of the Duke of
Wellington'.

249 *London Evening Standard*, 'Fine Arts: The
Duke of Wellington', 6 June 1845. This is the report
that claimed that Wellington entered the Adelaide
Gallery studio 'accidentally'.

250 This stereo-daguerreotype is held by
the George Eastman House in Rochester, New
York. The fact that the Ryall print is seen in
reverse demonstrates that, in this case, Claudet
eschewed the use of a re-reversing mirror in
front of his camera lens.

251 *Illustrated London News*, 'Statues, Portraits
and Memorials of Wellington', 13 November 1852,
p. 416. Thanks to Roberto C. Ferrari for sharing
this research.

252 This print itself appeared in various
manifestations. For example, it was published
as a mezzotint by Goupil & Vibert on 1 May 1845,
surrounded by a mat that, among other things,
was inscribed 'Engraved from M. Claudet's
Daguerreotype Portrait for which His Grace
sat May 1st, 1844'. On 1 May 1845 Watson issued
this same portrait as a stipple engraving in a
different mat, where it is accompanied by a
facsimile of Wellington's signature.

253 Alexander Simon Wolcott and John
Johnson, Royal Letters Patent No. 9672, issued
8 March 1843.

254 See Sotheby's, *Photographic
Images and Related Material*, Sotheby's,
London, 26 October 1984, item 21. After this
daguerreotype was reproduced in 1956 in
Gernsheim and Gernsheim, *L.J.M. Daguerre*
(Plate 83), Walker Evans in his review of the
book described it as a 'startling document',
suggesting that such pictures are 'worth stronger
presentation, and some articulation'. See Walker
Evans, 'Picture-Taking Pioneer', *New York Times
Book Review*, 28 October 1956, as reprinted in
David Campany, *Walker Evans: The Magazine
Work*, Steidl, Göttingen, 2014, p. 217.

255 *Illustrated London News*, 'Statues, Portraits,
and Memorials of Wellington'.

256 J. Watson, 'Daguerreotype Portrait of the
Duke of Wellington', *Illustrated London News*,
1 January 1853, p. 10.

257 See *Eclectic Magazine of Foreign Literature*,
'Arthur Wellesley, Duke of Wellington, With a
Portrait', vol. 27, no. 3, November 1852, p. 362; and
Eclectic Magazine of Foreign Literature, 'The Duke
of Wellington', vol. 49, no. 2, February 1860, p. 286.

258 See the cover of Walter Scott (ed.), *England
Under Victoria*, Eld & Blackham, London, 1885.

259 See *Kiosk: Eine Geschichte der
Fotoreportage, 1839–1973*, eds Robert Lebeck and
Bodo Von Dewitz, exhibition catalogue, Steidl,
Göttingen, 2001, pp. 24–7. The earliest known
French wood engraving after a daguerreotype
was published in *L'Illustration* only on 1 July
1848, based on a daguerreotype of the barricades
in Paris taken by Thibault five days before. See
the auction catalogue *Sotheby's Photographs*,
Sotheby's, London, 9 May 2002, pp. 32–5. For an
extended discussion of *L'Illustration*, see Thierry
Gervais, 'D'après photographie: Premiers usages
de la photographie dans le journal *L'Illustration*,
1843–1859', *Études photographiques*, no. 13,
July 2003, pp. 56–85. By 1855 the editors of
L'Illustration could declare: 'As for means of
satisfying the public, they have multiplied
through the discoveries of science and art
responding to the requirements of social activity,
that is to say with the admirable assistance of
photography, that fast and accurate method of
laying before the eyes of every nation anything
interesting that is offered and accomplished in
the other corners of the globe' (as quoted in Bajac,
The Invention of Photography, p. 119).

260 See Beegan, *The Mass Image*, p. 60; and Taft,
Photography and the American Scene, p. 419.

261 See Bruce T. Erikson, 'Eliphalet M. Brown,
Jr.: An Early Expedition Photographer', *Daguerreian
Annual*, 1990, pp. 145–56; and Terry Bennett,
Photography in Japan: 1853–1912, Tuttle Publishing,
North Clarendon, VT, 2006, pp. 27–9.

262 See *Felice Beato: A Photographer on the
Eastern Road*, ed. Anne Lacoste, exhibition
catalogue, J. Paul Getty Museum, Los Angeles,
2010, pp. 20–1. One could trace a similar
proliferation of photographic images from any
number of far-flung parts of the world. During
the winter of 1859, for example, Désiré Charnay
took a series of photographs at Mitla in Mexico.
Many of these photographs were subsequently
published in his *Cités et ruines américaines* in Paris
in 1863, but engraved images based on them were
also distributed in *L'Illustration* in 1861 and 1862,
then in *Le Tour du monde* in 1862, and finally in *Le*

Monde illustré in 1865. See Bajac, *The Invention of Photography*, pp. 118–19.

263 See, for example, *Journal of a Voyage: The Erwin Dubsky Collection: Photographs from Japan in the 1870s*, eds Filip Suchomel and Marcela Suchomelová, exhibition catalogue, Moravian Gallery, Brno, 2006; Filip Suchomel and Marcela Suchomelová, *... And the Chinese Cliffs Emerged out of the Mist: Perception and Image of China in Early Photographs*, Academy of Arts, Design and Architecture, Prague, 2011; and Luke Gartlan, *A Career of Japan: Baron Raimund von Stillfried and Early Yokohama Photography*, Brill, Leiden and Boston, 2016.

264 Wendy Wick Reaves and Sally Pierce, 'Translations from the Plate: The Marketplace of Public Portraiture,' in Grant Romer and Brian Wallis eds., *Young America: The Daguerreotypes of Southworth and Hawes* (New York: International Center of Photography, 2005), p. 89, 93.

265 Michael Leja, 'Fortified Images for the Masses', *Art Journal*, vol. 70, no. 4, Winter 2011, p. 82.

266 Michel Foucault, 'Photogenic Painting' (1975), in Gilles Deleuze, Michel Foucault and Adrian Rifkin, *Photogenic Painting: Gérard Fromanger*, ed. Sara Wilson, Black Dog Publishing, London, 1999, pp. 84–5. Thanks to Tomáš Dvořák for this reference.

267 See James Ryan, 'Images and Impressions: Printing, Reproduction and Photography', in *The Victorian Vision: Inventing New Britain*, ed. John M. Mackenzie, exhibition catalogue, V&A Publications, London, 2001, p. 227.

268 Joan M. Schwartz, 'The Geography Lesson: Photographs and the Construction of Imaginative Geographies', *Journal of Historical Geography*, vol. 22, no. 1, 1996, p. 17.

269 Antoine Claudet, 'Photography in its Relation to the Fine Arts', *Photographic Journal*, vol. 6, 15 June 1860, p. 266. The way *The geography lesson* conjoins reading and looking as a single experience forecasts a similar combination in the cardboard stereo-views issued by companies such as Underwood & Underwood, which from 1908 printed informative text on the back of the images, and issued maps and books with its sets of cards. We can imagine one person looking through a stereo-viewer at a scene while another reads this information aloud. Thanks to Britt Salvesen and Elizabeth Siegel for making that connection. See also Britt Salvesen, 'Solid Sight: Sculpture in Stereo', in Sarah Hamill and Megan R. Luke (eds) *Photography and Sculpture: The Art Object in Reproduction*, Getty Research Institute, Los Angeles, 2017, pp. 192–209.

270 Thanks to Rachelle Street for drawing this issue to my attention.

271 Oliver Wendell Holmes, 'The Stereoscope and the Stereograph' (1859), in Beaumont Newhall (ed.), *Photography: Essays & Images: Illustrated Readings in the History of Photography*, Museum of Modern Art, New York, 1980, pp. 59, 60.

272 Steve Edwards has listed numerous operatives who worked for one or other of these studios at some point. He mentions, for example, 'Chubb, Counsell, Edwards and Mills' as names that appeared in regional newspaper advertisements as having worked for Claudet at the Adelaide Gallery. He also names 'Francis Beattie, George Brown, J. T. Cooper, Jabez Hogg, John Johnson, and T. R. Williams' as Beard operators 'usually listed in the history books', but then adds more names based on his examination of affidavits from Beard's various litigations, including Alfred Wilkinson, Walter Samuel Scott, William Henry Williams, Cornelius Sharp, Walter Rowse Plimsoll, Alfred Barber and John Plimsoll, plus 'Mr Stephen, Mr Stoddard and W.T. Pitcher'. Edwards locates this collective authorship within the complications of the English legal system. Edwards, '"Beard Patentee"', pp. 379–80, 393.

273 Claudet's earliest self-portrait was a daguerreotype that he took while 'stretched on his back, because the plate required upwards of a quarter of an hour's exposure', but he continued to take them throughout his career. Among his last photographs, for example, is a series of albumen self-portraits taken in November 1867 in order to test the capacities of lenses made of glass, topaz and rock crystal. See *Photographic News*, 'Serious Fire at Mr. Claudet's Studio in Regent Street', 31 January 1868, pp. 51–2; and R. Derek Wood, 'Brewster's and Claudet's Topaz Camera Lens, 1867', *Microscopy: Journal of the Quekett Microscopical Club*, no. 31, February 1969, pp. 121–2. There are only two known portraits of Richard Beard, both of them albumen photographs made in the 1860s.

274 For more details on this legislation, see Elizabeth Anne McCauley, '"Merely Mechanical": On the Origins of Photographic Copyright in France and England', *Art History*, vol. 31, no. 1, February 2008, pp. 57–78. See also Taylor, *Impressed by Light*, pp. 139, 412; and *Photographic News*, 'Copyright in Photographic Portraits', vol. 8, 18 November 1862, p. 554. Among the interesting consequences of the passing of the 1862 copyright legislation were actions brought by print publishers against dealers in photographic prints for copyright infringement (selling unauthorised photographs of engravings after paintings). See, for example, an account of the legal actions taken by print publisher Ernest Gambart in Maas, *Gambart*, pp. 159–62.

275 Julian Cox and Colin Ford, 'Appendix A: Copyright Registers', in *Julia Margaret Cameron: The Complete Photographs*, J. Paul Getty Museum, Los Angeles, 2003, pp. 496–7.

276 See Beegan, *The Mass Image*, p. 60. For more on these developments, see Vincent Beechey, 'Photography Applied to Engraving on Wood', *Humphrey's Journal*, vol. 7, no. 10, 1854, pp. 151–2; J. De Witt Brinckerhoff, 'Photographic Engraving on Wood', *Photographic and Fine Art Journal*, vol. 8, no. 2, 1855, p. 48; and *Philadelphia Photographer*, 'Photographing on Wood', 1867, as quoted in Roger Pring, *Pring's Photographer's Miscellany: Stories, Techniques & Trivia*, Ilex, Lewes, 2011, p. 66.

277 See Schaaf, 'Revelations & Representations'.

278 The letter was published as 'Two Letters on Calotype Photogenic Drawing … to the Editor of *The Literary Gazette*', *Philosophical Magazine*, ser. 3, vol. 19, no. 121, July 1841, pp. 88–92, and is transcribed in Mike Weaver (ed.), *Henry Fox Talbot: Selected Texts and Bibliography*, Clio Press, Oxford, 1992, p. 59.

279 Eleven letters on the topic between Beard and Talbot survive, the earliest of them exchanged in July 1841, with Beard trying to persuade Talbot to allow him to issue calotype licences to cover particular towns, much as he had done for the daguerreotype. Talbot considered making Beard his sole agent, but despite the exchange of several drafts of an agreement vetted by their respective lawyers, no deal was ever signed. See Geoffrey Batchen, 'The Coal Merchant and Talbot: Richard Beard', June 2017, blog post in Schaaf (project director), *The Talbot Catalogue Raisonné*, http://foxtalbot.bodleian.ox.ac.uk/2017/06/02/coal-merchants-and-talbot-richard-beard/, accessed 16 August 2018.

280 Antoine François Jean Claudet to William Henry Fox Talbot, 24 December 1842, doc. no. 4679, and 25 January 1844, doc. no. 4922, *The Correspondence of William Henry Fox Talbot*, http://foxtalbot.dmu.ac.uk/letters/letters.html, accessed 23 October 2017. Talbot's mother also seems to have been involved in the discussions, as evidenced by her letter to Talbot of 13 September 1844: 'I hope you are thinking of some arrangement by which Nicole can spend a Month chez Claudet on your return from Belgium. Claudet having the stimulus of his own interest will spread your Fame by his success.' Elisabeth Theresa Feilding to William Henry Fox Talbot, 13 September 1844, doc. no. 5066, *The Correspondence of William Henry Fox Talbot*, ibid.

281 Antoine François Jean Claudet to William Henry Fox Talbot, 18 January 1843, doc. no. 4700, *The Correspondence of William Henry Fox Talbot*, http://foxtalbot.dmu.ac.uk/letters/letters.html, accessed 23 October 2017. Henneman also refers

to Keates in a later letter to Talbot: 'I have also asked some information of Mr Keates, on the Daguerrotype [*sic*] to which I shall be obliged to allude.' Larry J. Schaaf suggests that the reference is 'presumably' to 'Thomas William Keates (1818–1882), practical chemist, who was reportedly acquainted with Daguerre. He held several patents and later was the scientific chemists [*sic*] for the Joynson paper mill. He was elected a member of the Society of Arts in 1877 and finished his career as the Superintending Gas Examiner for London's Metropolitan Board of Works'. Nicolaas Henneman to William Henry Fox Talbot, 25 January 1845, doc. no. 5167, *The Correspondence of William Henry Fox Talbot*, http://foxtalbot.dmu.ac.uk/letters/letters. html, accessed 25 October 2017. Shaun Caton reproduces an oversize half-plate daguerreotype of an informally posed family group signed 'J. Hogg' and 'Keates' and dated December 1846. Shaun Caton, 'Trapping Apparitions: Daguerreotypes, Mirrors and Mementoes', *daguerreotype.nl*, March 2005, http://daguerreotype.nl/endless%20instant/march_2005.html, accessed 15 June 2016.

282 *Athenaeum*, Claudet advertisement, 6 July 1844, p. 609.

283 Elisabeth Theresa Feilding to William Henry Fox Talbot, 7 April 1844, doc. no. 4980, *The Correspondence of William Henry Fox Talbot*, http://foxtalbot.dmu.ac.uk/letters/letters.html, accessed 20 July 2017.

284 Antoine François Jean Claudet to William Henry Fox Talbot, 24 August 1844, doc. no. 5042, *The Correspondence of William Henry Fox Talbot*, http://foxtalbot.dmu.ac.uk/letters/letters.html, accessed 25 July 2017.

285 Translated by the author from the original French, ibid.

286 All three names are mentioned in letters as assisting Claudet. See, for example, Nicolaas Henneman to Talbot about Thomas Malone, 21 September 1844, doc. no. 5078; Talbot to Claudet about the availability of Henneman, 22 January 1844, doc. no. 8594; Claudet to Talbot about Murray, 30 November 1844, doc. no. 5118; and Calvert Richard Jones to Talbot about 'Mr Malone at Claudet's', 6 October 1845, doc. no. 5404; all in *The Correspondence of William Henry Fox Talbot*, http://foxtalbot.dmu.ac.uk/letters/letters.html, accessed 30 April 2017.

287 See Geoffrey Batchen, 'The Labor of Photography', *Victorian Literature and Culture*, vol. 37, no. 1, 2009, pp. 292–6. Roger Taylor has calculated that it took the Reading Establishment 72,000 discrete steps to manufacture 6000 prints. Taylor, *Impressed by Light*, pp. 19, 399 n44.

288 Schaaf, 'Introductory Volume', *The Pencil of Nature*, p. 33.

289 Benjamin Cowderoy, 'The Talbotype or
Sun Pictures and the Jubilee of Photography',
Photography, 6 June 1895, pp. 361–3, as quoted
in Schaaf, ibid. Talbot had carefully funded the
Reading Establishment as a separate institution
under Henneman's control, precisely so that he
would keep 'trade' at a safe distance from himself,
a landed gentleman. In the 1850s the Photographic
Society of London, seeking to maintain a clear
division between those 'in trade' and those 'in
society', decided at one point to ban from its
exhibitions any photographs that had already
been displayed in a shop window. Talbot would
have been well aware of such class prejudices. See
Taylor, *Impressed by Light*, pp. 70–1. In this context,
it is interesting to note Henry Collen's letter to
Talbot of 24 April 1841: 'On referring to Parkes'
Essays I find that the employment of Gentlemen
& the sons of the Nobility in the manufacture of
Glass, was confined to France, but as the account
is interesting from its bearing on the argument
of highly educated [*sic*] employing themselves
in the Arts of Manufacture, I have the pleasure to
send you the work itself; you will find the account
commencing at Page 351.' Henry Collen to William
Henry Fox Talbot, 24 April 1841, doc. no. 4245,
The Correspondence of William Henry Fox Talbot,
http://foxtalbot.dmu.ac.uk/letters/letters.html,
accessed 20 June 2017.

290 Benjamin Cowderoy to William Henry
Fox Talbot, 30 April 1846, doc. no. 5640, *The
Correspondence of William Henry Fox Talbot*,
http://foxtalbot.dmu.ac.uk/letters/letters.html,
accessed 20 June 2017.

291 See Maas, *Gambart*, p. 38.

292 Benjamin Cowderoy to William Henry Fox
Talbot, 30 April 1846.

293 ibid.

294 Gernsheim, *The History of Photography*,
p. 126. Some salt prints from Talbot's calotypes
were also being sold in shops in Paris. Frederick
Sinnett, an Englishman living in Paris who
described himself as a 'Bookseller, Printseller, and
Publisher', ordered a group of prints from Owen
Bailey in mid-1846 for the sum of £2 1s. These seem
to have included an image of a bust of Napoleon.
He then wrote to Cowderoy, on 3 October 1846,
to propose becoming Talbot's agent in Paris.
Others approached Talbot directly. A Frenchman
named Ninet wrote to Talbot on 20 September
1846 to 'request a certain number of Prints on
paper'. Having already bought up Sinnett's supply,
Ninet now asked for 'landscapes and prints with
human figures'. But nothing further seems to
have come from these advances. See Steven
F. Joseph, 'The Talbotype in Paris: An All Too Brief
Encounter', 31 March, 2017, blog post in Schaaf
(project director), *The Talbot Catalogue Raisonné*,
http://foxtalbot.bodleian.ox.ac.uk/2017/03/31/

the-talbotype-in-paris-an-all-too-brief-encounter,
accessed 4 April 2017.

295 Oscar Rejlander, 'An Apology for Art-
Photography, An Excerpt' (1863), in Vicki
Goldberg (ed.), *Photography in Print: Writings
from 1816 to the Present*, University of New
Mexico Press, Albuquerque, 1981, p. 142.

296 For more on this publication, see Hilary
Macartney, 'William Stirling and the Talbotype
Volume of the *Annals of the Artists of Spain*', *History
of Photography*, vol. 30, no. 4, 2006, pp. 291–308; and
Hilary Macartney and José Manuel Matilla (eds),
*Copied by the Sun: Talbotype Illustrations to the
Annals of the Artists of Spain by Sir William Stirling
Maxwell: Studies and Catalogue Raisonné*, Museo del
Prado and Centro de Estudios Europa Hispánica,
Madrid, 2016.

297 See Geoffrey Batchen, 'Summer Pleasures:
One of the Towers of Orleans Cathedral',
19 August 2016, blog post in Schaaf (project
director), *The Talbot Catalogue Raisonné*,
http://foxtalbot.bodleian.ox.ac.uk/summer-
pleasures-one-of-the-towers-of-orleans-
cathedral/, accessed 15 August 2018.

298 For more on this aspect of Talbot's career,
see *Sun Pictures: Catalogue Twelve: Talbot and
Photogravure*, ed. Larry J. Schaaf, exhibition
catalogue, Hans P. Kraus, Jr, New York, 2003; and
Larry J. Schaaf, '"The Caxton of Light": Talbot's
Etchings of Light', in Mirjam Brusius, Katrina Dean
and Chitra Ramalingam (eds), *William Henry Fox
Talbot: Beyond Photography*, Yale University Press,
New Haven, 2013, pp. 161–89.

299 Antoine François Jean Claudet to William
Henry Fox Talbot, 14 January 1861, doc. no. 8286,
The Correspondence of William Henry Fox Talbot,
http://foxtalbot.dmu.ac.uk/letters/letters.html,
accessed 16 March 2018.

300 See *Sun Pictures: Catalogue Twelve*, p. 46.
This image was first identified as a picture by
Claudet in Arthur T. Gill, 'Fox Talbot's Photoglyphic
Engraving Process', *History of Photography*, vol. 2,
no. 3, April 1978, p. 134.

301 Roland Barthes, 'The Death of the Author'
(1967), in *Image–Music–Text*, trans. Stephen Heath,
Hill & Wang, New York, 1977, p. 146.

Fig. 75
Richard Beard studio (London), *Richard Beard*, c. 1862.
Carte-de-visite (albumen photograph on card), 9.0 × 6.2 cm. Collection of the author, Wellington.

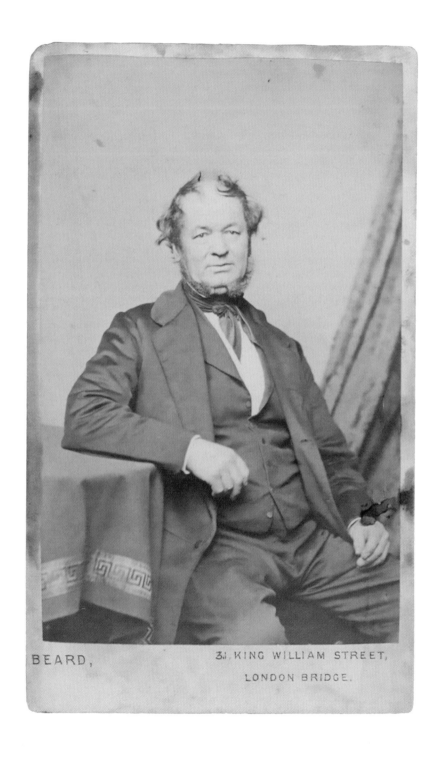

BEARD, 31, KING WILLIAM STREET,
LONDON BRIDGE.

Fig. 76
Claudet studio (London), *Antoine François Jean Claudet*, c. 1865.
Carte-de-visite (albumen photograph on card), 10.0 × 6.4 cm.

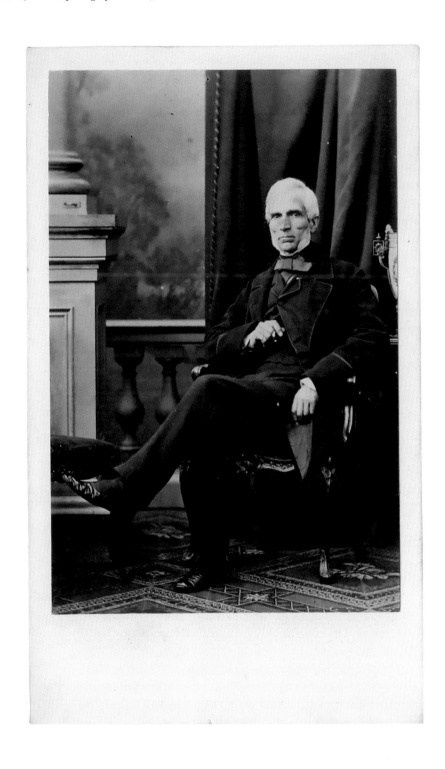

Acknowledgements

This text has been improved by many details unearthed by Karen Hellman in her 2010 dissertation on the career of Antoine Claudet. I thank her for generously sharing those details with me. Aspects of what follows have appeared in at least two of my previous publications: 'Double Displacement: Photography and Dissemination', in Thierry Gervais (ed.), *The 'Public' Life of Photographs*, Ryerson Image Center / MIT Press, Toronto, 2016, pp. 38–73, and *Obraz a diseminace: Za novou historii pro fotografii* [Image and dissemination: Towards a new history of photography], translated into Czech by Michal Simunek, edited and with an introduction by Tomáš Dvořák and an essay about the author by Michal Simunek (Nakladatelství Akademie múzických umění v Praze, Prague, 2016).

This book has enjoyed a long gestation. It had one of its many beginnings in 2001, when I was living and working in Albuquerque, New Mexico. During a trawl of that city's used-book stores, I came across a British auction catalogue from the 1970s. Featured among its other reproductions was a stereo-view of a woman shot by Antoine Claudet, a photographer who made many such portraits in the 1850s and 1860s. But this example was described as combining two different photographic mediums, one side of the stereo being a daguerreotype and the other an ambrotype. I had never heard of such a thing. I bought the catalogue, carefully photocopied the page, and began to compile a dossier on Claudet's work.

The following year I took up a job at the Graduate Center of the City University of New York. Unfortunately, my entire research library was accidentally destroyed upon its arrival in New York, including the auction catalogue and its accompanying dossier. I have never been able to find another copy of that catalogue. Claudet's multi-media stereo-portrait therefore remains a mirage, tantalising in my memory but unable to be verified. Despite this setback, I did my best to reconstitute the rest of my file of material on Claudet, including, after a while, related information about the career of Richard Beard, his greatest rival among the early London studios. I of course began to share this interest with my doctoral students. One of them, Karen

Hellman, decided to write her dissertation on Claudet, being particularly interested in his bicultural presence in both England and France.

At about this time I was invited to give a lecture at the Yale Center for British Art in New Haven. A member of my audience, Tim Barringer, suggested that perhaps I should approach the Center's Director, Amy Meyers, about the possibility of curating an exhibition about the early history of British photography for their galleries. Amy embraced the idea and the following few years were spent researching the work of Beard and Claudet in preparation for this exhibition, with Karen on board as my assistant curator. The Center supported Karen's research in the United Kingdom, allowing her to discover a number of previously unknown examples of Claudet's work. A book was also proposed, and Karen, Tim, Steve Edwards and Jennifer Tucker were all encouraged to write on the topic. Unfortunately, with the essays commissioned and checklist complete, the Center cancelled the exhibition amidst fears about the vulnerability of daguerreotypes as display objects.

After moving to New Zealand in 2010, I decided to separate out what I regarded as the most original aspect of this research: its concentration on the engraved reproductions of Beard and Claudet's daguerreotypes. This led to some reflection on the place of the photographic image, as opposed to the photograph, in the commercial life of a professional studio in the 1840s and 1850s, and thus on the role of these images throughout photography's history, including in the present. This volume is the end result. Although an account of the work of Beard and Claudet remains at its foundation, *Apparitions* demonstrates that the dissemination of photographic images in this period was a global affair, this being an economy embedded in the machinations of the British Empire. Hence, the book traces the traffic in these images in Britain but its story also encompasses photographic practices related to France, Italy, Canada, Germany, Turkey, Hungary, Russia, Austria, Mexico, Tahiti, Australia, New Zealand, Japan, India, and the United States.

Various fragments of this story have already appeared in some of my essays, most notably in one that appeared in *The 'Public' Life of Photographs*, a volume published in 2016 by the Ryerson Image Center in Toronto. I thank Thierry Gervais and Anne Cibola for that opportunity. That essay also appeared in 2017 in Chinese in 更多的疯狂念头 [*More Wild Ideas: History, Photography, Writing*], translated by Mao Weidong and published by China Nationality Art Photograph Publishing House. During the past few years, I have given a number

of public lectures about photography and the dissemination of photographic images. After one of these, delivered in Prague, I was approached by my host, Tomáš Dvořák, about the possibility of publishing an extended version in Czech. A small paperback titled *Obraz a diseminace: Za novou historii pro fotografii* was the result. I especially liked its format—the size of a small novel with a flexible cover and colour illustrations throughout—a format in keeping with the illustrated press it was discussing.

Encouraged by Tomáš's enthusiasm for the topic, I continued to work on my manuscript, considerably expanding its size and list of illustrations. Eventually, I decided to seek out a publisher for an English version. Having given yet another lecture at the Power Institute at the University of Sydney, I approached Marni Williams and Mark Ledbury at Power Publications about that possibility. They were both very positive about the prospect, but hoped to work in collaboration with another press, preferably one based in Europe or the United States. Tomáš put me in contact with Jan Heller at Nakladatelství Akademie múzických umění (NAMU) in Prague and the book you are now reading, a considerably revised and expanded English version of the earlier Czech text, is the fruit of their collaboration. I thank all these people for their support, along with Marni and Belinda Nemec for their careful copyediting of my text and Jan Brož and Armands Freibergs for their creative design of the book.

As you can imagine, my gratitude is due to a host of supportive colleagues and friends over the many years it has taken for this book to come into being. I have already mentioned my debt to Tim Barringer, Amy Meyers, Karen Hellman, Steve Edwards, Jennifer Tucker, Thierry Gervais, Anne Cibola, Mao Weidong, Tomáš Dvořák, Jan Heller, Mark Ledbury and Marni Williams. A number of other scholars have shared their knowledge of the field, encouraged my own efforts, or simply been a model of intellectual endeavour that I have sought to emulate. These kind people include Thomas Barrow, Jordan Bear, Roger Blackley, Elisa deCourcy, Anthony Hamber, Martyn Jolly, Russell Lord, David Maskill, Gael Newton, Beth Saunders, Larry Schaaf, Tanya Sheehan, Rachelle Street, Filip Suchomel, and Andrés Zervigón.

Any study of early British photography must necessarily build on the foundational research of a group of pioneering scholars that includes Alison Gernsheim, Helmut Gernsheim, Arthur Gill, R. Derek Wood, Pauline Heathcote, Bernard Heathcote, Roger Taylor, and Larry Schaaf. It is their fastidious work that has made my own

commentary possible. The listing of all these names, along with all those referred to in my notes, is not only a courteous academic convention: it is also a necessary acknowledgement of community, of the collective dimensions of individual scholarly practice.

The kind of photographic material being discussed here has not tended to be collected by museums. I have therefore collected some examples of it myself, a form of hands-on research I have often found helpful. In 2017, the Adam Art Gallery Te Pātaka Toi at Victoria University of Wellington offered me an opportunity to present an exhibition based on my collection. The exhibition was in turn the end result of an Honours seminar I taught on this same topic. I thank Christina Barton for the invitation to curate this exhibition (titled *Apparitions: the photograph and its image*) and my students—Matthew Barrett, Nicola Caldwell, Frances Crombie, Peter Derksen, Moya Lawson, Alys Pullein, Millie Singh and Kate Weaver—for indulging my interests and sharing their own research. A catalogue of the same name was published to accompany this exhibition. I thank the Ronald Woolf Memorial Trust for funding this publication and Gerry Keating and Matthew Barrett for photographing various items that appeared in it, some of which also appear here. I also thank Victoria University of Wellington for supporting my research and helping to cover the considerable costs of some of the reproductions that appear in this book.

Finally, I thank my partner Justine Varga for all her support through thick and thin, and my children Felix and Madeleine for remaining happily indifferent to my scholarly efforts and thereby reminding me of all the other things that life has to offer.

Index

A

Aberdeeen Journal, 92, 192

Académie des sciences, 17, 27, 42, 180, 181, 184

Ackermann, Rudolph, Jr. (1796-1863), 152 *fig. 68*, 153 *fig. 69*

Airy, George Biddell (1801-1892), 103, 193

Anelay, Henry (1817-1883), 74

Annan, J. Craig (1864-1946), 107, 111 *fig. 45*

Arago, François (1786-1853), 31, 42-43, 177, 179, 180, 184, 185

Arkwright, Richard (1732-1792), 102

Art-Journal, 103, 193

Art-Union, 22, 166, 167 *fig. 72*, 176, 179, 182

The Athenaeum, 20, 26, 109, 161, 176, 178, 180, 183, 193, 194, 198

Atkins, Anna (1799-1871), 56

Aubert & Co. (est. c. 1835), 32

aura, 7, 174

B

Babbage, Charles (1791-1871), 103

Bann, Stephen, 8, 9, 22, 174, 175, 177, 195

Barber, Alfred (1809-1884), 72, 197

Barringer, Timothy, 88, 192, 203, 204

Barrow, Sir John (1764-1848), 79

Barthes, Roland (1915-1980), 9, 173, 174, 175, 199, 208

Baxter, George (1804-1867), 99, 101 *fig. 40*, 102, 193

Beard, Richard (1801-1885), 30, 33, 35-36, 39, 40, 53, 56, 57, 61, 62, 67, 69, 70-73, 92, 98, 109, 113, 117, 129, 158, 159, 163, 180, 181, 182, 187, 188, 189, 190, 192, 194, 197, 200 *fig. 74*

Beard, Richard, Jr (1826-?), 113, 114-15 *figs 47-48*, 119 *fig. 49*

Richard Beard studio, 36, 37 *fig. 12*, 41 *fig. 13*, 42, 53, 54, 55 *fig. 20*, 56-57, 58-9 *figs 21-22*, 60, 61, 63 *fig. 23*, 64, 67, 69, 70, 78, 79, 80-2 *figs 27-29*, 84, 89-91 *figs 33-35*, 92, 106, 109, 117, 121 *fig. 51*, 122, 129, 182, 186, 187, 188, 191, 192, 193

Beato, Felice (1832-1909), 151, 196

Beatty, Francis (c. 1807-1891), 69-70, 187

Beegan, Gerry, 118, 122, 190, 195, 198

Belcher, Sir Edward (1799-1877), 79, 191

Benjamin, Walter (1892-1940), 7, 9, 57, 172, 174, 175, 187

Bentham, Jeremy (1748-1832), 102

Bentinck, Lord George (1802-1848), 87, 103

Berry, Miles (dates unknown), 39, 40, 52, 72, 181, 182, 183, 186

Bird, Dr Golding (1814-1854), 14 *fig. 4*, 15

article in *Floricultural Cabinet and Florist's Magazine*, 15

Bisson, Louis-Auguste (1814-1876), 129, 131 *fig. 56*, 132, 133 *fig. 57*, 179, 195

Blake, Robert, 72

Blanchard, Émile (1819-1900), 132

Bogue, David (1807-1856), 126-128, 187, 195

The Comical Creatures from Wurtemberg, 126, 127 *fig. 54*, 195

Bosley, William (fl. 1840s), 103, 105 *fig. 42*

Brande, William Thomas (1788-1866), 103, 193

Brewster, David (1781-1868), 102, 168-169 *figs 73-74*, 170, 176, 184, 185, 186

Bright, John (1811-1889), 87, 109, 192

British Association for the Advancement of Science, 20, 185

British Queen, 32

Brooks, Henry, 163

Brougham, Lord Henry (1778-1868), 83 *fig. 30*, 84, 103, 191-192

Brown, Eliphalet M., Jr (1816-1886), 150, 152-153 *figs 68-69*, 196

Buckland, William (1784-1856), 21, 106, 107 *fig. 43*, 176

Burdett-Coutts, Angela (1814-1906), 106, 107, 194

Buron (fl. 1839), 32

Byron, Lord [George Gordon] (1788-1824), 102

C

Caldesi, Leonida (1822-1891), 159

Callow, J., 44 *fig. 14*

Cameron, Julia Margaret (1815-1879), 159, 198

Canning, Charles John (1812-1862), 56, 58 *fig. 21*

Cardinal d'Amboise, 23, see also Niépce, Joseph Nicéphore

Carpmael, William (1804-1876), 33

Chalmers, Thomas (1780-1847), endpapers, 92, 93 *fig. 36*, 192

Chapple, William (fl. 1840s), 72

Charivari, 32

Cheval avec son conducteur, 23

Children, John George (1777-1852), 56, 181

Christian Register, 26, 177

Claudet, Antoine Jean François (1797-1867), 30, 39-40, 42, 45, 50, 53, 62, 64, 66, 67, 69, 72-73, 74, 75, 84, 87, 92, 94-95, 98, 102-103, 106, 107, 109, 113, 117, 118, 122, 126, 128, 129, 142, 144, 148, 154, 156, 158-159, 160-163, 170, 178, 180, 181, 182, 183, 184, 185, 186, 188, 189, 190, 191, 192, 193, 194, 195, 196, 197, 199, 201 *fig. 75*

Antoine Claudet studio, imprint page, endpapers, 65 *fig. 24*, 68 *fig. 25*, 78, 83 *fig. 30*, 85 *fig. 31*, 86 *fig. 32*, 87, 92, 93 *fig. 36*, 96-7 *figs 37-38*, 100-101 *figs 39-40*, 105 *fig. 42*, 108 *fig. 43*, 110-111 *figs 44-45*, 120 *fig. 50*, 123-124 *figs 52-53*, 127 *fig. 54*, 139 *fig. 60*, 141 *fig. 62*, 143 *fig. 63*, 168-69 *figs 73-74*, 178, 182

The Geography Lesson, cover, 154, 155 *fig. 70*, 156, 197

Claudet and Houghton, 40, 42, 45, 50, 117, 182, 183, 185

Claudet, Frances George (1837-1906), 144

Claudet, Henri (1828–1880), 107, 154
cliché verre photograph, 17
Clift, William (1775–1849), 103
Colonist, 21, 177
commodity fetishism, 7, 172
Cook, Conrad (fl. 1831–1850), 108, 193
Cooper, John Thomas (1790–1854), 52, 53, 69, 185, 186, 197
Cousins, Samuel (1801–1887), 66
Cowderoy, Benjamin (1812–1904), 162–163, 199
Cruikshank, George (1792–1878), 54, 55 *fig. 20*, 56, 187
History & Description of the Crystal Palace, 117, 195
Curzon, Robert (1810–1873), 56

D

Daguerre, Louis Jacques Mandé (1787–1851), 13, 17, 20, 21, 23, 25 *fig. 9*, 26, 27, 30–31, 32, 39, 40, 42, 43, 45, 52, 176, 177, 178, 179, 182, 183, 184, 185, 186, 187, 188, 190, 196, 198
Historique et description des procédés du daguerréotype et du diorama, 17, 31, 176, 179, 185, 188
Le Daguerréotrappe, 32
Davy, Humphry (1778–1829), 102, 188
Derrida, Jacques (1930–2004), 11, 172, 175
de St. Croix (Ste. Croix), M. (fl. 1839), 52, 185, 186
d'Urville, Jules Sébastien César Dumont (1790–1842), 129, 131 *fig. 56*, 132, 133 *fig. 57*, 195
Dickens, Charles (1812–1870), 106–107, 109, 110–111 *figs 44–45*, 122, 194
Bleak House, 107
Household Narrative of Current Events, 122, 195
Dillwyn, Lewis Weston (1778–1855), 183, 184, 185, 189, 191
Dimond and Co., 52
diorama, 17, 26, 176, 177, 179, 183, 188
dissemination, 6, 10, 11, 13, 129, 158, 160, 171–173, 175, 177, 202–204
Donné, Alfred François (1801–1878), 26, 31
Doussin-Dubreuil, Alexandre (fl. 1842–1845), 192
Duchâtel, Charles-Marie (1803–1867), 27, 178
Duke, Sir James (1792–1873), 84
Dumoutier, Pierre-Marie Alexandre (1797–1871), 129, 131 *fig. 56*, 132, 133 *fig. 57*
The Eclectic Magazine of Foreign Literature, 145 *fig. 64*, 148, 196

E

Edgeworth, Maria (1768–1849), 60–61, 187, 188, 192
Egerton, Jeremiah (fl. 1840s), 72, 178, 187
England under Victoria, 148, 149 *fig. 67*, 196
Ennis, Helen, cover, 195
Ensign, Thayer & Co., 94
G.R. and H. Elkington & Co. of Birmingham, 53
Evans, Walker (1903–1975), 196
Excursions daguerriennes, 43
Fairholme, Lieutenant James Walter (1821–c. 1848), 78, 191

F

Faraday, Michael (1791–1867), 103, 105 *fig. 42*, 175, 193–194
Fazzini, Gaetano (fl. 1830s–1840s), 20
Feilding, Lady Elisabeth Theresa (1773–1846), 185, 189, 198
Fitz, Henry, Jr. (1808–1863), 33, 34 *fig. 11*

FitzJames, Captain (1813–1848), 78–79
Armand-Hippolyte-Louis Fizeau (1819–1896), 28 *fig. 10*, 49 *fig. 18*, 53, 186
Forbes, James David (1809–1868), 20
Foucault, Michel (1926–1984) 151, 197
Francis, George William (1800–1865) 16 *fig. 5*, 17
Franklin, Lady Jane (1791–1875), 78–79
Franklin, Sir John (1786–1847), 21, 78–79, 80 *fig. 27*, 176

G

Gambart, Ernest (1814–1902), 163, 166
Garrison, William Lloyd (1805–1879), 57
Gaspey, William (1812–1888), 117, 195
Gill, Samuel Thomas (1818–1880), 189
Giroux, Alphonse (1776–1848), 27, 40, 176, 179, 188
Gleason's Pictorial Drawing-Room Companion, 79
Goddard, John Frederick (1795–1866), 35
Goodman, George Barron (also Geshon Ben Avrahim) (?–1851), 70, 189–190
Gore, Lieutenant Graham (c. 1808–1848), 79
Goupil-Fesquet, Frédéric (1806–1893), 43, 46 *fig. 15*
Graham, Thomas (1805–1869), 103, 184
Grove, William Robert (1811–1896), 66, 103, 189, 191
Guenney, 129, 131 *fig. 56*, 132

H

Harper's Weekly, 150
Harris, George Francis Robert (1810–1872), 56
Hastings, David, 102, 193, 194
Heine, Wilhelm (1827–1885), 150–151, 152–153 *figs 68–69*
Henneman, Nicolaas (1813–1898), 95, 198, 162–163, 164–167 *figs 71–72*, 166, 192, 198–199
Hill and Adamson, 92
Hobart Town Courier, 21, 22, 70, 132
Hogg, Jabez (1817–1899), 187, 197–198
Holland, Edward (fl. 1840s), 72, 182, 190
Holmes, Oliver Wendell (1841–1935), 157, 159, 197
Houghton, George (fl. 1834–?), 40, 42, 45, 50, 172, 180, 182–183, 185
Household Words, 107, 122, 194–195
Hunt, Robert (1807–1887), 23, 177

I

Ibbetson, Levett Landon Boscawen (1799–1869), 18 *fig. 6*, 19 *fig. 7*, 20, 53
Illustrated London News, 2 *fig. 1*, 74, 76 *fig. 26*, 78–79, 81–83 *figs 28–30*, 86 *fig. 32*, 84, 87, 113, 114–124 *figs 47–53*, 117, 122, 128–129, 135–136 *figs 58–59*, 134, 144, 150–151, 190–192, 194–196
L'Illustration, 150, 196
Illustrirte Zeitung, 150
'Improvements in Apparatus for taking and obtaining likenesses and Representations of Nature and of Drawings, and Other Objects', 33
Ingram, Herbert (1811–1860), 74, 190
International Magazine of Literature, Art and Science, 94, 192

J

Jazet, Jean-Pierre-Marie (1788–1871), 22
Napoleon reviewing the guard in the Place du Carrousel, 22
Jerdan, William (1782–1869), 102, 104 *fig. 41*
National Portrait Gallery of Illustrious and Eminent

Persons of the Nineteenth Century, 104 *fig. 41*
Jerrold, Douglas William (1803-1857), 109
Johnson, John (1813-1871), 35-36, 180
Johnson, William S., 36
Joly de Lotbinière, Pierre-Gustave (1798-1865), 43
Josephs, Edward, 72
Kellogg, Elijah Chapman (1811-1881), 94
Duchess of Kent [Princess Victoria of Saxe-Coburg]
 (1786-1861), 116

K
Kilburn, Douglas T. (1811-1871), 194, 196
Kilburn, William Edward (1818-1891), 109, 112 *fig. 46*,
 113, 117, 129, 132, 134
William King [Earl of Lovelace] (1805-1893), 56
Kossuth, Lajos (1802-1894), 92, 94, 95, 96 *fig. 37*, 192

L
Landells, Ebenezer (1808-1860), 75, 76 *fig. 26*
Landseer, Edwin Henry (1802-1873), 177
Launceston Advertiser, 21, 177
Law, Benjamin (1807-1882), 132
Lawrence, Thomas (1769-1830), 54, 102, 104 *fig. 41*, 177
Leja, Michael, 151, 197
Lerebours, Noël Marie Paymal (1807-1873), 31-32, 40,
 42-43, 41-51 *figs 14-19*, 154, 178-179, 183-184, 199
Leslie, Frank (1821-1880), 150
 Frank Leslie's Illustrated Newspaper, 79, 150, 192
Le Vesconte, Henry Thomas Dundas (d. c. 1848), 79
*Literary Gazette, and Journal of Belles Letters, Arts,
 Sciences*, 72, 150, 175, 101, 108, 190, 193-194, 198
Le Lithographie, 27, 178
Liverpool Mercury, 92, 192
Livingstone, David (1813-1873), 87
Llewelyn, John Dillwyn (1810-1882), 183-184, 189, 191
London Evening Standard, 142, 196
London Labour and the London Poor, 88,
 89-91 *figs 33-35*, 192
London Photographic Society, 166
Lord, Russell, 178, 184, 191, 204
Marchioness of Londonderry [Frances Anne Vane]
 (1800-1865), 113
Lubbock, John William, 3rd Baronet (1803-1865),
 103, 106
Admiral Lütke [Friedrich Benjamin Graf von Lütke]
 (1797-1882), 82 *fig. 29*

M
Magazine of Natural History, 15
Magazine of Science and School of Art, 15, 16 *fig. 5*, 176
Maguire, Thomas Herbert (1821-1895), 106
Malone, Thomas Augustine (1823-1867), 95, 162, 193, 198
Manchester Art Treasures, 138
Marquess of Northampton [Charles Douglas-
Compton] (1816-1877), 22, 103
Martens, Conrad (1801-1878), 15, 175
Maurisset, Théodore (fl. 1834-1859), 32, 188
La Daguerréotypomanie, 32, *188*
Mayhew, Henry (1812-1887), 88, 89-91 *figs 33-35*, 192
Marx, Karl (1818-1883), 7, 174
Mayall, John Jabez Edwin (1813-1901), 107, 109, 117,
 159, 192, 194-195
 as Professor Highschool, 109
McCauley, Elizabeth Anne, 174, 177, 197

McQueen's, 38
Medical Hall of Furnival, 35
*The Mechanic and Chemist: A Magazine of the Arts
 and Sciences*, 12 *fig. 3*, 13
Melville, Harden (1824-1894), 191
Merwanjee, Hirjeebhoy (1817-1883), 52, 181, 186
Minton & Co., 122, 195
metallic speculum, 36
Mirror of Literature, Amusement, and Instruction, 13,
 14 *fig. 4*, 26, 52, 175, 186
Mitford, Mary Russell (1878-1855), 95
Monaldi, Alessandro (fl. 1830s-40s), 20
Le Monde illustre, 197
Morley, Henry (1822-1894), 107, 194
Morning Chronicle, 35, 126
Morning Herald, 70-71, 109, 190-191, 193
Morse, Samuel (1791-1872), 179

N
Le National, 184
Newland, John William (1809/10-1857), 193
Niépce, Claude Félix Abel (1763-1828), 23
Niépce, Isidore (1805-1868), 31, 39, 177, 179, 183
Niépce, Joseph Nicéphore (1765-1833), 23, 31, 177
 Cardinal d'Amboise, 24 *fig. 8*
Nottingham Mercury, 69, 194
Nowrojee, Jehangeer, 52, 101, 106

O
O'Connell, Daniel (1775-1847), 92, 192
Official Description and Illustrated Catalogue, 117
Ojibbeway Indians, 84
Ørsted, Hans Christian (1777-1851), 103
*Orunudoi: A Monthly Magazine Devoted to Religion,
 Science, and General Intelligence*, 134, 135 *fig. 58*
Ouvrard, M. Gabriel-Julien (1770-1846), 84

P
panorama (panorama prints), 74-75, 117-18, 151, 156,
 160, 190, 191
 *Grand Panorama of the Great Exhibition of All
 Nations 1851*, 117, 119 *fig. 49*
 London in 1842, 76 *fig. 26*
 of Yedo (Edo), 151
Pattinson, Hugh Lee (1796-1858), 45, 51 *fig. 19*, 184
The Pencil of Nature, 166, 198
Perry, Commodore Matthew C. (1794-1858), 150, 152, 153
Peter Jackson, London & Paris, 112 *fig. 46*
Phillibrown, Thomas (1800-1899), 94, 96 fig. 37
Phillips, Wendell (1811-1884), 57, 59 *fig. 22*
Photographic News, 69, 100, 107, 109, 197
Pickering, Edward J. (fl. 1840s), 137, 139 *fig. 60*
Pictorial Times, 85 *fig. 31*, 87, 192
Pierce, Sally, 151, 197
Pinson, Stephen, 26, 177-178, 191
Platier, Jules (fl. 1830s-1840s), 32
Playfair, Lyon, 1st Baron Playfair (1818-1898), 103, 106
Ploucquet, Hermann (1816-1878), 122, 126, 195
Poliorama pittoresco, 20
Pomare IV [Aimata Pōmare IV Vahine-o-
Punuatera'itua] (queen) (1813-1877), 99
Pius VII (pope) (1742-1823), 23
Prévost, Pierre (1764-1823), 190-191
Pritchard, George (1796-1883), 98-99, 102, 193, 199

Prout, John Skinner (1805-1876), 134
punctum, 7, 174

Q
Quadrant studio, 106

R
Raeburn, Henry (1756-1823), 102
Reading Establishment, 162, 163, 164, 164-165 *fig. 71*,
 166, 167 *fig. 72*, 198, 199
Reaves, Wendy, 151, 197
Renouard, Charles Paul (1845-1924), 25 *fig. 9*
Rembrandt Harmenszoon van Rijn (1606-1669), 62
Rejlander, Oscar (1813-1875), 166, 199
Religious Tract Society, 15
Reynolds, Sir Joshua Reynolds (1723-1792), 62
Robison, Sir John (1778-1843), 31, 179
Roffe, William (1817-c. 1894), 148
Parsons, William, 3rd Earl of Rosse (1800-1867), 103
George Routledge & Co, London, 106, 176, 182
Royal Gallery of Practical Science
 (Adelaide Gallery), 30, 130
Royal Polytechnic Institution, 39, 50, 63 *fig. 23*, 70,
 176, 182
Royal Society of Edinburgh, 31
Ruskin, John (1819-1900), 160, 185
Ryall, Henry T. (1811-1867), 92, 136, 142, 144, 148, 196

S
Salathé, Frédéric (1793-1860), 48 *fig. 17*, 51 *fig. 19*
Sartain, John (1808-1897), 109, 145 *fig. 64*, 148
Schaaf, Larry J., 162, 175-178, 181, 192-193, 198-199, 204
Schwartz, Joan M., 164, 197
Silvy, 159
Sinnett, Frederick, 199
George Smith & Sons, 122
Solomon, Abraham (1823-1862), 140-141 *figs 61-62*, 142
The Spectator, 53, 64, 181, 188-189, 196
Sperling, Joy, 177
Stirling-Maxwell, Sir William, 166
Annals of the Artists of Spain, 166, 199
Stoop, Dirk (c. 1615-1686), 23
Frerès, Susse (fl. c. 1839), 31, 131 *fig. 56*, 188
Sun Pictures in Scotland, 166
Sutton, Thomas (1819-1875), 62, 67, 188
Sydney Morning Herald, 70-71, 189-191, 193
Swan, Donald, 107, 111 *fig. 45*

T
Tagg, John, 61, 188
Talbot, Constance (1811-1880), 12, 21, 26, 30, 36, 38,
 56, 57
Talbot, William Henry Fox (1800-1877), 68 *fig. 25*,
 96, 100-101, 162-163, 164-167 *figs 71-72*, 170, 175-176,
 180-183, 185, 188-193, 198-199, 206
Tallis, John (1817-1876), 117
Taylor, Roger, 178, 184, 188, 196-199, 204
Thillon, Anna (1817-1903), 103
Thirlwall, Master, 84
Portrait of Master Thirlwall, 81 *fig. 28*
Thompson, George, 57
The Times (London), 26, 38, 40, 50, 70, 98, 109, 142,
 182-183, 186,
Timmey, 129, 131 *fig. 56*, 132

Le Tour du monde, 161, 196
Pauline, Lady Trevelyan (1816-1866), 20, 176, 185
Trucanini [Truganini] (1812-1876), 132

U
United States Magazine and Democratic Review, 160

V
Van Diemen's Land, 132, 177
Vernet, Émile Jean-Horace (1789-1863), 22, 43,
 46 *fig. 15*, 171, 176
Victoria (queen) (1819-1901), 103, 122, 126, 194, 116
Visitor, or Monthly Instructor, 15
Vizetelly, Henry Richard (1820-1894), 87, 190-191
von Berres, Joseph (1821-1912), 177-178
 Phototyp nach der Erfindung des Professor Berres, 26
von Guérard, Eugene (1811-1901), 134
Voyage au pole sud et dans l'Oceanie, 129, 131 *fig. 56*,
 133 *fig. 57*, 195

W
Watson, James (1799-1874), 196, 72, 141 *fig. 62*, 144, 148
Weber, 46 *fig. 15*
Wedgwood, Josiah (1730-1795), 62, 188
Wellesley, Arthur, 1st Duke of Wellington (1769-1852),
 104 *fig. 41*, 196
Westminster Review, 18-19 *figs 6-7*, 20-21, 176
Thomas Wharton & Co., 61, 129, 187
Wheatstone, Charles (1802-1875), 36, 181
Wills, William Henry (1810-1880), 107, 194
Wolcott, Alexander S. (1804-1844), 32, 35, 71, 72, 180,
 187, 190, 196, 197
Wolcott (mirror) camera, 33, 35, 36, 38, 40, 41 *fig. 13*,
 54, 61, 63 *fig. 23*, 69, 180, 181, 182, 187
Wolcott's Mixture, 35, 180
Wolcott's Reflecting Apparatus, (see Wolcott camera)
 Wolcott/Johnson daguerreotype portrait, 33
Wolcott and Johnson enterprise, 35, 180, 182
Wood, R. Derek, 179, 183, 186-187, 190, 197, 204
Wood, Paul, 107, 55 *fig. 20*, 174
Wordsworth, William (1770-1850), 102
Woureddy (d. 1842), 132
Wright, Joseph, 102
Erasmus York, Eramus (or Caloosa) [Erasmus
 Augustine Kallihirua] (c. 1834-1856), 122

Y
Young, Thomas (1773-1829), 102

Geoffrey Batchen teaches art history at Victoria University of Wellington in New Zealand, specialising in the history of photography. His books include *Burning with Desire: The Conception of Photography* (1997), *Each Wild Idea: Writing, Photography, History* (2001), *Forget Me Not: Photography and Remembrance* (2004), *William Henry Fox Talbot* (2008), *What of Shoes? Van Gogh and Art History* (2009), *Suspending Time: Life, Photography, Death* (2010), *Obraz a diseminace: Za novou historii pro fotografii* (Czech, 2016), and 更多的疯狂念头 [*More Wild Ideas*] (Chinese, 2017). He also edited *Photography Degree Zero: Reflections on Roland Barthes's Camera Lucida* (2009) and co-edited *Picturing Atrocity: Photography in Crisis* (2012). In April 2016 his exhibition *Emanations: The Art of the Cameraless Photograph* opened at the Govett-Brewster Art Gallery in New Plymouth, New Zealand. A book of the same name was published by Prestel.